MASTERPIECES

The Best-Loved Paintings from America's Museums

SIMON & SCHUSTER
Rockefeller Center
1230 Avenue of the Americas
New York, New York 10020

10 9 8 7 6 5 4 3 2 1

Library of Congress Cataloging-in-Publication Data
Frankel, David, 1954–
 Masterpieces : the best-loved paintings from America's museums /
 David Frankel.
 p. cm.
 Includes index.
 1. Painting—United States—Catalogs. I. Title.
 N510.F73 1995
 750'.74'73—dc20 95-939
 CIP

ISBN 0-684-80197-3

Developed and produced by Redefinition, Inc., Alexandria, Virginia, in association with
the United States Historical Society, Richmond, Virginia

Printed in Singapore

MASTERPIECES

The Best-Loved Paintings from America's Museums

DAVID FRANKEL

Foreword by Robert H. Kline
Chairman of the United States Historical Society

SIMON & SCHUSTER
New York London Toronto Sydney Tokyo Singapore

CONTENTS

FOREWORD

An old *New Yorker* cartoon shows two middle-aged ladies standing in front of the *Mona Lisa*. One woman says to her friend, "I don't know what's so great about that painting. I had a smile like that for years."

Why we like or don't like a particular painting is a mystery, but it's no mystery that we love some, hate some, and don't much care about others.

All of this prompted the United States Historical Society to decide a few years ago to ask a number of American museums to tell us which were the paintings that the people—the museum-goers—liked the most. I knew that museums keep accurate records and follow trends pretty closely so I asked them to base their answers on the numbers of postcards, color slides, and prints of their paintings that they sold. Also, on the frequency of requests to see particular paintings.

We are grateful to the museums for their cooperation. Many of them expressed the same kind of curiosity that I had about what the results of our search would be.

The paintings that appear in *Masterpieces: The Best-Loved Paintings from America's Museums* reflect selections made by thirty-three American museums. We based our selection of the museums on geographic range, cooperation by the museums themselves, and diversity of focus—we wanted to represent many different kinds of museums. Of course, with a different mix of museums, we would have arrived at a different mix of painters.

I find it interesting that while all of the people who expressed their opinions were visitors to American museums, only a third of the selected artists are American. Almost a third of the artists are French, or lived and worked in France, and the rest are from other countries

And it appears that the one artist best-loved is not American but French—Pierre-Auguste Renoir. He is the only one whose paintings were selected by two museums.

Why are the French more than proportionately represented here? Probably because so many French Impressionst and modern painters from the late nineteenth and early twentieth centuries—like Monet, Renoir, Seurat, van Gogh, Matisse, Picasso, and Chagall—were first, and most eagerly, embraced by American collectors.

Eventually the American museums that grew from these collections were to display stunning examples of Impressionist and modern art.

There are, of course, many American artists whose works are best-loved—Grant Wood, Georgia O'Keeffe, Edward Hopper, Jackson Pollock, Winslow Homer, Reginald Marsh and so on, as you will see in browsing through *Masterpieces*.

But as different as these painters are—divided by time, language, and geography—what they share is even more remarkable. Each had the ability, in his or her own lifeime, to render the human condition with such power, compassion, or accuracy that their visions continue to touch us today.

Equally as interesting as the artists who were selected is the way that Redefinition, the company that developed and produced this book, decided to organize it. Normally, art books are arranged by periods or styles or subjects, and so you find similarities between adjacent paintings, for valid and scholarly reasons. But because of the important role museums played in the development of this book, the paintings are arranged in alphabetical order *by museum*.

So you're in for some surprises—pleasant and rewarding. You may be startled to see a Bruegel followed by Ogata Korin followed by a Bellini and then Gainsborough. It may be mind-boggling (it was for me) to see Jackson Pollock, John Singleton Copley, and Vincent van Gogh in sequence.

Mind-boggling, yes, but exciting and stimulating.

The paintings shown here represent what many observers see as a major change—and a maturing—in the tastes of the American museum-going public over the last 30 years or so.

What happened? During the 1960s and '70s, American museums started putting together "blockbuster" exhibitions that attracted and educated millions of new art lovers.

The pioneer of that revolution was Thomas Hoving, then director of The Metropolitan Museum of Art in New York City. He assembled and displayed art from around the country and around the world with a curator's passion and a showman's flare. Until those magnificent exhibits were unveiled, most museum galleries were often nearly empty. People just didn't think about going to museums for outings, as they do today.

But now we do think about it, and we go as a normal part of our lives to exhibitions in New York City, Chicago, Los Angeles, Richmond, Washington D.C., Tulsa, and other cities and towns across the country. Museums in England, France, Italy, Russia, Japan and now the Vatican are enjoying record attendance.

In America, people have learned to know and to love art—especially modern art. Paintings such as *The Flower Carrier* by Diego Rivera, and Georgia O'Keeffe's *Ram's Head* are widely known and loved, as are other modern works in the book.

I wonder why it is that this appetite for the modern, which is so well developed in America, has taken such a long time to mature in France and Japan, and has never aroused much interest in

Italy where, surrounded by centuries-old masterpieces, they still love their old masters.

Your appetite for all the art that you will find here will, I hope, be whetted as you make your way through the collection.

Browsing through *Masterpieces* is like walking through a museum gallery. The book's design ensures that the best-loved painting is always in front of you—just as it would be in a museum. David Frankel's lively and informative text is like having a curator at your side to tell you things that you might never know about.

With each of the paintings are commentaries about the artist, the subject and technique of the painting, its provenance and some basic and helpful information about the museum in

which the original is displayed.

In addition to the full-page reproductions of the best-loved paintings, you will see other works by each of the artists, occasional photographs and, in some cases, relevant paintings by other artists. For instance, in the pages about Monet's painting *The Seine at Bougival* we see a photographic portrait of the artist and, on the same page, a painting by Fantin-Latour that shows Monet with seven of his fellow artists. Then we can look at a photograph of the artist's garden in Giverny and the painting by Edouard Manet of Claude Monet in *The Studio Boat*. We also see Monet's *Women in the Garden* and his early painting *Impression, Sunrise*. And what an unexpected delight it is to see a miniature of *The Bath* by Monet's teacher, Charles Gleyre.

You will find that with each best-loved painting there is a mini-immersion in the art, the artist, and his world. I know that this will be a pleasant and rewarding experience for you and your friends. I hope that you will, as I did, come away with a new excitement and appreciation for the many masterpieces that we are blessed with in our American museums.

As you look through *Masterpieces*, please keep in mind that the works featured are those that the museums told us are their best-loved.

You may ask "Why did they choose that one?" Or "Why in the world did they leave out (you name it)? Everyone knows that is one of the best!" For instance, you may ask, "Why is Grant Wood's *American Gothic* not one of the best-loved?" Well the answer is this:

American Gothic is in the collection of The Art Institute of Chicago, and that museum said that Georges Seurat's masterpiece, *A Sunday on La Grande Jatte,* is their best-loved painting. (I imagine that the current popularity of the Seurat painting is a result of Stephen Sondheim's delightful musical "Sunday in the Park with George," inspired by *La Grande Jatte*.)

But wait! You will find *American Gothic* in the section devoted to another of Grant Wood's popular paintings, his sardonic *Daughters of Revolution,* which the Cincinnati Art Museum selected as its best-loved. So take heart.

Tell your museum the painting that you love best, or write to the Society and tell us your preference.

It's quite possible that there will be other volumes of best-loved paintings.

One of these may include the one that is your favorite.

In the meantime, I invite you to begin your journey through these pages and experience the excitement and pleasure that these best-loved masterpieces can give.

—*Robert H. Kline*

CHAIRMAN, UNITED STATES HISTORICAL SOCIETY
RICHMOND, VIRGINIA

money, partly because he had an expensive taste for imported foods. He tried to endure, writing, "When every day I eat my dry bread with a glass of water, I come to believe that it is a beefsteak through sheer will." But in 1893 Gauguin requested repatriation as a "destitute" French citizen, leaving Teha'amana weeping on the beach.

His return was unsuccessful. A Paris show of his work brought few sales and bad reviews. "I should like never to see Europeans again," Gauguin said.

In 1895 he returned to Tahiti, where he worked in the same French-colonial government that he blamed for ruining Tahitian culture. Sick again, he was in and out of the hospital, spending scant cash on painkillers. Teha'amana visited him but wouldn't stay. In Copenhagen his daughter Aline died from pneumonia in 1897 at age 20. Deeply depressed, Gauguin swallowed arsenic early in 1898, but he survived, "condemned to live."

Financial success came in 1900, when the paintings he was sending to Paris finally found their market. He left Tahiti for a new start in the Marque-

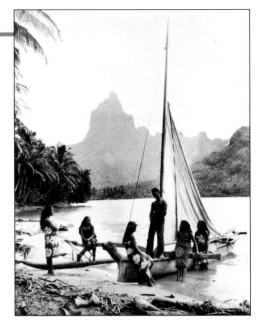

By Gauguin's day, French colonialism had begun changing primitive Tahitian customs, but scenes like the one shown here still existed.

sas, but a Paris friend cautioned him against returning to France: "Your arrival would upset a tendency...which is taking place in public opinion about you: you are now that extraordinary, legendary artist who...sends disconcerting, inimitable works...you have passed into the history of art." Gauguin died in the Marquesas in 1903, an empty laudanum bottle beside his bed. ❑

functional objects, which inspired him to make ceramics and carvings.) He took visual ideas from Egyptian and classical sculpture, South American art, and Western artists from Botticelli to Manet.

Gauguin's motifs are as sym-

Shell Idol, ca. 1893. Gauguin carved this figure from ironwood decorated with mother-of-pearl. The artist was fascinated by the supernatural.

bolic as his colors: flowers may symbolize innocence, a bird the presence of evil. He believed in what he called "synthesis," an insistence on the "essential," the spirit. This was why he went to Tahiti, where, he said, he had "escaped everything that is artificial and conventional"—including the conventions of painting. ❑

Watching for his daughter Aline, Gauguin wrote: "I am attracted by a form, a movement, and then paint them, with no other intention than to do a nude." The *Noa Noa* story may then be merely picturesque.

Iconographically, *Spirit of the Dead Watching* is a South Seas twist on Edouard Manet's *Olympia*, which Gauguin greatly admired. He had once painted a copy

of *Olympia*, and he kept a reproduction of it in his hut in Tahiti. Seeing it, a visitor had wondered whether the woman was his wife: "'Yes,' I lied. Me, the *tane* [husband] of Olympia!" ❑

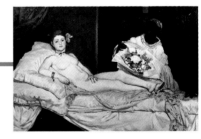

Manet's *Olympia*, 1863, may have inspired *Spirit of the Dead Watching*.

American industrialist A. Conger Goodyear, who donated it to the Albright-Knox Art Gallery in Buffalo, New York in 1965. ❑

gallery's well-known paintings include Vincent van Gogh's *La Maison de la Crau*, Pablo Picasso's *La Toilette*, Jackson Pollock's *Convergence*, Henri Matisse's *La Musique*, and Andy Warhol's *100 Cans*. About eight major new exhibits are mounted each year.

The gallery has a collection of sculpture from various time periods and cultures. The collection includes pieces from 16th-century France, 11th-century Cambodia, 14th-century India, and many others.

The museum has an education department, which offers art classes for adults and for children. There are also guided tours of the museum. ❑

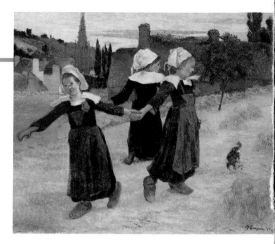

of civilization," Gauguin now
dreamed of a "studio in the
Tropics." He sailed for Tahiti in
1891.

The island had seen nothing
like him. His long hair provoked
the natives to nickname him
taata-vahine, man-woman; he
quickly cut it. He rented a hut in
a coastal village and took a 13-
year-old girl called Teha'amana as
a wife. Gauguin was happy here:
"In the morning when the sun
rose the house was filled with
radiance....[T]he two of us would go out and refresh our-
selves in the nearby stream as sim-
ply and naturally as in the garden
of Eden."

Yet life was not as sublime as
Gauguin painted it. He was often
sick. And he was always short of

painted, almost evanescent rear wall, and the perspec-
tive of the yellow cloth, which makes the girl's body
seem to float. The figure at the bed's foot, with its
masklike face, is of course supernatural.

In departing from orthodox procedures, Gauguin
was aided by Japanese prints, with their odd perspec-
tives and flat chromatic planes. (He admired Japanese

at night. Gauguin claimed he owed his knowledge of
local folklore to Teha'amana.

Actually, the story echoes a scene from a novel by
Pierre Loti, which Gauguin owned, and his main
encounter with Tahitian ghosts seems to have been in a
book by Belgian ethnographer J. A. Moerenhout.
Describing the genesis of the *Spirit of the Dead*

pencer Churchill, a
politician Winston
was bought by the

> *"I'm going away to be
> at peace, to rid myself of the
> influence of civilization."*

ction of modern American and
European art. The museum is
particularly strong in art dated
fter 1945.

Included in the Albright-
Knox's collection of modern art
re works of Abstract Expres- sionism, Pop Art, and art of the
'70s, '80s, and '90s. The museum
also features works that represent
the major trends in art through-
out history, starting with its old-
est piece, a Mesopotamian figure
dated 3,000 B.C. Some of the

SPIRIT OF THE DEAD WATCHING BY PAUL

THE ARTIST

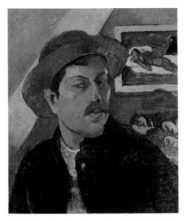

Self-Portrait with a Hat (1893–94) includes a reversed image of *Spirit of the Dead Watching*.

Paul Gauguin's celebrated with-drawal to the Pacific offered later artists an example not just of a way to paint but of a way to be. His famous paintings of Tahiti made him a major actor in the creation of modern art; his equally famous, or notorious, lifestyle animated the idea of the artist as rebel, nonconformist, social outcast. Generally, before the late 1800s suffering and art weren't causally connected in French culture. For Gauguin, though, the artist was an alien in society: "Civilization that makes you suffer. Barbarism which is to me rejuvenation."

THE TECHNIQUE

Simplified, idealized figures posed tableaulike, a love of pattern and design verging on abstraction, and, above all, warm, glowing colors—these trademarks of Gauguin's Tahitian painting are clear in *Spirit of the Dead Watching*. Gauguin described the logic of the work's palette: "The cloth has to be yellow, both because this color comes as a surprise to the viewer and

THE SUBJECT

In a book on his Tahitian experience, *Noa Noa*, Gauguin told the story of how, coming home late one night, he found the house dark. "I struck a match and I saw: motionless, naked, lying stomach down on the bed, her eyes huge with fear, Tehura looked at me without recognition. I stood for some moments in a strange uncertainty. Her terror was contagious. A phos-

THE PROVENANCE

When Gauguin painted *Spirit of the Dead Watching* in 1892, his Danish wife Mette was acting as a kind of European agent for him,

trying to sell not on[shipped to her but he had bought as a

THE MUSEUM ALBRIGHT-KNOX ART GALLERY

The Albright-Knox Art Gallery is located at 1285 Elmwood Avenue in Buffalo, New York. The gallery's governing body was founded in 1862, making it the sixth oldest arts organization in the United States.

The marble museum galler[which opened in 1905, original[had been planned to house th[art exhibition for the Pa[American Exposition of 190[The plan fell through when [short supply of marble delaye[

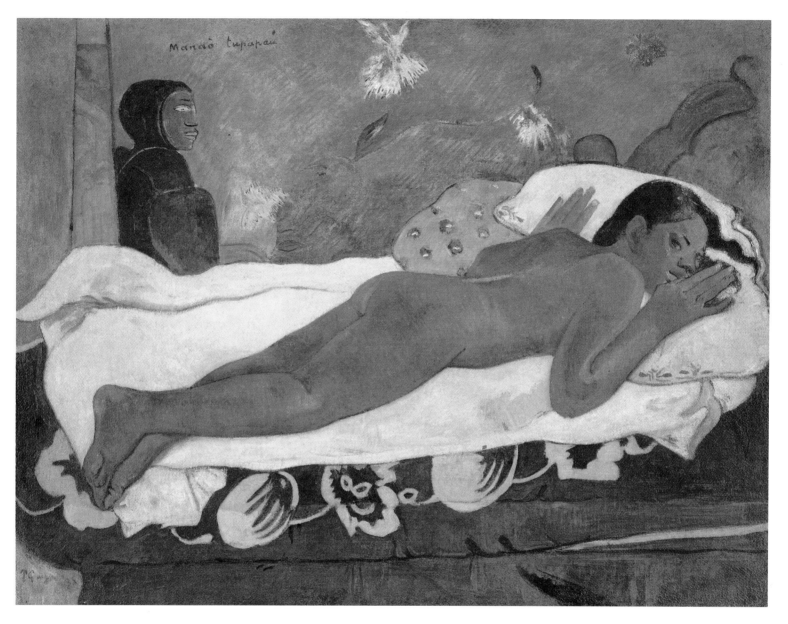

SPIRIT OF THE DEAD WATCHING
by Paul Gauguin, 1892
oil on burlap mounted on canvas
28 ½ x 36 ⅜ in. (72.4 x 93.4 cm.)
A. Conger Goodyear Collection
Albright-Knox Art Gallery
Buffalo, New York

The young woman, dwarfed by huge figures in Seurat's *La Grande Jatte*, is Lucie Brû, whose father bought the painting in 1900.

concealing it, the *Grande Jatte.*"

Though a private man, Seurat functioned well in the art world politics of his time. In 1884, when the *Baignade* was rejected by the Salon, the official showplace of French art, he showed it with the alternative

group that was to become the Société des Artistes Indépendants. He became an active member of the Société and was quickly recognized as a leader of his generation. In 1887, at a Brussels exhibition in which he showed, the Pointillist painter Paul Signac recorded an "incredible hubbub...Seurat's canvas was invisible, the crowd so large it was impossible to get near it."

In March of 1891 Seurat

abruptly fell ill. He made his way to his mother's apartment, where he died two days later, probably of diphtheria. He was only 31.

The Impressionist painter Camille Pissarro, who had greatly admired Seurat, attended the artist's funeral. The next day he wrote to his son, Lucien, "I think you're right: it's all over with Pointillism." ❑

it." Seurat posed his figures in the studio, as in a life-drawing class at the École. He effaced their individuality, giving them the quality Blanc had found in classical sculpture—"the dignity of a type....The type condenses and epitomizes all joys, all sorrows; it is not one, it is all." Seurat himself wrote of wanting to portray modern people "in their essential traits," like the figures on classical friezes; hence the still, set quality of the *Grande*

Jatte, and the figures shown in profile. Seurat wanted strong, classic pictorial structures that would convey a sense of order and permanence.

Seurat's art could easily have ended in chilly abstraction. His goal, however, was "harmony," and often he achieved it. This is only one of the contradictions of Pointillism, an art in which the solid is revealed through the particle, in which form simultaneously coheres and disintegrates in the eye. ❑

Seurat, 1884; A. Grevin, 1886.

individual's alienation under capitalism. Seurat probably did have some satiric intent. The woman at right, for example, wears an exaggerated bustle and leads a monkey on a leash; he may have drawn her from cartoon or advertising imagery (that of A. Grevin, say). His critique, however, is gentle and subtle. "All Seurat intended," wrote Signac, who

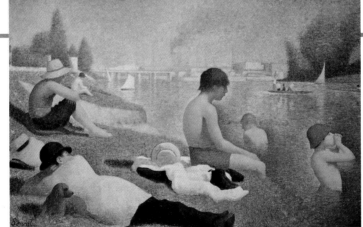

knew the artist well, "was a clear, cheerful composition of well-balanced verticals and horizontals with warm hues and clear tones dominating, the most luminous white at the center." ❑

Seurat's *Une Baignade, Asnières*, a companion to *A Sunday on La Grande Jatte*, shows a working-class watering spot just across the Seine from the fashionable Grande Jatte.

because the pictures are a burden....Monsieur Brû [is buying] the *Grande Jatte* for 800 francs. He is asking for and getting (thrown in, as it were) one of the best of the drawings, the portrait of Mme. Seurat. These people feel no shame at all in selling their brother's portrait of

their mother!" From Casimir Brû the painting passed to his daughter, Lucie, and her husband. There was one intermediate owner before the *Grande Jatte* was bought by the Art Institute of Chicago in 1926. ❑

Rooms—68 authentic studies of interiors since the 13th century—and the Rubloff Collection of more than 700 paperweights.

In addition to the *Grande*

Jatte, favorite works at the museum include Pierre-Auguste Renoir's *On the Terrace*, Grant Wood's *American Gothic*, and Edward Hopper's *Nighthawks*. ❑

MUSEUM HOURS
Monday, Wednesday–Friday:
10:30 a.m. to 4:30 p.m.
Tuesday: 10:30 a.m. to 8 p.m.
Saturday: 10 a.m. to 5 p.m.
Sunday: 12 to 5 p.m.

ADMISSION
Admission charged.
Free on Tuesdays.
Free to children under 6.

Mme. Ernestine Seurat, the artist's mother, conté crayon, 1882–83.

r, Ernestine, came
of carvers and car-
an uncle was an
ter who probably
on sketching trips.
died art in 1875 at
y a liberal reformer
in preparing future
areers in the com-
In 1878 Seurat
e École des Beaux-
studied the classi-

Much of Seurat's early work takes the form of exquisite drawings in which figures and shapes seem to coalesce out of clouds of dark crayon, with no firm contour to distinguish them from their surroundings. It was not until 1883 that he began his first large-scale canvas, *Une Baignade, Asnières*, which he immediately

followed with *A Sunday on La Grande Jatte*. A visitor from around this time has left us a glimpse of Seurat's atelier: "a tiny cell containing a low, narrow bed opposite some old canvases turned to the wall, the *Baignade* and some marine scenes....A red divan, a few chairs; a small table with some favorite journals, books by young writers, brushes and paints, and a wad of tobacco; leaning on a panel and completely

QUE

lue) as well as green, white, and a few of the tones
to meld in the viewer's eye, creating the rest of the
suggestion. By "decomposing" tones into their "con-
nts," the Pointillists would "stir up luminosities more
ose created by mixed pigments." Seurat, Pissarro contin-
first to conceive the
ely followed his

Seurat had read Charles Blanc's *Grammaire des arts du dessin*, which argued that color obeyed consistent, codifiable rules. He had looked at the color wheel of the American physicist N. O. Rood. He had also studied such abstruse fields as the electromagnetic properties of light. In part, Seurat's goal was a reconciliation of art and science.

Pissarro saw something else, though: "Seurat is from the École des Beaux-Arts, he's steeped in

poorer place than
atte, are looking
ss the river to the
enery in the paint-
ht corner.
r work, conversely,
ures face left—as if
the young men in
of whom might be
them. In the
tories rise in the
the *Grande Jatte*

their chimneys are hidden by trees. The Grande Jatte is a more sheltered place, and its people dress more expensively.

Some critics have made out the *Grande Jatte* as a social exposé. They have suggested that its women are prostitutes. Noting how none of the figures looks directly at any other (and only one, the child, looks at the viewer), they have discussed the

Monkey b
cartoon b

NCE

finished until the late spring of 1886. Shown in the
Impressionist exhibition that May, it was the most
controversial picture of the show.
Seurat kept the painting until

his death, when his estate was divided between his companion Madeleine Knoblock and the artist's family. In 1900 the family sold off much of its inheritance. Paul Signac would write in his journal, "The family, although millionaires, is selling all of them...I think mainly

THE MUSEUM

➤ Sculpture Court and galleries for American art and sculpture.

Over 300,000 works of art comprise the varied collections—Chinese bronzes, American silver,

European decorative arts, and paintings from the Middle Ages to the present. The photography collection includes works by Alfred Stieglitz, Eugène Atget,

Edward Weston, and Paul Strand. Architectural drawings feature major Chicago architects and buildings. Two unique collections are the Thorne Miniature

A SUNDAY ON LA GRANDE JATTE BY GEORGES SEURAT

THE ARTIST

Georges Seurat; an undated portrait by an unknown photographer.

"These young chemists who build up pictures from little spots"—that was Paul Gauguin's description of the Pointillists, his rivals in Post-Impressionism. By far the most significant of these artists was Georges Seurat. A radical experiment in painting, Pointillism—a way of constructing images out of myriad particulate dots—might have seemed so labor intensive as to be self-defeating. It was Seurat, inventor of the school, who gave it force.

Born in Paris in 1859, Seurat began to draw as a child. His father, a real estate speculator, was distant

Seurat *(sixth from the left)* attended classes at the École des Beaux-Arts in Paris from 1878 to 1880.

and cool, but the fa[...] fortably off. And [...] elsewhere in his b[...]

THE TECHNIQUE

An early critic of the Pointillists saw these artists as wild radicals who deserved to be shot. What is striking about Seurat, though, is not only how much deliberation his method took, but how formal it was, how rooted in order.

The principle is well described by Pissarro, who, though 30 years older than Seurat, was a disciple of his for a time. Using

"methods based on science," Pointillism was an attempt "to substitute optical mixture for the m[...] ments"—that is, the colors being mixed by the eye o[...] rather than by th[...] palette. Countle[...] dots of a limited [...] ors—the primaries

THE SUBJECT

In 1884 the Grande Jatte was a parklike island in a northwestern Paris suburb on the Seine, a place of picnicking and boating and promenading. This was the leisurely kind of place the Impressionists loved; indeed Claude Monet, Pierre-Auguste Renoir, and others had worked nearby. But Seurat's picture is quite different from theirs, and interpreta-

tions of it have diff[...]
The Grande J[...] across the water f[...] the *Baignade*, wh[...] painted the year [...] the two paintings [...] both mural scale, [...] exactly the same s[...] Imagine them sid[...] the *Baignade* to [...] working class [...]

THE PROVENANCE

Seurat began *A Sunday on La Grande Jatte* in May of 1884 and finished it, or thought he did, the following spring. While spending the summer of 1885 in Grandcamp on the At-

lantic coast, however, he began to experiment with the tuting his images of small dotlike brush strokes—the Pointillism. Returning to Paris, he entirely reworked th[...] *Grande Jatte* according to this new principle. The w[...]

THE MUSEUM THE ART INSTITUTE OF CHICAGO

The Art Institute of Chicago is made up of three buildings separated by railroad tracks but connected at the entrance level. The Allerton Building, on Michigan Avenue at Adams Street, was built in 1893 for the World's Columbian Exposition. The Rubloff Building opened in 1976 f[...] the Art Institute gallery space; [...] Building, opened [...] the McCormick

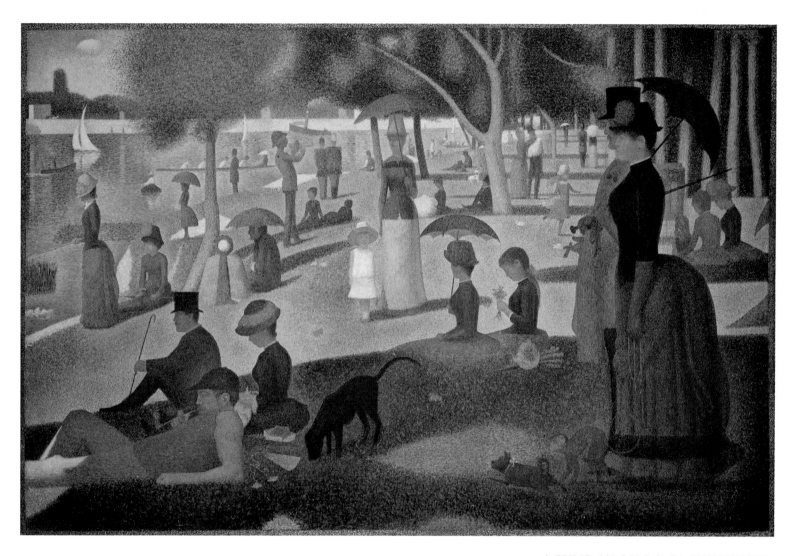

A SUNDAY ON LA GRANDE JATTE
by Georges Seurat, 1884-1886
oil on canvas, 81 ½ x 121 ¼ in. (207.6 x 308 cm.)
Helen Birch Bartlett Memorial Collection
The Art Institute of Chicago
Chicago, Illinois

terranean town of Nice; from then on he would spend part of the year there while Amélie stayed in Paris. (She and Matisse would finally separate in 1939.)

In Nice Matisse would paint a famous series of nude and exotically dressed women, the "Odalisques." In 1929 he virtually stopped painting for several years to concentrate on sculpting and printmaking.

Matisse considered leaving France during World War II but felt "it would be deserting." After a stomach operation in 1941 he became a near-invalid. Yet in 1943 he remarked, "All the signs indicate that I am about to start working on large-scale compositions, as if I had the whole of life, or another life, before me." There still remained the Vence Chapel, for which he designed stained glass and furnishings, and the paper cutouts of his last years—his "drawings with scissors." He died in 1954. ❑

La Négresse, **1952, a paper cutout.**

perched as a series of long curves.

Matisse perfectly understood the Renaissance system of perspective, with its deceptively convincing illusion of pictorial depth; yet in *Purple Robe and Anemones*, he made floor, cushion, table top, and walls look flat and vertical. In conventional perspective the cross-hatching in the floor, for example, would tighten toward the top to give the impression of recession. Here it is a group of even diamonds, each apparently equidistant from the eye. Similarly, though we're looking into the depth of a corner (signaled by the slope of the red cushion on the right, and the line where floor meets wall on the left), the stripes on both walls are evenly spaced. The stripes on the floor cushion are similarly regular. Looking at the painting, we wonder: How does that woman keep her seat? Why doesn't she slide onto the floor—or off the canvas altogether? ❑

picture, its every detail is expressive. The place occupied by figures or objects, the empty spaces around them, the proportions, everything plays a part." What is striking in works like *Purple Robe and Anemones* is that there are no empty spaces around the

Matisse collected costumes and textiles that he used in his paintings. The purple striped garment at left may be the same one used in ***Purple Robe and Anemones.***

figure. The whole canvas is a mesh of active line, here vertical, here diagonal, here straight, here curved, here checkered. Her body defined by the stripes of her robe, the model is just one of these areas of pattern—one element in a universe of interwoven energies. ❑

of Claribel for the book's frontispiece. Etta bequeathed the Cone collection to the Baltimore Museum of Art, to which it passed in 1950. The collection includes 42 Matisse oil paintings dating from 1917 to 1940 (at least one from each year), as well as examples of his sculpture, illustrated books, prints, and drawings. ❑

Japanese prints, and the sisters' reconstructed apartment room

The museum has an art school on its premises and a branch gallery in downtown Baltimore. ❑

PURPLE ROBE AND ANEMONES

➤ hardship but growing recognition, Matisse spent the summer of 1905 in a Mediterranean village, painting eccentrically hued images to exhibit that fall at the Salon d'Automne. Hung in a roomful of equally loud canvases by André Derain, Maurice Vlaminck, and others, they caused a sensation. Also in the room was a statue in the Renaissance style; a critic is said to have remarked of it, "Donatello au milieu des fauves!" (Donatello among the wild beasts!) Thus Fauvism was born and named.

Fauvist color and composition did not satisfy Matisse for long, but his work remained controversial. In 1908 an American critic condemned him "to the limbo of artistic degeneration" for the ugliness of his female

After a 1906 trip to Biskra, Algeria, Matisse painted *Blue Nude* with exotic plants in the background.

figures. (Matisse: "I don't paint women, I paint pictures.") At the Armory Show of 1913, New Yorkers heaped more insults on his work. The same year, when his *Blue Nude: Memory of Biskra* of 1907 was shown in Chicago,

art students burned it in effigy.

Matisse's visual experiments were influenced by non-Western tradition. He admired Persian and Islamic art and visited North Africa several times. He also loved southern light, heat, and color. In late 1917, when his palette had been running to blacks and somber blues, he visited the Medi-

Odalisque with Red Pantaloons, 1922. Film starlets posed as odalisques, or harem women, for a series of paintings in the '20s.

➤ repeatedly and arduously reinvented himself as a painter. Compare, for example, *Odalisque with Red Pantaloons* of 1922 to *Purple Robe and Anemones*: the body in the earlier work is modeled and solid-looking; in the later it is a series of quick, fluid arabesques framing planes of pattern, and the face is almost flat. This is only one of the permutations in Matisse's style throughout his career.

Many of Matisse's later works look like constant, experimental shufflings and recombinations of the same components: flowers, fruit, fabrics, female, furnishings. In *Purple Robe and Anemones*, he puts

them together by dividing the canvas into four quadrants, defined by the two walls, the floor cushion or sofa, and the black-latticed floor with its table. The quadrants meet in the busy space almost at the painting's center. Against this active but regular geometry, the female figure is

➤ fans is trying to trace different spreads, throws, screens, rugs, and cushions from painting to painting, where they often appear quite differently. The robe in *Purple Robe and Anemones*, for example, appears in at least two other paintings from the same

year—*Small Odalisque in a Purple Robe* and *Woman in a Purple Robe with Ranunculi*.

The woman with flowers or plants is another frequent Matissean motif, appearing as early as 1896–97 in *The Dinner Table*, emerging in a more

assertive mode in *Blue Nude: Memory of Biskra*. The symbolism of female beauty and fertility is reinforced in *Purple Robe and Anemones* by the way the flowers melt into the woman's shoulder and breast. Matisse once wrote, "When I paint a

➤ became a personal friend; they first bought work by him as early as 1906. (The sisters knew Matisse through their friendship with Gertrude Stein.)

Claribel died in 1929, leaving her art collection to her sister. In 1934, Etta published *The Cone Collection of Baltimore–Maryland*; Matisse drew a memorial portrait

➤ Pope, who also designed the West Wing of the National Gallery of Art in Washington, D.C.

One of the museum's most important holdings is the Cone collection, a 1950 bequest of Baltimore collectors Etta and Claribel Cone. The

Dr. Claribel Cone, ca. 1915–16.

Cone Wing houses their collection, which consists not only of works by Matisse (including *Blue Nude: Memory of Biskra, above*) and other European artists, but also of textiles, African art,

PURPLE ROBE AND ANEMONES BY HENRI MATISSE

Henri Matisse in a photograph taken in Baltimore, 1930.

THE ARTIST

Together with Pablo Picasso, Henri Matisse dominated Western painting through the first half of the 20th century. But whereas Picasso was a child prodigy, Matisse showed no early talent or interest in art. Born in 1869 in Picardy, he led an uneventful small-town childhood. He spent the year 1887–88 aimlessly studying law in Paris. Then he returned to Picardy and the life of a law clerk.

When he was 20, however, his mother gave him a box of paint to see him through a convalescence. The gift changed him. "Before, I had no taste for anything, I was filled with indifference," he would recall. "But the minute I had this box of colors in my hands, I felt my life was there."

Matisse taught himself the basics of painting from a manual and then studied at a local crafts school. In the fall of 1891 he returned to Paris. The following spring, the man now considered among the greatest of all painters failed the entrance exam for the École des Beaux-Arts. He eventually entered the school in 1895. In 1896, the French government bought a work of his and he was accepted into the conservative Société Nationale des Beaux-Arts, but this was not the career path that he chose to follow.

Matisse married in 1898. He already had a daughter from a prior relationship. With his wife, Amélie, he would have two sons. The family was poor; Amélie worked as a milliner and was often her husband's unpaid model.

After years of financial ➤

THE TECHNIQUE

In 1905 Matisse titled a now famous painting with a quotation from the poet Charles Baudelaire: "Luxe, calme et volupté." Luxury, calm, and sensual delight. The phrase is virtually the motto of his art. The painter later explained, "What I dream of is an art of balance, of purity and serenity, devoid of troubling or depressing subject matter...a soothing, calming influence on the mind, something like a good armchair."

This equilibrium was hard won. Seeking serenity for the viewer, Matisse himself at the easel might tremble, sweat, swear, weep. He sometimes couldn't look at his finished paintings lest they recall the anxiety of their creation. Matisse ➤

"I feel through color, and therefore my work will always be organized through color."

THE SUBJECT

As a studio interior with female model, *Purple Robe and Anemones* resembles many works of what is called the Nice period (from Matisse's arrival in Nice, in 1917, to the end of the '20s). It shows a similar interest in the pattern and flow of cloth, and a similar deployment of studio props—flowers, furniture, fruit. The work was painted in 1937, however, well after the Nice period, and is different in mood: the color brighter and cleaner, the paint looser, the modeling of the figure more daring.

Matisse often used fabric designs in his work; he was fascinated by decorative art. (Both his mother and his wife had worked with cloth as hatmakers.) He kept a wardrobe of interesting garments for his models in his studio, and a hobby for Matisse ➤

THE PROVENANCE

Purple Robe and Anemones was bought the same year Matisse painted it by a frequent collector of his, Etta Cone. Etta and her sister Claribel, a medical research doctor, came from a cotton-mill-owning family in Baltimore. Together they created a large collection of works by Cézanne, Gauguin, Picasso, van Gogh, and others. Their largest holdings were of Matisse, who ➤

THE MUSEUM — **THE BALTIMORE MUSEUM OF ART**

Etta Cone, ca. 1890.

The Baltimore Museum of Art is located at Wyman Park, Art Museum Drive, in Baltimore, Maryland. Founded in 1914 the museum was housed in a private home at 101 West Monument Street until it moved into its present building in 1929. The building was designed in the classical style by John Russell ➤

An artist's rendering of Pope's museum plan, 1926.

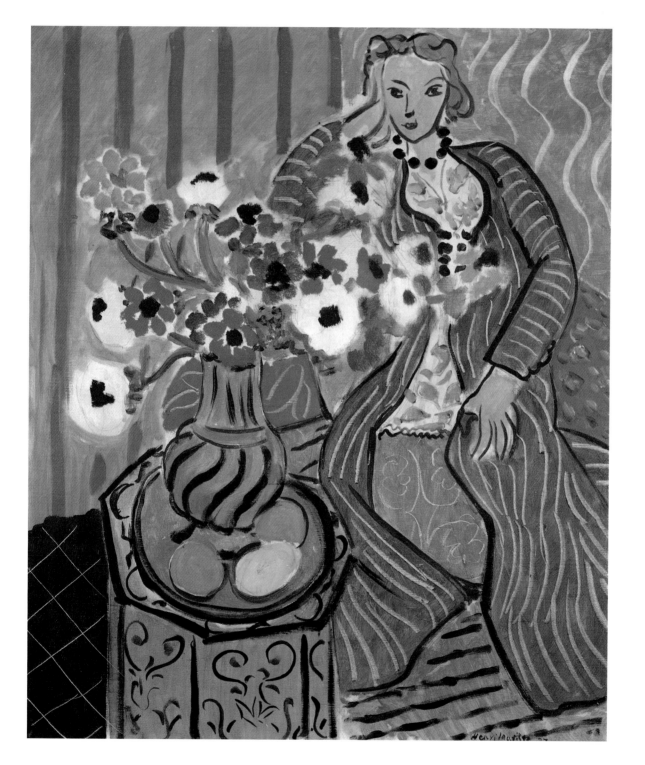

PURPLE ROBE
AND ANEMONES
by Henri Matisse, 1937
oil on canvas
28¾ x 23¾ in.
(73.1 x 60.3 cm.)
The Cone Collection
The Baltimore
Museum of Art
Baltimore, Maryland

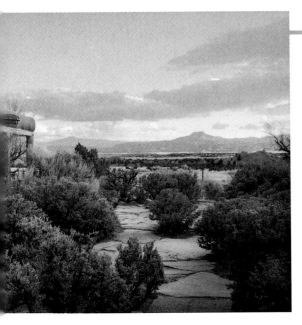

with other women and refused to let O'Keeffe have a child. By the spring of 1929, when O'Keeffe was invited to visit a friend in New Mexico, she welcomed the break from her marriage. After four months of sightseeing, camping, taking in the local culture, and learning to drive, she knew she had come to a turning point in her life: "I feel so suspended between one crystalizing and another—one that has finished and one that is beginning."

From then on O'Keeffe would regularly summer in New Mexico, abandoning Stieglitz for the season. (Yet, when apart, the couple would trade letters daily.) In 1940 she bought Rancho de los Burros, a house set in the hilly landscape of many of her paintings. She later bought a second house in the town of Abiquiu and divided her time between the two. In 1949, three years after Stieglitz's death, she moved west permanently.

In the '30s O'Keeffe could expect 1,000 visitors a week to her exhibitions—she had become an institution. In the late '40s and '50s, the popularity of Abstract Expressionist painting temporarily eclipsed her work, but she was indifferent; she had never liked the art world. She continued to work and began traveling worldwide, relishing the flying as much as the destinations: a late series shows clouds seen from the air.

By 1958, New York's Metropolitan Museum of Art was hailing her as an "American Master." A formidable grande dame, she lived on in New Mexico until her death in 1986. ❑

pretation" free-associating critics had made of her abstractions. For a typical early writer, O'Keeffe's art expressed "what every woman knows but what women heretofore have kept to themselves." O'Keeffe herself

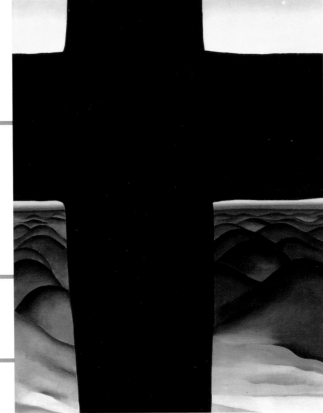

Black Cross, New Mexico, 1929. O'Keeffe was fascinated by the Catholic crosses she saw in the desert landscape.

said of one piece, "It is essentially a woman's feeling." But when male critics saw the work this way, she tried to forestall them. Her flowers, for example, powerfully suggest a warm, sensual inside softness; but to read them as sexual metaphors is to risk being single-minded—they're flowers. ❑

**. Flowers
eeffe's
. Some
e given
tions to
ngs.**

echoes of the Crucifixion (a central vertical shape with wide high horizontals). O'Keeffe had painted the crosses on the New Mexico hills and was taken with the region's Hispanic Catholicism, but her deepest mystical feeling seems to have been the

experience of standing "alone with the earth and sky" and feeling "something in me going off in every direction into the unknown of infinity." *Ram's Head, White Hollyhock—Hills* may signal that intimation of selflessness in the face of sky and land. ❑

a psychologist, but they were both active in the New York art community. Most of the

Lowenthals' collection was donated to the Brooklyn Museum in a 1992 bequest. ❑

strong in ancient Egyptian art.

Two research libraries are open to the public; a library of Egyptology is open by appointment. Workshops, films, and lectures are held year-round. ❑

MUSEUM HOURS
Wednesday–Sunday: 10 a.m. to 5 p.m.

ADMISSION
Free.
Donation suggested.

RAM'S HEAD, WHITE HOLLYHOCK—HILLS

➤ tographers and was an important photographer himself. O'Keeffe admired him enormously: "I believe," she told a friend, Anita Pollitzer, "I would rather have Stieglitz like something—anything I had done—than anyone else I know of."

In October of 1915, back in South Carolina, O'Keeffe had an artistic breakthrough. "I found myself saying to myself," she would recall, "I can't live where I want to—I can't go where I want to—I can't do what I want to—I can't even say what I want to…. I was a very stupid fool not to at least paint as I wanted to and say what I wanted to when I painted." Working late into the night on her knees on her bedroom floor, she made a group of abstract charcoal drawings that she called "Specials." Eventually she mailed the drawings to Pollitzer, who took them to Stieglitz. He thought them "the purest, finest, sincerest things that have entered 291 in a long while."

In May 1916 Stieglitz hung some of the "Specials" in 291—to O'Keeffe's alarmed surprise, for he hadn't asked her first. A successful one-woman show followed the next year. Stieglitz urged O'Keeffe to move to New York and become an artist full-time; in June 1918 she did. She and Stieglitz began living together almost immediately—he had to leave his wife—and they married in 1924.

Exhibiting O'Keeffe's work, managing her career, and being central in her personal life, Stieglitz was often seen as the creator of her artistic identity. Yet when the two met, O'Keeffe's esthetic ideas were well along: she had read widely, including Gertrude Stein on Henri Matisse and Pablo Picasso and Wassily Kandinsky's *On the Spiritual in Art* (twice). It was her involvement in modern art, after all, that had led her to 291 and to Stieglitz.

Furthermore, the relationship between the two was often difficult. She had to elbow for space among the men of Stieglitz's art world, whom she drily called "the boys." He flirted

A 1978 photo of O'Keeffe's house at Ghost Ranch, New Mexico, which she bought in 1940. The mountain in the background is called the Pedernal and was sacred to local Indians. It appears in several of O'Keeffe's paintings.

➤ The flower and the skull are opposites—the one soft, the other hard, the one blooming and evanescent, the other dead and timeless, the one full of color and form, the other life stripped down to bedrock. Visually, though, the shapes are related flows of hollows and cavities, exteriors rounding into interiors, delicately graded whites. Bones and flowers appear often in O'Keeffe's work. If the flowers seem sexual, the bones may show a sexuality turned sterile. The visual resonances between them make fertility and sterility two sides of the same coin.

O'Keeffe might have discouraged such a reading. In 1924 she wrote of wanting to produce work "as objective as I can make it," for she "didn't like the inter-

➤ *Rose*, both from 1931. In those paintings, skull and flower are set against black or black and white backdrops. *Ram's Head, White Hollyhock—Hills* is the first of many canvases to combine a skull with the desert landscape. O'Keeffe's popularity has made these images so familiar as to obscure the originality of floating that horned emblem in the sky.

There are various ways to read such pictures, but their meanings are also deeply personal. *Ram's Head, White Hollyhock—Hills* has some qualities of the religious icon, with suggestions of sacrifice and

Pink Tuli[p] were one [of] favorite s[?] male crit[ic]s erotic int[?] her flowe[rs]

➤ was consigned to the Downtown Gallery, New York. In 1958 it was bought from the gallery by Edith and Milton Lowenthal.

Milton Lowenthal was a lawyer and Edith Lowenthal was

➤ White in 1893 and completed in 1924. Built in the Beaux-Arts style, the structure is only a fraction of the planned size.

American paintings and decorative arts are one of the museum's major strengths. Besides Edward Hicks' *The Peaceable Kingdom*, the American collection includes two portraits of George Washington by Charles Wilson Peale, Albert Bierstadt's *A Storm in the Rocky Mountains*, and examples by other artists such as John Singer Sargent, Thomas Eakins, and George Caleb Bingham. The museum is also

RAM'S HEAD, WHITE HOLLYHOCK—HILLS BY GEORGIA O'KEEFFE

THE ARTIST

Georgia O'Keeffe as a student at the University of Virginia, 1915.

A distinctly American artist, Georgia O'Keeffe thought herself "one of the few who gives our country any voice of its own." Though well aware of modern European painting, O'Keeffe didn't visit Europe until she was in her 60s. Her deepest inspirations were, on the one hand, America's wide lands and skies and, on the other, the intricacies she found in such objects as bones and flowers. Her images of these subjects have become American cultural icons.

O'Keeffe was born outside Sun Prairie, Wisconsin, in 1887, to the family of a farmer and a storekeeper. She knew she wanted to be an artist by the time she was 11 and took the conventional art education of the time. Nearly 70 years later, she would still remember how, at the Art Students' League in Manhattan, a male student told her, "It doesn't matter what you do. I'm going to be a great painter, and you will probably end up teaching in some girls' school." And once she graduated, O'Keeffe did find herself teaching school—in Virginia, South Carolina, and finally Texas.

On and off between 1914 and 1916, O'Keeffe studied in New York City and visited Alfred Stieglitz's 291 Gallery. Stieglitz was a legendary figure. The U.S. exhibitor of the great European moderns, he also supported American painters and pho-➤

THE TECHNIQUE

Light Coming on the Plains III, 1917, watercolor.

O'Keeffe spent vital childhood years under bright, open prairie skies, which stayed with her during her years in the East: "The plains—the wonderful great big sky—makes me want to breathe so deep that I'll break." A watercolor group of 1917, *Light Coming on the Plains*, is near her work's heart.

Sky nearly fills *Ram's Head, White Hollyhock—Hills*; the hills form a low horizon line, squashed by cloud and light. O'Keeffe makes the stubby New Mexico hills simply the base for the brilliance of the air and for the supernatural vision that she centers in it—the floating ram skull. ➤

THE SUBJECT

To O'Keeffe, her first days in New Mexico in 1929 were "like the loud ring of a hammer striking something hard." The desert changed her, or else she discovered herself there. And the animal bones she would sometimes find in this unpitying landscape were at its core: "They are strangely more living than the animals walking around....The bones seem to cut sharply to the center of something that is keenly alive on the desert...."

O'Keeffe sent some of the bones back east in 1930. One day the following summer, she had left a horse's skull on the dining table. She was looking at an artificial rose; there was a knock at the door. Going to answer, she tucked the flower into the horse's eye. When she saw what she had done, she knew she had to paint it.

Ram's Head, White Hollyhock—Hills, 1935, then, follows on from *Cow's Skull with Calico Roses* and *Horse's Skull with White* ➤

THE PROVENANCE

O'Keeffe painted the first of her New Mexico animal skulls in 1931, then had a period of illness and absence from the Southwest. It was another four years before she returned to the theme in *Ram's Head, White Hollyhock—Hills*. The painting stayed in her own collection for a number of years, then ➤

THE MUSEUM THE BROOKLYN MUSEUM

The Brooklyn Museum is located at 200 Eastern Parkway in Brooklyn, New York. It contains over a million works of art from all periods of history and all parts of the world.

The museum's beginnings date back to 1823, when it opened its doors in Brooklyn Heights as the Apprentices' Library Association. It passed through several more incarnations over the century, enlarging its scope and size, as well as moving locations.

The present museum building was designed ambitiously by the firm of McKim, Mead & ➤

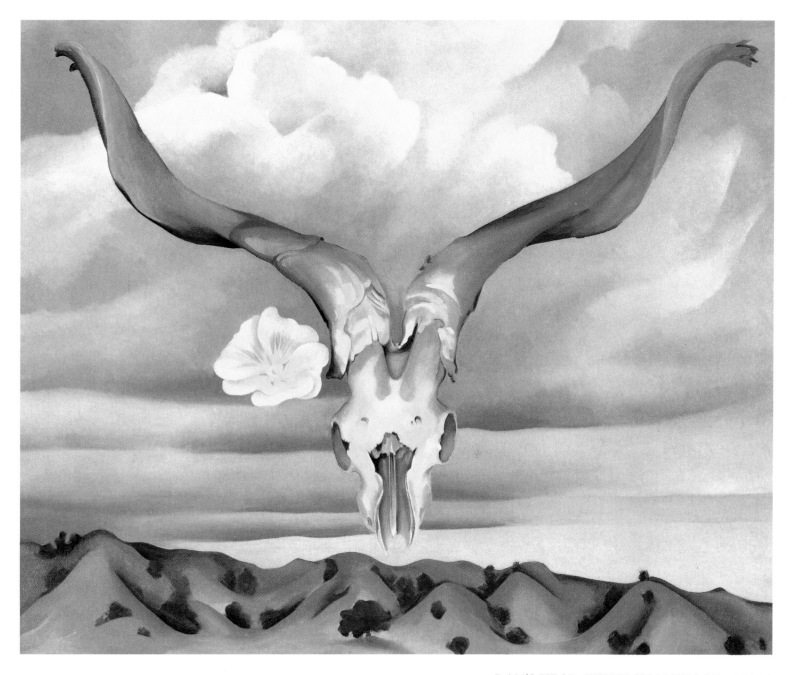

RAM'S HEAD, WHITE HOLLYHOCK—HILLS
by Georgia O'Keeffe, 1935
oil on canvas
30 x 36 in.(76.2 x 91.5 cm.)
Bequest of Edith and Milton Lowenthal
The Brooklyn Museum
Brooklyn, New York

Montana grew more accessible and more crowded, he knew his way of life was vanishing. Deciding to become a professional artist, he "never sang to the horses and cattle again."

Besides paintings, Russell produced a stream of book and magazine illustrations; in time the editors of these books and magazines also started to publish his writing, which is vivid and witty. His career was improved by his marriage in 1896 to Nancy Cooper, who managed his business and made him work regular hours, so successfully that his cowboy pals loathed her. It was

an extremely close marriage, however. The Russells lived in Great Falls, Montana, and spent their summers in a lakeside log cabin called Bull Head Lodge.

Russell was a popular man, a hilarious story-teller. Large collections of his paintings hung in Great Falls saloons, which he also frequented. When he got his first one-man show in New York in 1907, it was

because a traveler had come across his work in a Montana hotel bar.

Russell lived to question the presence of whites in the West: "This country today is fenced and settled by ranch men and farmers.

...I am glad...I knew it before nature's enemy the white man invaded and marred its beauty." By the time he died in 1926 the Cowboy Artist had seen one of his paintings sell for $10,000, painted murals in the Montana State Capitol, won an honorary doctorate from the University of Montana, and received a one-man show at the Corcoran Gallery of Art in Washington, D.C. ❏

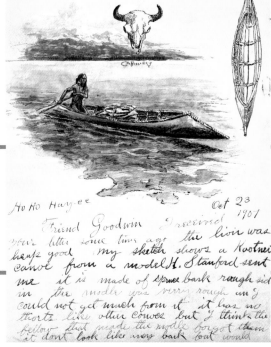

A letter from Russell was almost always decorated with artwork and the painter's buffalo skull logo. This 1907 letter to a young illustrator named Philip Goodwin shows a Kootenai spruce bark canoe.

earth in the foreground and by the figures of the two Indians and their guns. A bank of cloud above the foreground rider frames him, accentuating his stature. (Were the sky empty, he would seem a smaller, less significant figure.) His dark body stands out against the skyline, his light horse

against the darkness of the herd. And while the painting's more distant shapes are something of a blur, the Indian and the hunted buffalo are clearly focused, holding our attention. ❏

called "the surround": riders would separate a small band of buffalo out from the main herd, then race alongside to make the kill. In Russell's different versions of the chase, the hunters use bow, lance, and rifle. Russell's skill as an animal painter has been attributed to his years as a trapper: he knew animals' anatomy because he'd had to skin them.

The buffalo was a favorite motif in Russell's work. Not only was it an impressive animal in itself, it was closely linked to an Indian way of life that was already vanishing by Russell's time. His feeling for the animal's symbolism was so heartfelt that a buffalo skull became a famous part of his signature. ❏

Accurate portrayal of cowboy practices was a Russell trademark. In *The Jerkline*, a 1912 painting, the lead horses of a wagon train are jerked back on course by means of reins—or jerklines—attached to their bits.

local artist. In 1962 the McLaughlins donated the work to the C. M. Russell Museum in memory of their deceased son James Lachlan McLaughlin. ❏

MUSEUM HOURS
May–September, Monday–Saturday: 9 a.m. to 6 p.m.
October–April, Tuesday–Saturday: 10 a.m. to 5 p.m.
Sunday: 1 p.m. to 5 p.m.

ADMISSION
Admission charged.
Free to children 5 and under.

Russell posing for the photographer in his log cabin studio. Behind him are several of his paintings and some gear from his Indian collection.

BUFFALO HUNT

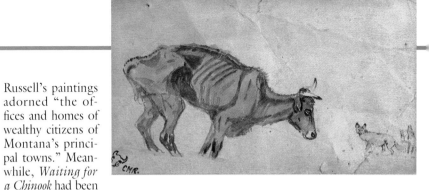

THE ARTIST

➤ to the horses and cattle."

Whenever he wasn't working, Russell sketched ranch life. Most of these drawings he gave away or traded for supplies. Still, they began to make him a reputation. The winter of 1886–87 was severe in Montana; out on the range, Russell's boss was faced with the job of letting ranchers in the town of Helena know that many of their cattle had died. The letter took the form of a Russell watercolor: a starved cow staggering in the snow, coyotes watching from a distance. Underneath, Russell wrote "Waiting for a Chinook"—a warm wind, the end of

winter. The fate of cattle was a subject of burning interest to local people, and Russell's small sketch was seen by everyone in town.

Later that year Russell was written up in a Helena paper: "The fame of an amateur devotee of the brush and pencil has arisen in Montana, and, nurtured by true genius within the confines of a cattle ranch, has burst its bounds and spread abroad over the Territory." By that time, according to the article,

Russell's paintings adorned "the offices and homes of wealthy citizens of Montana's principal towns." Meanwhile, *Waiting for a Chinook* had been made into a print and a very popular postcard.

Unlike many cowboys of those years, Russell admired the Native American peoples. He spent the winter of 1888–89 living in the camp of a group of Blood Indians in north-

ern Montana and Canada. He was to write, "The red man was the true American....The history of how they fought for this land is written in blood a stain that time cannot grind out."

In 1893 while Russell was visiting his parents, he received a sizeable commission from a St. Louis family. At the same time, as

THE TECHNIQUE

➤ certainly developed over time. *Cowboy Camp during the Roundup*, ca. 1887, has qualities of folk art: most of the action takes place in a single plane in the foreground, and where Russell works in the picture's depth he gets things out of scale. (The tiny settlement in the painting is Utica, where Russell painted behind a saloon, the rightmost of the buildings.)

Buffalo Hunt, though, painted just three or four years later, is far more naturalistically rendered and artfully constructed. The foreground Indian, for example, is larger than the farther one, and here the proportions are convincing. Whereas the action of *Cowboy Camp* is spread out, various devices in the later painting focus the eye: the central buffalo runs at the heart of an X suggested by lines and patterning in the

Cowboy Camp during the Roundup; an early painting.

THE SUBJECT

➤ His paintings showed a far wider variety of exchanges between Indians and whites than the Western myth would portray. He showed the two communities here wary of each other, there helping each other through dangerous winters; he showed Indians charging tolls to allow cowboys through their terri-

tory; he showed the domestic life of Indians, and cowboys made welcome in it. And he sometimes showed the two at war.

There's no question that he admired the Indian way of life. He painted or drew the scene shown in *Buffalo Hunt* over 60 times. It demonstrates a maneuver

THE PROVENANCE

➤ granddaughter, Mrs. Ione Symmes, remembered it hanging in her parents' home in Great Falls when she was in high school. That memory has led to a tentative date for the painting of around 1890 to '91.

In 1960 Mrs. Symmes sold *Buffalo Hunt* to Mr. and Mrs. J. L. McLaughlin, owners of a general contracting firm in Great Falls. Area residents, who were not necessarily art collectors, were interested in obtaining works by the popular

THE MUSEUM

➤ seven galleries, and a library. The Russell home, where Russell and his wife Nancy lived from 1900 to 1926, is decorated with period furnishings. Likewise, the log cabin studio that the artist built from telephone poles in

1903 is filled with cowboy gear and Native American artifacts.

In addition to a comprehensive collection of Russell art, the museum has a firearms collection of guns from the 19th and early 20th centuries, the Sharp Indian

Photograph Collection, and numerous Native American artifacts. Many of the artifacts—including pipes, a cradle, and moccasins—were owned by Russell and depicted in his paintings. ❑

BUFFALO HUNT BY CHARLES MARION RUSSELL

THE ARTIST

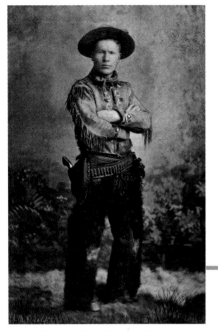

Charles Russell worked as a cowboy from 1882 to 1893. This portrait was taken in 1883; Russell was 19.

Together with artists like Frederic Remington and Henry F. Farny, Charles Marion Russell shaped the now-familiar popular image of the Wild West. Farny and Remington were both schooled painters—Farny having studied in Europe, Remington, if briefly, at Yale. Russell, though, earned his nickname "the Cowboy Artist."

Born in St. Louis in 1864, Russell came from an affluent family. He was bad at schoolwork but showed early talent. He once saw a man with a trained bear in the street; that night he modeled the bear in mud he scraped from his shoes. He was four at the time. He also was fascinated with the West. One of his great-uncles had built a trading post on the Arkansas River; another had been governor of New Mexico Territory and had been killed by Indians. A surviving schoolbook of Russell's is filled with cowboy-and-Indian drawings. The clincher was the gift of a pony on his 10th birthday: he would be a cowboy. In March of 1880 Russell's parents gave in, sending him to a family friend's in Montana, supposedly for the summer. He never came back. An army officer who met him then would remember, "I really had never seen as green a looking boy as Charlie Russell was." The Battle of the Little Big Horn was only four years' history, and he had turned up in Montana as a 16-year-old with a paint box. But Russell persevered, working first on a sheep ranch—"I did not stay long as the sheep and I did not get along well"—then as a trapper. From 1882 to 1893 he was a cowboy: "For 11 years I sung ➤

THE TECHNIQUE

Russell was basically a self-taught artist. His training amounted to a few days in a St. Louis art school when he was 15. He quickly quit: "Hell," he later recalled, "they just tried to teach me to draw a straight line." To Russell, drawing and making clay models were second nature; in range camps, bunk houses, and bars, he sketched constantly on scraps of paper to make folks laugh.

It's difficult to know just how he developed his technique (a word he liked to spell "teckneque"), yet his work ➤

THE SUBJECT

Russell's paintings were famously accurate. If he showed a branded pony or steer, the brand belonged to a working ranch. He knew that horses could tell when a bear was near better than men could, and that cowboys killed lice by pounding their shirts with rocks. Long after he left the range, he was making paintings about incidents he remembered there.

He got American Indians right from having spent a lot of time with them over the years. He could tell an Indian's tribe from the design of his beads. Russell's studio was full of Native American clothing and artifacts that he copied carefully. ➤

Sioux moccasins from Russell's collection of Indian artifacts.

THE PROVENANCE

At a Great Falls Christmas party in 1899, Russell raffled a work for $300 that 15 years later sold for $5,000. His patrons included the film star Douglas Fairbanks and Britain's Prince of Wales. The provenance of *Buffalo Hunt* is less glamorous, and probably more to his own taste.

Russell gave the painting to a Montana country doctor, Willard Long, as a gift. Long lived near Utica, where Russell had been a cowboy, and the two men would sometimes camp out together. Apparently Long passed the painting on to the next generation; his ➤

THE MUSEUM C. M. RUSSELL MUSEUM

The C. M. Russell Museum is located at 400 13th Street North in Great Falls, Montana, on land the cowboy artist once owned. The museum opened in 1953 upon a bequest of Emma Josephine Trigg, Russell's neighbor and friend and a collector of his work.

Since opening, the museum complex has been expanded twice; its 46,000 square feet now include the Russell original residence, a log cabin studio, ➤

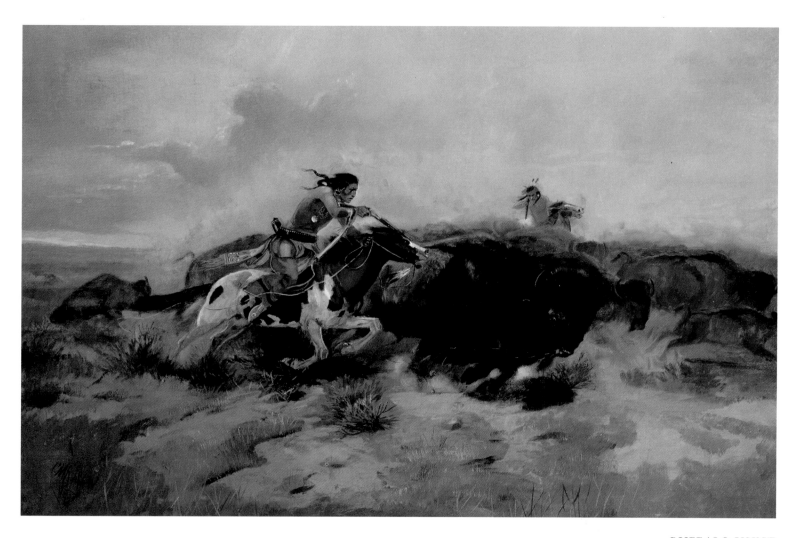

BUFFALO HUNT
by Charles Marion Russell, 1890 or 1891
oil on canvas
24 x 36 in. (61 x 91.4 cm.)
C. M. Russell Museum
Great Falls, Montana

was made in Munich, and Wood went there to supervise. He saw the Munich museums and visited Nuremberg. Wood also found a new influence—German art. The result was *American Gothic*, a 1930 portrait of a farm couple, which brought the painter overnight fame. Two years later, he painted the much publicized *Daughters of Revolution*.

Despite his fame, Wood never permanently left Iowa. In an essay called "Revolt against the City," Wood announced a rebellion "against the domination exercised over art and letters and over much of our thinking and living by Eastern capitals of finance and politics." He attacked America's "pseudo-Parisians," despite his own stay in that city, and argued that by staying at home, a Midwestern painter might free himself of the "colonial spirit" and create his own style.

In 1932 Wood tried to advance the Regionalist revolt by founding the Stone City Colony and Art School and teaching there. The colony only lasted two summers, but this was a sign less of failure than of Wood's growing success and its increasing demands on his time. In the '30s he would direct Iowa's Public Works of Art Project, paint murals in the Iowa State University Library, teach at the University of Iowa, exhibit in Chicago and New York, and travel widely to lecture.

He also found time to marry a light-opera singer, Sara Maxon, in 1935; they divorced in 1939.

By the end of the '30s, Regionalist art had begun losing popularity. With the war in Europe and the easing of the Depression, America's attention moved away from the farm. Rural art seemed wishful fantasy to some. But to Wood the fantasy was real; he went on painting rural life until he died of cancer in 1942. ❏

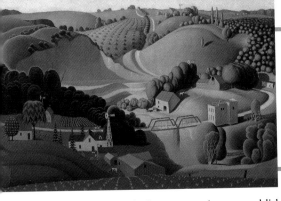

eyes, the teacup in those starved fingers—before penetrating to the Leutze in the dark background. Wood makes his satiric point. ❏

the one hand, they were trying to establish themselves as an aristocracy of birth, on the other they were trying to support a democracy." Wood often showed rural life as bucolic, but he obviously knew about the pressures of a small town. He called *Daughters of Revolution* "the only satire I have ever painted," but *American Gothic* and a few other works seem equally pointed. *Daughters of Revolution*, he said, was "a pretty rotten painting. Carried by its subject matter." ❏

Art in New York City. In 1958 he sold it to Greek shipping magnate Stavros Niarchos as part of a financial divorce settlement. Niarchos sold the painting to the Cincinnati Art Museum in 1959. ❏

MUSEUM HOURS
Tuesday–Saturday:
10 a.m. to 5 p.m.
Sunday: 11 a.m. to 5 p.m.

ADMISSION
Admission charged.
Free to children under 18.
Free to everyone on Saturdays.

American Gothic

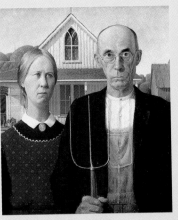

American Gothic, 1930.

The 1930 painting *American Gothic* made Wood both instantly famous and controversial. Shown in a competitive exhibition in Chicago, where Wood's humorless-couple-with-pitchfork won a bronze medal, *American Gothic* was seen as an attack on simple country people.

Iowa farmers in particular felt themselves insulted by one of their own. Wood defended himself; the figures, "tintypes from my family album," were actually his sister and his dentist, and he had "tried to characterize them honestly, to make them more like themselves than they are in actual life....To me they are basically good and solid people." Wood also claimed that his real inspiration had been architectural, an Iowa farmhouse he had seen, and he had simply "imagined American Gothic people with their faces stretched out long to go with this American Gothic house." Be that as it may, Wood's later images of Iowa life were usually less ambiguous and far more sympathetic.

Ironically, Wood's *American Gothic* was influenced by his visit to Germany and its museums in 1928. He described his admiration for Hans Memling; he also liked Albrecht Dürer and Hans Holbein. This is where he got the austerity of *American Gothic*, the slightly comical grimness, the frozen quality, the sharpness of the figures against their sharp ground. This, in a word, is where he got the Gothic.

The Donor, ca. 1485, by Hans Memling, an artist whose works Wood admired.

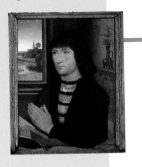

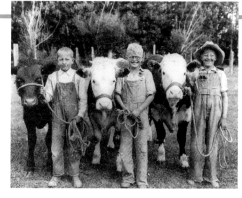

g a more tra-
d spent the
n Paris. He
going to art
taly and the
Here he as-
eret look for
e didn't last.
924, back in
od found a
lor operator
t-free apart-
r murals and
wing year,
ng.
cation was

intermittent; the largest part of it was probably his year in Paris, when he was already over 30. Although largely self-taught, he wasn't exactly provincial—he

A rural image from the 1930s is reminiscent of Wood's paintings: 4-H members pose proudly with their calves.

would visit Paris for a third time in 1926, when he had a show there, and he was also to go to Germany.

In early 1927, the American Legion commissioned Wood to design a stained-glass window for the Veterans Memorial Building in Cedar Rapids. The window

Stone City, 1930, wa Wood's firs major land scape. Tw years later, h opened an ar school in th same town

Perhaps Wood was trying to find ways to bind together an image that was compositionally the opposite of his German models. He did it through a diamond form suggested by the bright shapes in the foreground: from the face of the woman at the far left, up to that of her neighbor, across and down to the head and neck of the woman at the right, and back across the hand and teacup. Inside the diamond, the viewer's eye skates across darker horizontals—the slitlike mouths and

.
Daughters of
ose mouths
htly wound,

the eyes that cold? Wood set his stern sisters against Leutze's *Washington Crossing the Delaware*, a classic, heroic image of the history the D.A.R. celebrated in its very name. Pictorially, *Daughters of Revolution* stands at left and right on the strongly patterned arcs of the women's collars, like the wheels on a car with the Leutze as the chassis. Can this history rest on these necks?

For Wood the D.A.R. exhibited a "great inconsistency" as Americans: "They were forever searching through great volumes of history and dusty records, tracing down their Revolutionary ancestry. On

first owner of *Daughters of Revo-* s the film actor Edward G. Robin- m actress Katharine Hepburn also

collected Wood.) Robinson bought the painting in the late '30s from a dealer after seeing it on loan in a show at the Museum of Modern

n art, and
The muse-
first- and
aean sculp-
he only one
d States.
djoined to a

professional art school, which is operated by the museum's parent organization, the Cincinnati Museum Association. ❑

DAUGHTERS OF REVOLUTION BY GRANT WOOD

Grant Wood, 1932, and his painting _Arbor Day_, completed the same year.

A gallery of essential Americana would be incomplete without the works of Grant Wood. Had he painted only _American Gothic_, he would have won a place. Together with Thomas Hart Benton and John Steuart Curry, he was one of the Regionalist painters creating an American art outside the urban East, an agrarian art of the heartland.

It's n
Wood becar
of Regionali
the Iowa fa
ther had set
1901, when
died, and hi
town of Ced

Wood v
coal when h
June of 19
graduated f
took the tra
enroll in su
city's desig
the next yea

THE TECHNIQUE

Wood wanted to assert the virtues of American rural life; the paradox was that the visual sources of his art were European. His early work is a gentle descendant of French Impressionism and other plein air painting, on its way to becoming the vernacular orthodoxy it is today. Even when his art makes its forward leap with _American Gothic_, it is influenced by 15th- and 16th-century German and Flemish painting.

Daughters of Revolution, though, lays Gothic art on its side.

THE SUBJECT

In bringing Wood to Germany and German art, the artist's stained-glass window for the Cedar Rapids Veterans Memorial Building was a major advancement in his

The 24 x 20 foot Cedar Rapids Veterans Memorial window designed by Wood.

career. He also owed _Daughters of Revolution_ to the same commission.

A St. Louis company
to manufacture the wind
Wood's design. (The glass

THE PROVENANCE

A Cedar Rapids membe
D.A.R., claiming to speak
"who glory in the fact t

THE MUSEUM CINCINNATI ART MUSEUM

The Cincinnati Art Museum sits atop Ohio's scenic Mt. Adams at Art Museum Drive in Eden Park. It was founded in 1881, and five years later its original building— designed in a style known as "Richardson-Romanesque"—was

opened. Since it first opened, seven wings and a garden court have been added to the museum.

The building of the museum was inspired by the efforts of the Women's Art Museum Association, which—beginning in

1877—held
exhibitions
Local busin
West offer
permanen
1880 on th
the comm

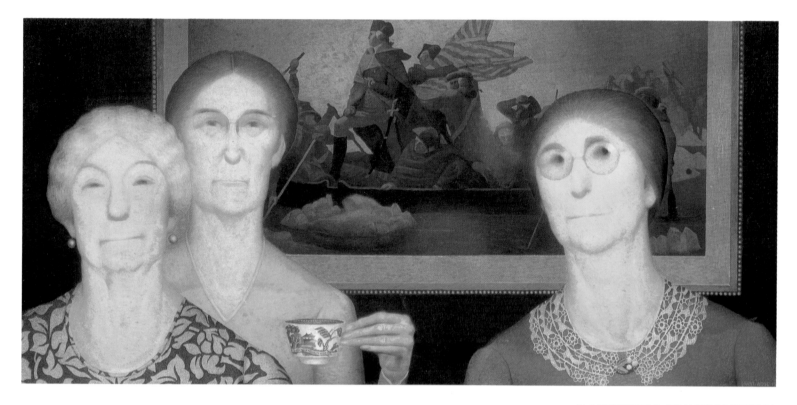

DAUGHTERS OF REVOLUTION
by Grant Wood, 1932
oil on masonite panel
20 x 40 in. (50.8 x 101.6 cm.)
The Edwin and Virginia Irwin Memorial Fund
Cincinnati Art Museum
Cincinnati, Ohio

move on to Philip's court in Madrid. In 1580, in fact, he undertook a commission from the king, *Martyrdom of St. Maurice.* But a contemporary wrote, "The picture does not please His Majesty, and that is no wonder, for it pleases few, though there is said to be much art in it...the saints should not be painted in a manner that removes the desire to pray before them."

The tone is common in early discussions of El Greco—mingled admiration and bafflement, even resentment. A visitor of 1611 would write, "Though we have repeatedly condemned his opin-ions and paradoxes, we cannot but place him among the great painters." El Greco was sure of his own stature and refused to bow to his patrons; he often fought them over money. During one of these disputes over a mas-terpiece, *Burial of the Count of Orgaz,* 1586–88, he claimed, "It is as true that the sum paid is much less than the value of my sublime work as it is that my name will always be remembered by the generations to come, which will...extol the author as one of the greatest geniuses of Spanish painting."

El Greco prospered in Toledo, but he seems to have remained an outsider. To one

El Greco's reconstructed palace in Toledo.

contemporary writer, "His nature was as strange as his painting." The artist signed his work not El Greco but D o m e n i k o s Theotokopou-los, sometimes adding the initials KRHS, standing for "Cretan." He had a son by a woman he never married. He lived for years in a 24-room palace, yet was sometimes behind on the rent. (The palace no long-er exists; the build-ing now known as El Greco's house is a reconstruction.)

In 1612–14, El Greco painted *Ador-ation of the Shep-herds,* which he wanted hung over his tomb. He died in April 1614, aged 73. The monastery where he was buried has been destroyed; his grave is unmarked. ❑

of color is less grand, more expressive, than Titian's.

For El Greco, following Renaissance ideas of proportion and perspective strictly was being "a donkey covered with lion's skin." His distortions of form and his incorporeal color were delib-erate; he believed the artist's eye

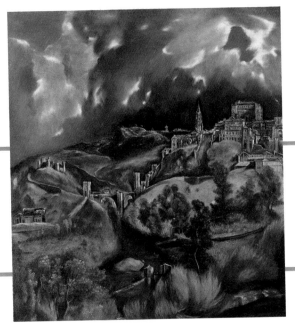

and mind gave more meaning to a painting than verisimilitude and convention. Some scholars have suggested that El Greco's figural distortions arose because he had a visual defect. But when painting a portrait, where his fee depended on likeness, El Greco was accurate. ❑

Toledo, ca. 1608; El Greco lived in this city 37 years and painted it repeatedly.

tion that the bottom was cut, but fresh canvas under the frame sug-gests the work is intact.) Another version sets the Crucifixion out-side Toledo, the city that figured large in El Greco's imagination.

El Greco is known to have read a text by Francisco Patrizzi arguing that light was the ulti-mate expression of the divinity. The light in *Christ on the Cross with Landscape* is intense—the sky dark yet blazing, the body incandescent. It is light as idea, spirit, grace. ❑

convent held onto the painting until 1952, when it was sold to Tomás Harris, a London-based

art collector. That same year, M. Knoedler and Company, a New York City art dealership, sold the painting to the Cleveland Museum of Art. ❑

Brunswick, Germany.

Besides *Christ on the Cross with Landscape,* other popular works in the museum include Edgar Degas' *Frieze of Dancers,*

J. M. W. Turner's *Burning of the Houses of Parliament,* and George Bellows' *Stag at Sharkey's.* ❑

MUSEUM HOURS
Tuesday, Thursday, Friday:
10 a.m. to 5:45 p.m.
Wednesday: 10 a.m. to 9:45 p.m.
Saturday: 9 a.m. to 4:45 p.m.
Sunday: 1 p.m. to 5:45 p.m.

ADMISSION
Free.

CHRIST ON THE CROSS WITH LANDSCAPE

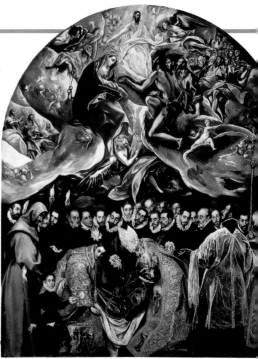

THE ARTIST

➤ a "disciple of Titian"; perhaps he entered Titian's workshop, but this is not recorded. He was in Rome by 1570, when an artist friend, Giulio Clovio, calling him "unique in painting," asked a cardinal of the Church for patronage for him. El Greco lived in Italy for several years, but he won no large commissions there. It's said that when the Pope complained about nudity in Michelangelo's Sistine Chapel murals, El Greco "made so bold as to say that should the whole work be destroyed he would take upon himself to make it again honestly and decently and not less good."

One day, Clovio tried to take El Greco for a stroll: "There was a festive atmosphere in the town. When I entered El Greco's studio I was astonished to see the curtains were drawn close so that I could hardly see....El Greco was seated on a chair doing nothing; he was neither working nor sleeping. He would not come out with me, for daylight would have disturbed his inner light."

In the 1570s the richest country in Europe was Spain. The Spanish king, Philip II, was making large art commissions for the Escorial palace outside Madrid, so El Greco went to Spain. Exactly when isn't known, but he was in Toledo by 1577, working on his first masterpieces. One of these was *El Espolio* (*The Disrobing of Christ*); hard churchmen recognized its "inestimable value," then haggled over the price.

El Greco would remain in Toledo the rest of his life. An ecclesiastical capital said to have resembled "a continuous Holy Week," the town was austere. To a visitor in 1580 it was "one of the worst cities of the world because of its hills, narrow streets, darkness, dirt, tiny plaza, lack of water, the mosquitoes, the bad manners of its people, and one hundred thousand things more." El Greco probably hoped to

THE TECHNIQUE

➤ painting between the Renaissance and the birth of modernism, those sacred images make no pretense at perspective or the illusion of space. The figures have little depth, physically or

Madonna and Child, undated. This panel found in a Spanish church shows the gilding and religiosity that typify the Byzantine icon.

psychologically, but there is a profound religiosity.

Many critics have traced the Byzantine in El Greco, particularly as he grew older. His lunar, phosphorescent color, his picture structures, his flattened perspectives and shallow spaces, his foreground positioning of figures, and his intense spirituality all have Byzantine precedents. But if El Greco was once an icon painter, he mastered one system only to learn another. In Titian he discovered Italian ideas about compositional drama, space, the volumes of the body, and how to structure an image through color and light. He also admired Tintoretto, whose use

THE SUBJECT

➤ proportions of the canvas—the *Crucifixion with Two Donors* nearly three quarters as wide as it is high, the *Christ on the Cross with Landscape* a little over half as wide as high—increases the skyward

pull in the later work; narrow and vertical, it strains upward, following the gaze of Christ, the locomotive clouds acting almost like the lines used by cartoonists to signal speed. The removal of the donors focuses the work on the Christian tragedy.

In other versions a skull and bones may lie at the cross's foot, and a tiny horseman may ride on a road toward the hills, his size suggesting the relative strengths of man and God. (The absence of these motifs in *Christ on the Cross with Landscape* has led to specula-

THE PROVENANCE

➤ is in a book called *Paseo por Madrid*, published in 1815, which mentions a *crucifixo* by El Greco in the Convento de las Salesas Nuevas, on the street of San Bernardo in Madrid. At the time, the convent was less than 20 years old; it was built in 1798. How or when the convent came by its Crucifixion or who owned the painting for the first two centuries of its existence is not known. The

THE MUSEUM

➤ collection is divided by culture and arranged chronologically. The sections include Asian, Egyptian, Islamic, and Greek and Roman art. One of the best known exhibits in the museum is the medieval collection in the European section, which contains religious sculpture, crosses, and books. This section of the

museum also showcases the Guelph Treasure, a rare collection of nine sacred objects from a cathedral in 11th-century

CHRIST ON THE CROSS WITH LANDSCAPE BY EL GRECO

A 1582 engraving of Candia, El Greco's birth city, located on the island of Crete in the Mediterranean.

THE ARTIST

El Greco, self-portrait from *The Burial of the Count of Orgaz*, detail. Some critics dispute the identity of the portrait.

If any art exemplifies Spanish painting, it is that of El Greco—who wasn't Spanish but Greek, from the island of Crete. For a later Spanish artist, Salvador Dalí, El Greco seemed "impregnated with all the savors, the substance and quintessence of the ascetic and mystical Spanish spirit...he became more Spanish than the Spaniards themselves."

Little is known of his early life. He must have been born around 1541, for a document of 1606 puts his age at 65. His name was not El Greco—"The Greek"—but Domenikos Theotokopoulos, and he probably lived in the seaport city of Candia; he is mentioned as a "young Candiote" in one instance, and in Candia in 1566 he signed a legal document by writing "Maistro Menegos Theotokopoulos, sgourafos" (Master Domenikos Theotokopoulos, painter). He was well educated; his family was probably affluent. (Later, his library would contain works of literature, philosophy, history, science, medicine, and architecture in Greek, Latin, Italian, and Spanish.) In 1566 a work of his was sold in a Cretan lottery.

Crete was then ruled by Venice, a great artistic center. El Greco was in Venice by August of 1568. A letter describes him as ➤

THE TECHNIQUE

The art of El Greco is beautiful but strange—beautiful because it is strange. Years after his death, a critic described his work as "so capricious and extravagant that it was good only for him." An 18th-century writer thought his art "ridiculous" for its "disjointed drawing" and "unpleasant color." To a 19th-century critic, he moved between "delirium" and "lucid intervals." To another, he had a "pathological problem."

El Greco's figures are often distorted—elongated and attenuated, stretched on some rack of the soul. His color and the overall mood of his works can be unearthly. In the eerie *Visitation* of 1607–14, for instance, the Virgin appears to a mortal woman, the two gray-cloaked figures indistinguishable from one another.

El Greco's Greek upbringing must have influenced him. The painting sold in the lottery in Crete in 1566 is described as having a gold ground; it was surely a Byzantine icon. Unlike Western ➤

THE SUBJECT

El Greco painted a number of Crucifixions. The Cleveland Museum's *Christ on the Cross with Landscape* is one of his most powerful.

The painting probably dates from between 1605 and 1610. Comparison with the *Crucifixion with Two Donors* circa 1580, 20-odd

years earlier, shows how El Greco's work grew less Italian in Toledo. The body of Christ holds nearly the same position in both pictures. In the later painting, though, the figure is thinner, longer, its curve more subtle, the chest and waist more slender—the body more immaterial. A change in the ➤

THE PROVENANCE

The early history of *Christ on the Cross with Landscape* is as obscure as is much about El Greco himself. The first surviving record of it ➤

Crucifixion with Two Donors, ca. 1580, includes portraits of the Covarrubias brothers of Toledo. Donors commissioned paintings as gifts for churches and often appeared in the painting.

THE MUSEUM THE CLEVELAND MUSEUM OF ART

The Cleveland Museum of Art is located at 11150 East Boulevard in Cleveland, Ohio. The original museum building first opened in 1916, but a series of additions—including a three-story wing added in 1970 by architect Marcel Breuer—have more than doubled the size of the structure. Built on three acres of elevated land overlooking a pond and terraced gardens, the Cleveland is regarded as one of the most attractive art institutions.

Artwork in the museum's ➤

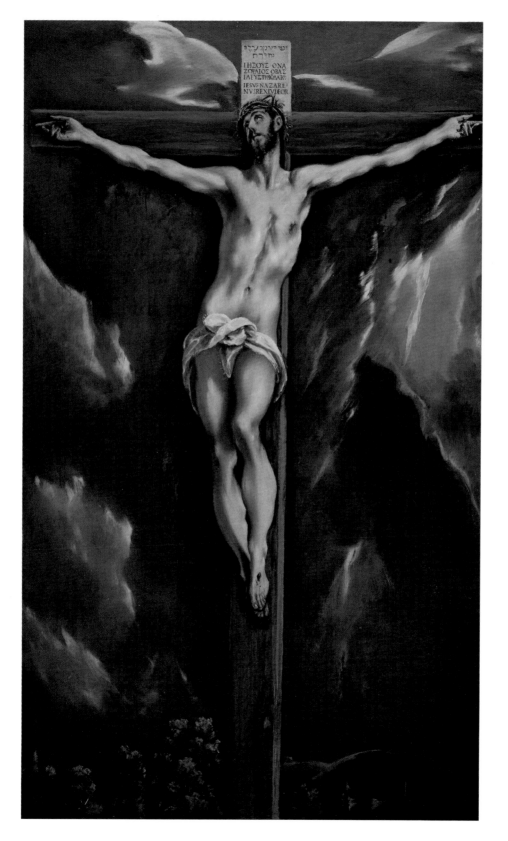

glasses. (Here, in the audience, Church first met his future wife.) During its three-week run, the exhibit earned $3,000 in admissions and $6,000 in subscriptions for an engraving. Like *New England Scenery*, the painting set a record price for an American painter, but now the figure was over seven times higher: $10,000.

Both *Niagara* and *The Heart of the Andes* traveled to England, where they won a reputation for Church as the heir to the British artist J. M. W. Turner: "On this American more than any other," according to the *London Art Journal*, "...does the mantle of our greatest painter appear to

us to have fallen." This upset of the prevailing cultural hierarchy made Church a kind of hero to Americans. *Niagara* was considered a "truly great National Work"; to a *Harper's Monthly* writer in 1859, "We all have an individual pride in it, as we have in Niagara itself."

During the 1860s Church was perhaps the most famous and well-paid painter America had seen. At the end of the decade, however, he had largely left painting behind to begin work on a great house and estate on a hilltop above the Hudson River. Church had traveled in the Near East and had been thrilled by its

landscape and culture. He named his house Olana, from an old Persian word, for "fortress." With advice from architects, Church designed the house himself; it is full of Near Eastern motifs

Living in Olana, absorbed with its construction and decor, Church increasingly withdrew from the public eye. By the 1880s, in any case, his style was out of fashion, but he continued to paint until at least 1895, despite degenerative rheumatism. He died in 1900 in New York. ❏

Sketches for Church's home: the south facade *(left)*, and the dining room cornice *(below)*.

look for his intentions; here, the manipulation of the geography heightens our sense of the falls' pitiless power. There is often a sense of terror in Church's panoramas; his art reflects a conflict of the European-derived

consciousness in the Americas—thrilled by the new-found land, yet awed and scared by it. ❏

In an 1854 photograph, Niagara Falls is seen with visitors and the trappings of civilization. Church eliminated both in his painting.

The pictorial theatrics of Church's paintings, their sense of monumental distances rendered in brilliant clarity and detail and laid out for a viewer airborne like an angel, sugar-coated the science. One contemporary called

his art both "a delight and a lesson"; another described it as "an intellectual feast." For yet another, Church had vindicated "his claim to be considered as the artistic Humboldt of the new world." ❏

Niagara was purchased by John Taylor Johnston in 1861 for $5,000. (He was later the first president of the Metropolitan Museum of Art.) In 1867, *Niagara* won the second medal at the Paris

Universal Exposition. Sold at auction in 1876 from the Johnston collection, it reached the then-large figure of $12,500. The buyer was W. W. Corcoran, founder of the Corcoran Gallery of Art. ❏

W. W. Corcoran, 1883, in a photograph by Mathew Brady.

lection features an assortment of Dutch, Flemish, and French paintings. Art collectors Edward and Mary Walker provided the museum with the French paintings from the late 19th and early

20th centuries in the Walker Collection.

The Corcoran sponsors unique education programs, including the Corcoran School of Art, which offers Bachelor of Fine

Arts (BFA) degree programs in fine art, graphic design, and photography. The gallery's continuing education program gives art classes for adults, teenagers, and children. ❏

NIAGARA

THE ARTIST

The summer of 1853 found Church sketching in the Andes. He had read the naturalist Alexander von Humboldt's *Cosmos: Sketch of a Physical Description of the Universe*, a book in which Humboldt argued that South America was environmentally the richest continent on Earth—in animal and plant life, scenery, climate. In 1855 Church sent four South American landscapes to the National Academy of Design's annual show. Combining photographically detailed descriptions of plants and trees with panoramic views, they were a great success. In 1857 Church followed up with a larger triumph still, the exhibition of *Niagara* in New York. That year he returned to South America, where he visited the volcano Cotopaxi in Ecuador. He would paint a number of images of the mountain.

Church painted on a grand scale. (*Niagara* is over seven feet wide; a later work, *The Heart of the Andes*, is 10 feet wide; the photographic technology of the time could not compete.) He was also something of a showman, a painterly Barnum, his spectacles made respectable by their intellectual heft. *Niagara* was shown in a one-work exhibition, admission 25 cents a head. In its two-week run it received 100,000 visitors.

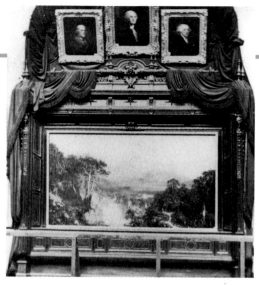

The Heart of the Andes went on many exhibitions. Here it is displayed at a New York City fund-raising fair in 1864 to help buy medical supplies for Union soldiers in the Civil War.

The Heart of the Andes, 1859, received a similar special exhibition, but the presentation was fancier: the painting was installed between parted curtains in a paneled wooden structure made to suggest a mansion window. Imagining themselves in a grand South American room with a spectacular view, visitors gazed at the painting through opera

THE TECHNIQUE

iar position creates suspense: if you somehow found yourself where the picture puts you, you'd plummet and die. Church contrived this groundlessness deliberately, playing tricks with the falls' geography: the long diagonal rim that runs from the painting's bottom left corner toward the top right is actually a good deal shorter than he showed it. By making well over half the painting

water, he concentrated the sense of torrential flow. Two years earlier, a critic had written of Church's *Tequendama Falls*, "He should not paint falling water—for he cannot." Church had obviously been practicing.

Niagara's precise description of water in many moods reflects Church's scientific accuracy. However, he was loose with the waterfall's map. Such liberties are useful places to

THE SUBJECT

Cosmos." It was the intricate variety and beauty of natural life that proved the intention of the divinity.

Humboldt believed that painters who studied "the true image of the varied forms of nature" carefully, and described it accurately, could help people understand the world's complexity and its traces of divine plan. To achieve the detail of description he wanted, Church studied physics, biology, meteorology, geology. He would orchestrate this minuteness in breathtaking spectacles, using outsized canvases to depict scenes of natural grandeur. He liked spots like Niagara, places that seemed beyond human history, showing God's design unmeddled with by man. Living creatures are rare in Church's work; in *Niagara*, there are no signs of the tourists that he surely saw at the site.

THE PROVENANCE

That July, the painting was shown in London. Earlier American artists had not impressed the British critics, but *Niagara* was greatly admired. John Ruskin, the great Victorian scholar and theoretician of art, is said to have checked the gallery window to be sure that the rainbow in the painting's upper left wasn't a reflection of sunlight.

THE MUSEUM

building is now the Renwick Gallery and is operated by the National Collection of Fine Arts.

The Corcoran has an extensive collection of American art from prerevolutionary portraits to contemporary works, with the 19th century particularly well represented. The gallery also has acquired two significant collections of European art. Bequeathed by U.S. Senator William A. Clark in 1925, the Clark Col-

NIAGARA BY FREDERIC EDWIN CHURCH

THE ARTIST

Frederic Edwin Church, 1870, oil on porcelain.

Frederic Edwin Church was a 19th-century phenomenon. He exploited the new networks of travel, visiting once inaccessible regions foreign and American and bringing them back to the American public in epic pictorial form.

Church was born in Hartford, Connecticut, in 1826. His father was a wealthy businessman and wanted Church to go into business too, but his son's artistic talent and ambition were clear from an early age. When Church was 18, a family friend arranged an apprenticeship for him with Thomas Cole, probably the most respected American painter

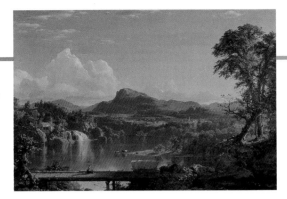

New England Scenery, which sold for a record price in 1852, was the first painting in Church's mature style.

of the time. Cole usually didn't teach, but he took Church on.

A few years later, in 1847, Church opened a studio in New York. He occasionally painted allegorical works, as Cole had done, but he concentrated on landscapes, usually made from sketches he had done during summer tours of New England and New York State. He had

established himself by 1848, when he was only 22, and would become a member of the National Academy of Design the following year. *New England Scenery*, painted in 1851, briskly sold at what was then a record price for a living American painter—$1,300. Eventually Church would be declared "the Michelangelo of landscape art." ➤

THE TECHNIQUE

In the 19th century, Niagara Falls was the single most pictured sight in North America. Many painters tried to convey its splendor; Church, by wide agreement, was the first to succeed. To one contemporary viewer, "This is Niagara, with the roar left out!"

Church first visited Niagara Falls in March 1856—late winter, when they were under snow and ice. He returned in the sum-

Niagara reflects Church's vision of this higher style of landscape painting.

mer and autumn, trying different views, producing studies in pencil and oil. Only after these experiments did he pick his site, and the long horizontal format that compresses and intensifies the picture's energy.

The viewer of Niagara seems to glide above Horseshoe Falls, above the rapid waters but not apart from them—there is no dry land in the picture's foreground. This unfamil- ➤

THE SUBJECT

Late in life, Church would describe Thomas Cole as "an artist for whom I had and have the profoundest admiration." Cole saw the artist's mission as "a great and serious one," and believed "a higher style of landscape" painting could emerge that would "speak a language strong, moral and imaginative."

Niagara reflects Church's vision of this higher style of landscape painting.

Church is sometimes placed among the artists of Cole's Hudson River School, but what sets Church apart from other landscape

painters of his time was his interest in the day's new scientific thinking. Particularly important to him was the naturalist von Humboldt, whose writing combined the rationality of the scientist, cataloging the orders of life and matter, with a sensitivity to "the feeling of unity and harmony in the ➤

THE PROVENANCE

Church worked on *Niagara*, he said, only when "the sky was clear and the sun shining bright." Nevertheless, he finished the great canvas in less than two months. *Niagara* went on view on May 1, 1857, in a

one-picture show in a gallery in Manhattan. It was a hit—for one reviewer, "the finest oil-picture ever painted on this side of the Atlantic"—and it established Church's reputation as a painter. ➤

THE MUSEUM THE CORCORAN GALLERY OF ART

The Corcoran Gallery of Art is located at 500 17th Street, NW, in Washington, D.C. It was founded in 1869 by banking mogul and philanthropist William

Wilson Corcoran, whose private collection of American art made up the museum's first permanent collection. Corcoran commissioned architect James Renwick

to design the original building, but in 1897 the growing collection moved to a structure designed by Ernest Flagg where it remains today. The original ➤

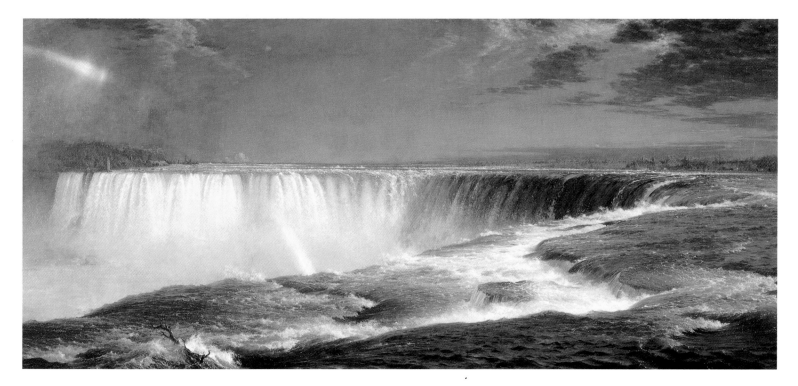

NIAGARA
by Frederic Edwin Church, 1857
oil on canvas
42 ¼ x 90 ½ in. (107.3 x 229.9 cm.)
The Corcoran Gallery of Art
Washington, D.C.

founded the Société Anonyme des Artistes and organized the first of its series of exhibitions. The Paris press dubbed the show the "Exhibition of Impressionists" on the strength of one of Monet's contributions, *Impression, Sunrise*, 1873. A critic wrote of this work, "Wallpaper in its embryonic state is more finished than that seascape." The Monets were living in Argenteuil, a riverside Paris suburb. To paint the effects of light on water, Monet built a studio on a boat— a cabin with windows, a canopy over the deck.

In 1879 Camille Monet died after a long illness; she had borne a second child the year before. Shortly after, Alice Hoschedé, the wife of a former patron of Monet's, Ernest Hoschedé, moved in with Monet, bringing her six children. The couple married in 1892, when Ernest died.

As he grew older, Monet began to spend less time in Paris. He also distanced himself from the Société Anonyme, saying of Impressionism in 1880, "The little church has today become a banal school which opens its doors to the first dauber who comes along." In 1883 the family moved to a house in Giverny, 50

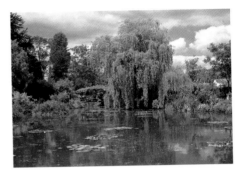

The artist's garden in Giverny inspired a number of Monet's later works.

miles from Paris. Monet began landscaping the garden with its now-famous pond of waterlilies— an artificial pond he created himself. He also traveled to paint, taking trips along the Normandy coast and to the Mediterranean.

By this time he had won his battle with the Salon and was becoming a wealthy man. Giverny would become a pilgrimage site for artists.

In his later years, Monet gradually lost his sight. His sense of color became so distorted that he had to choose pigments by the labels on the tubes. Yet he kept working almost until he died in 1926 at age 86.

Bougival he has worked more quickly and drawn more crudely, allowing rough blocks of paint to suggest the distant buildings and trees. The handling of bridge and roadway in the foreground, where the paint is relatively continuous and flat, suggests the direction he was coming from; the water, though, is a sheet of thick horizontal dabs, each unconnected from the other.

Monet was a remarkable colorist. He defined space and form through contrasts and shifts of color rather than through the subtle tonal gradations of the studio artist. And the colors were unmixed—at first, perhaps, because he was working too fast to labor over the palette, then because he found that the use of pure color made the canvases bright, airy, scintillating—a crucial discovery.

would later systematize in Pointillism. Seurat admitted to being influenced by Monet but thought his work came out of "intuition"—not a virtue for the

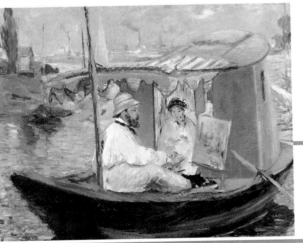

In *Claude and Camille Monet in the Studio Boat*, 1874, Édouard Manet depicts Monet working plein air.

younger artist, who worked laboriously on *A Sunday on La Grande Jatte* for a good two years, planned every inch, and proceeded out of an ambitious theory of color. Monet, however, would say at the end of his life, "I have always had a horror of theories. I have only had the merit of having painted directly from nature."

Massachusetts), which shows another view of the river.

The 1869 painting went from the Bernheim-Jeune collection to a private French collector, who sold it to the Currier Gallery of Art in September 1949.

and gardens were also designed by Wright. The Zimmerman House and the museum's original building are listed on the National Register of Historic Places.

The museum also has a

school called the Currier Art Center, which offers classes to children in drawing, watercolor, oil painting, clay sculpting, printmaking, and weaving.

THE SEINE AT BOUGIVAL

Impression, Sunrise, 1873. An early Monet work, this painting inspired the name for the new Impressionist style of art.

➤ Africa, or claimed to, and Adolphe had to buy him out.

Soon he was back in Paris, with a parental allowance contingent on serious study. Accordingly he took academic classes. Preferring outdoor painting over the studio work then thought fundamental, he benefited there mainly by meeting Pierre-Auguste Renoir, Alfred Sisley, and Frédéric Bazille. All but Bazille, who died in 1870, would take part in the Impressionist exhibitions of the following decade.

During these years, inclusion in the annual juried Salon exhibition remained the only way an artist could advance. It was 1865 before the Salon accepted anything by Monet. He showed there again the next year and was praised on both occasions, in 1866 by the writer Émile Zola:

"Here is a temperament, here is a man in the midst of that crowd of eunuchs!" Yet the Salon jury rejected Monet in 1867. A jury member explained, "Too many young people think only of pursuing this abominable direction. It is high time to protect them and save art."

Two years earlier, Monet had begun a relationship with the 18-year-old Camille Doncieux. With Adolphe's censure of his behavior and the Salon rejection, Monet's income dried up. In August 1867 he left a pregnant Camille in Paris while he returned to his family in Le Havre. She bore their son without him.

In 1870, after he married Camille, he met the dealer Paul Durand-Ruel, who would spend 29,000 francs on his paintings between 1872 and '73. Unable to sell them, however, Durand-Ruel did not buy again until 1881. Monet had to borrow money constantly.

To circumvent the Salon in 1874, Monet, Camille Pissarro, Edgar Degas, Renoir, Sisley, and other artists

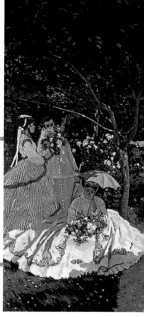

Women in 1866–67. wife Cami each of th

A Radical Style

Monet's teacher, Charles Gleyre, an academician at the École des Beaux-Arts, thought nature was "all right as an element of study, but it offers no interest." For Gleyre, art meant rendering perfect, classical figures, great dramas of history, and subjects from mythology.

The Bath, by Charles Gleyre.

Impressionism was a rejection of the contemporary orthodoxy championed by Gleyre and others like him. It abandoned academic ideas of the figure and was intent on capturing the effects of light and depicting contemporary themes. When he had become a master Impressionist painter, Monet advised a student, "Paint it just as it looks to you."

THE TECHNIQUE

➤ broken brushwork, the absence of conventional modeling, shading, and, eventually, perspective. (Monet admittedly loved plein air, but he often began a work on site, then finished it later elsewhere—sometimes indoors.)

Works like *The Seine at Bougival* show the beginnings of Monet's Impressionist technique proper. Two years before, he shaped every leaf of a tree, every flounce of a dress in *Women in the Garden*. In *The Seine at*

THE SUBJECT

➤ *enveloppe*—the wrapping of colored air that surrounds all physical objects.

In the summer of 1869, though, Monet and Renoir relished the pleasures of sociability. They often worked at La Grenouillère, a café

and bathing spot on an island in the Seine not far from Bougival—exactly the kind of place Georges Seurat would paint 15 years later in *A Sunday on La Grande Jatte*. The comparison is useful, for it is with Impressionism that paint begins to break up on the canvas in the way that Seurat

THE PROVENANCE

➤ several owners before it was featured in the 1910 collection of Bernheim-Jeune, an influential Paris art dealer.

The title of this painting has caused some confusion over the years. Monet also painted another scene in 1870 called *The Seine at Bougival* (now at Smith College in

THE MUSEUM

➤ some pieces dating as far back as the 17th century. The gallery's holdings include Tiepolo's *The Triumph of Hercules*, Pablo Picasso's *Woman Seated in Chair*, Georges Rouault's *The Wounded Clown*, and Edmund Tarbell's *Summer Breeze*. The gallery's collection of furniture, silver, pewter, and glass represents craftsmanship throughout the centuries in Europe and America.

Another highlight of the museum's collection is the Isadore J. and Lucille Zimmerman House, designed by American architect Frank Lloyd Wright. The house was built in 1950; its furniture

"One must seize the moment of the landscape, for that moment will never return."

THE SEINE AT BOUGIVAL BY CLAUDE MONET

THE ARTIST

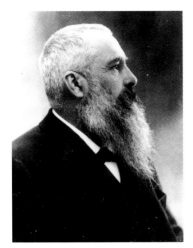

Claude Monet, ca. 1895.

"My studio! But I have never had a studio. That"—the open countryside—"is my studio." So Claude Monet claimed as the grand old man of Impressionism, identifying a crucial element of his art: painting plein air, recording his "impressions before the most fugitive effects" of light and weather.

When Monet was a teenager in Le Havre, painting outdoors was suspect. Indeed, he felt an "intense aversion" to the seascapes of the local artist Eugène Boudin, preferring to make humorous caricatures. Boudin eventually persuaded Monet to join him in painting on the coast. Monet later remembered, "Suddenly a veil was torn away. My destiny as a painter opened up to me."

Although Monet remembered his childhood environs as "entirely concerned with commerce," his fa-

In this 1870 painting by Henri Fantin-Latour, Monet (far right) and fellow painters meet in Édouard Manet's studio; Manet is at the easel.

ther, Adolphe, a successful businessman, wasn't totally opposed to art; after the 18-year-old Monet left for Paris in 1859, Adolphe would support him on and off for at least 10 years. He was drafted into the military in 1861, but he fell ill in North ➤

THE TECHNIQUE

The essentials of Monet's painting can be found in the words of his early teacher, Eugène Boudin, who believed, "Everything that is painted directly on the spot has always a strength, a power, a vividness of touch, that one does not find again in the studio." The artist, Boudin said, should work with "his first impression, which is the good one."

Monet wanted to be spontaneous rather than studied; he saw his work as "simply the expression of my own personal experiences."

Working outdoors and painting quickly to capture the changing scene produced the trademarks of Monet's Impressionism: the rapid, ➤

THE SUBJECT

In 1869 Monet and Camille were living in Bougival, a Paris suburb. Renoir was living not far off, and the two artists spent that summer together, painting scenes on the River Seine. In a letter from this period, Monet wrote, "Renoir is bringing us bread from his house so that we don't starve. For a week no bread, no kitchen fire, no light—it's horrible." Yet his work that summer was a crucial step forward.

The landscape of The Seine at Bougival is typical of Monet's early maturity—a civilized landscape of houses and people, suggesting the everyday life of the time. Within a decade or so of The Seine at Bougival, cityscapes and people would drop out of Monet's paintings. He would focus instead on nature, and, as in his series on Rouen Cathedral, on what he called the ➤

THE PROVENANCE

The Seine at Bougival was painted in 1869 after Monet had fallen on hard times. In this scene Monet painted what was his own backyard—at the time, he lived in the town of Bougival along the Seine.

Although Monet had been recently refused by the Salon a⸗ was thus unable to sell many paintings during this period, The S⸗ at Bougival was bought within a few months of its completio⸗ dealer Père Martin for 100 francs. (This was at a time when ca⸗ approved by the Salon might sell for thousands.) The painting⸗

THE MUSEUM THE CURRIER GALLERY OF ART

The Currier Gallery of Art is located at 192 Orange Street in Manchester, New Hampshire. The gallery opened in 1929 in a building reminiscent of an Italian Renaissance palace. The building's construction was funded by a bequest of former New Hampshire governor and bank president Moody Currier and his wife, Hannah. Currier was not an art collector, but he had long wished to found an art institution in his state; the museum property is also part of the bequest.

The museum's collection includes European and American paintings and sculpture, with ➤

I
G

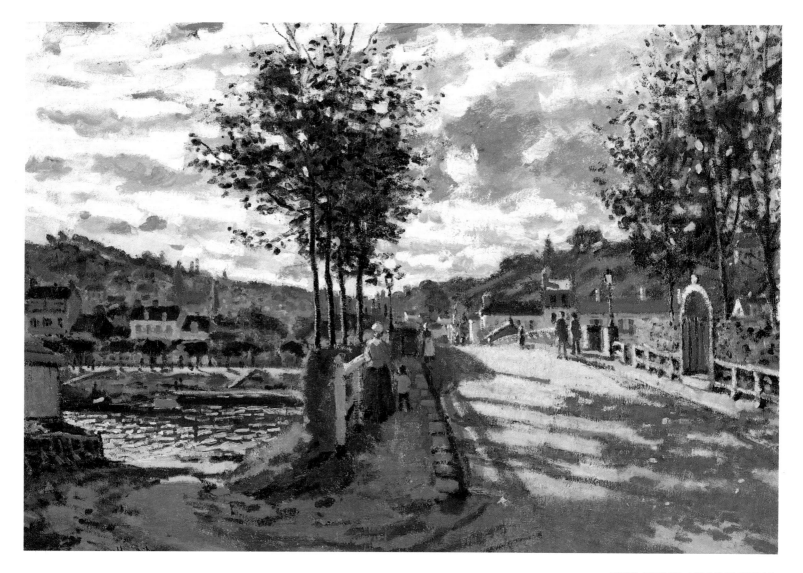

THE SEINE AT BOUGIVAL
by Claude Monet, 1869
oil on canvas
25¾ x 36⅜ in. (65.4 x 92.4 cm.)
The Currier Gallery of Art
Manchester, New Hampshire

the book had been done by a Briton. Pyle was flattered. A few years later, an internationally authoritative textbook on illustration would say that "American pen drawing...is the best," discussing Pyle's work at length.

From 1894 to 1900, Pyle taught a popular art class at a Philadelphia art school. But he hated indifferent pupils, complaining, "I can't stand those damned women on the front row who placidly knit while I try to strike sparks from an imagination they don't have." In 1898 he started a school to teach gifted students during the summers at Chadds Ford, Pennsylvania, 10 miles up the Brandywine River from Wilmington. Besides Pyle's classes there were bicycle rides, swimming, and picnics. N.C. Wyeth, who was a student at Chadds Ford (and would be the father of Andrew Wyeth), helped pay his way by milking cattle. He would remember the summer school as "those glorious days!"

Pyle ran the school for five years. After his 50th birthday he preferred to teach from his studio in Wilmington. At the same time, while he continued to publish children's books (a celebrated Arthurian series comes from these years), his own work was becoming more ambitious. Painting murals for courthouses and state capitols, he felt he needed to see the Renaissance masters firsthand.

Pyle was fascinated by Europe but had never been there. Early on, he had written to a friend in England, "I doubt whether I shall ever cross the ocean to see those things which seem so beautiful and dream-like in my imagination, and which if I saw might break the bubble of fancy and leave nothing behind but bitter soap-suds." Indeed, when he finally went to Italy in 1910, he hated Rome—the ruins were "ugly." Florence, though, showed him that "the old masters certainly were glorious painters and I take back all that I ever said against them."

Pyle's health was failing, however; he had a kidney ailment. He died in Florence in November 1911. ❑

Lady Lilith, 1864–76, by Dante Gabriel Rossetti, depicts the languid beauty in Pre-Raphaelite art; Pyle's mermaid may have been based on similar women.

Rossetti and Holman Hunt in reproduction, even as a child. Many of his illustrations show their influence. Also, the only important Pre-Raphaelite collection in the United States before World War I was coincidentally in Wilmington, owned by a cousin of Pyle's wife, the wealthy industrialist Samuel Bancroft, Jr.

In any case, the influence is too strong to discount. The somewhat sinister sexuality of *The Mermaid*, the archaism, the style of the figures down to the woman's pallid skin and long hair, jeweled and waterlogged, all have precedents in Victorian English art. The painting was among Pyle's last; he died as his work seemed about to head in a new direction. ❑

and death. Though we can't see her face, this mermaid doesn't seem totally the *femme fatale*. However, the youth's awkward pose—he has one foot in the sea—insinuates that she may drag him under. Pyle may have known a painting by Frederick Leighton, illustrating the German poet Goethe's lines on a fisherman's encounter with a siren: "Half she drew him in,/Half sank he in,/and never more was seen."

In Western society the 19th century was a time of industrialization; the Pre-Raphaelites tried to reassert the values of preindustrial life. The battle was long lost, of course, and as a result, much of that work has pained languor or a repressed violence. *The Mermaid* may be a reflection of this mood—or of Pyle's mysticism. ❑

After Pyle's death, one of his students, Ethel P. B. Leach, painted his studio just as he had left it. *The Mermaid* is still on the easel.

vanishes rather quickly in the water—but there is no way of knowing. In 1940 Pyle's children donated the work to the Delaware Art Museum in memory of their mother. ❑

and Elizabeth Shippen Green. The museum also has a contemporary art collection and a section devoted to English Pre-Raphaelite art. ❑

MUSEUM HOURS
Tuesday–Saturday:
10 a.m. to 5 p.m.
Sunday: 12 p.m. to 5 p.m.

ADMISSION
Admission charged.
Free to children 6 and under.
Free to everyone from
10 a.m. to 1 p.m. on Saturdays.

THE MERMAID

THE ARTIST

➤ choir—he was a good tenor. With a year of part-time attendance at the Art Students' League, however, his work improved, and he began contributing regularly to the Harper's group of magazines.

At first Pyle's drawings were only the bases for pictures that other artists would complete. Then late in 1877 he proposed *A Wreck in the Offing*, showing coastal lifeguards hearing of a ship in trouble. Pyle begged the art director to let him finish the gouache himself: "With some hesitating reluctance he told me I might try....I believe I worked upon it somewhat over six weeks, and I might indeed have been working upon it today (finding it impossible to satisfy myself with

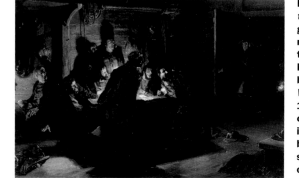

it) had I not...reduced myself to my last five cent piece in the world." Forced by insolvency to turn the drawing in, Pyle was

In *A Wreck in the Offing*, lifeguards react to news of a distressed ship. First published by *Harper's Weekly* in 1878, the success of this illustration brought Pyle a steady stream of new work.

elated when it became a double-page spread.

In 1879, having established a reputation and the publishing connections he needed, Pyle returned to Wilmington. Specializing in writing and illustrating articles on historical topics and on picturesque regions of the East Coast, he was soon prosperous enough to marry, which he did in 1881. In 1883, Pyle published *The Merry Adventures of Robin Hood*, one of the first of his many illustrated children's books. The English designer William Morris was astonished that the artist was American; he wished, he said, that

THE TECHNIQUE

➤ of the fingers," fearing that technical dexterity might be confused with pictorial success. When he taught, he emphasized imagination over imitation, telling his students, "Throw your heart into the picture, then jump in after it....Live in your picture."

Viewers trying to live in *The Mermaid* would find themselves in a dangerous place. Water swells to the bottom of the frame where we stand, heightening the feeling of oceanic surge and flow, threatening the precariously balanced male figure. The horizon line is high, the rocks to the right a steeply slanting vertical, increasing the sense of fall.

The palette is unearthly—greens, off-whites, browns, the yellow of a struggling, failing sun.

In his earlier drawings Pyle emphasized line, emulating Albrecht Dürer, William Hogarth, and other artists of the engraving. Later, when printing technology allowed the half-tone reproduction of images in color, he became more of a painter. The dominant influence on *The Mermaid* is surely the Pre-Raphaelite art of 19th-century England. Evidence of Pyle's knowledge of the Pre-Raphaelites is circumstantial, but he would certainly have seen artists like Dante Gabriel

THE SUBJECT

➤ Pyle had a mystical side. He was fascinated by Emanuel Swedenborg, an 18th-century Swede who experienced religious revelations. (In the hands of another artist, William Blake, Swedenborg's writings had led to truly visionary images.) Pyle read Swedenborg throughout his life.

The Mermaid is a morbid, suggestive image linking eroticism

THE PROVENANCE

➤ Students of his remembered that he did not consider it finished, and one of them added the leaping fish and the crab by the young man's foot. Perhaps Pyle intended to flesh out the mermaid's tail—it

THE MUSEUM

➤ considered the height of American illustration. Represented artists at the museum who were Pyle's students include N. C. Wyeth, Maxfield Parrish, Frank Schoonover,

The Brandywine Tradition

Pyle's school at Chadds Ford, Pennsylvania, inspired a generation of American artists who would be forever linked to that region near the Brandywine River. Although many of Pyle's students eventually developed unique styles, their works reflected the same elegant technical approach to illustrative art that Pyle taught and practiced. The heroic past figured prominently in the images of the Brandywine artists. They employed subjects from the Revolutionary war, medieval England and the age of exploration. To Pyle and his acolytes, history was somehow more exciting, colorful, and romantic than anything in the present or future.

N. C. Wyeth, the most famous student to come out of the Brandywine school, went on to follow in his teacher's footsteps—illustrating books and magazines in a style that echoed Pyle himself. But perhaps N. C. Wyeth's greatest tribute to his teacher was the founding of an American art dynasty that still resides in and near Chadds Ford: Wyeth's son Andrew and his grandson James carry on the Brandywine tradition.

Johnny's Fight with student N. C. Wyeth. tion is from the 192[book *Drums* by Jame[

THE MERMAID BY HOWARD PYLE

THE ARTIST

Howard Pyle posing in an artist's smock in his studio, 1910.

In turn-of-the-century America, the illustrations of Howard Pyle were known wherever books and magazines were read. In the era of the photograph and the half-tone his work is less familiar, but his influence endures in the work of one of America's most popular artists, Andrew Wyeth.

Pyle was born in 1853 in Wilmington, Delaware. His Quaker family lived in the country outside town in a book-filled house built in stages between 1740 and the War of Independence. Nearby on the Brandywine River was a battlesite where, in 1777, the British had beaten George Washington. It was a rich childhood; Pyle was trying to write poetry when he was very young. What stopped him, in fact, was he hadn't yet learned the alphabet.

Pyle was a daydreamer and doodler at school. When he was about 16, his parents decided he would study art. He took the standard courses with an academic teacher in nearby Philadelphia; he also learned anatomy from a Philadelphia surgeon.

After graduating, Pyle worked in his father's leather business. But he couldn't give up art. In the spring of 1876, some humorous verses and drawings of his appeared in the New York magazine *Scribner's Monthly*. Later, the magazine accepted an illustrated article about the island of Chincoteague, off the Virginia coast. The children's magazine *St. Nicholas* also took a Pyle fairy tale. Encouraged, he decided to move to New York.

When he got there, Pyle found less magazine work than he had hoped. Indeed, a Scribner's editor suggested he should take a job with a church ➤

THE TECHNIQUE

When Pyle's career began, the chief method of mechanically reproducing illustrations remained the engraving. A craftsman would carve a copy of the artist's picture into a wooden block from which the image would be printed. The original never reached the public and, in fact, was usually destroyed in the tracing process. In the same decades when French artists were discovering the physicality of paint on canvas, Pyle's audience never saw his paint, never even saw the images he'd painted, but only copies.

Pyle's technique, then, is meticulous but to the point. In the com-

Dr. Wilkinson flees from the local wolf in this scene from *The Salem Wolf*, 1909, which Pyle wrote and illustrated.

mercial world of magazines and books, technique was secondary to emotional and dramatic punch. Brushstrokes tend to disappear, subordinated to illusion. Indeed, Pyle claimed to distrust "the wisdom ➤

THE SUBJECT

Unlike many illustrators, Pyle often picked his own subjects, and his choices suggest a distinct escapism. He loved history—medieval England, revolutionary America. And he relished pirate themes. Some of his works are violent and, indeed, Pyle is most interesting when scariest—there's a scene from *The Salem Wolf*, for example, in which the wolf chases a terrified man over a snowy, desolate hillside. ➤

THE PROVENANCE

When Pyle and his family sailed for Italy in 1910, he left *The Mermaid* on his easel in Wilmington. There is no other record of it but the painting itself; and no client stepped forward to claim it, so it was pre-

sumably an uncommissioned image painted for his own satisfaction. ➤

THE MUSEUM DELAWARE ART MUSEUM

The Delaware Art Museum, which is located at 2301 Kentmere Parkway in Wilmington, was created in 1912 when local residents formed the Wilmington Society of the Fine Arts to raise funds for the purchase of 48 works by Howard Pyle.

The Society also collected works by artists who had been Pyle's students at the Brandywine school.

The museum's collection of 19th- and 20th-century American art emphasizes the period between 1890 and 1940, widely ➤

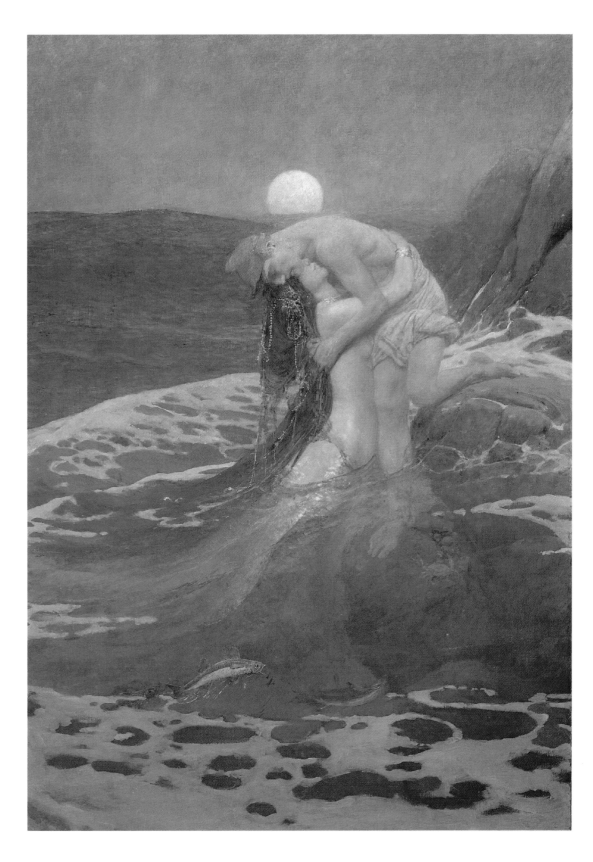

notwithstanding, he was an intellectual; a good friend, Abraham Ortelius, was a geographer who moved with liberal thinkers of the day. Bruegel's patrons included influential men from the Church and government. And Antwerp was a large, cosmopolitan seaport city; it had over 300 artists—more artists, in fact, than butchers.

In 1563 Bruegel married the daughter of Pieter Coecke van Aelst. The couple moved to Brussels, where the majority of Bruegel's paintings were done, in the last six years of his life.

Bruegel's era was violent. The Flemish Lowlands (modern Holland and Belgium) were then a Spanish possession, and an intermittent 80-year war of liberation was beginning. Spain also extended the anti-Protestant

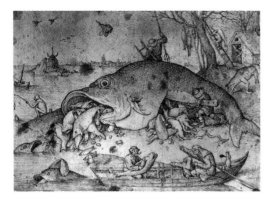

Big Fish Eat Little Fish, 1556. Bruegel illustrated the familiar proverb in the style of artist Hieronymus Bosch.

Inquisition to the Lowlands, killing thousands. Bruegel's paintings often reflect the grim times, but his political opinions are not known. Before he died in 1569, he reportedly made his wife burn a group of satirical drawings,

afraid that they would land her in trouble.

Bruegel was in his 40s when he died. His friend Ortelius wondered whether his early demise should be attributed "to Death, who may have thought him older than he was on account of his supreme skill in art, or rather to nature, who feared that his genius for dexterous imitation would bring her into contempt." Whether he misled Death or embarrassed Nature, he left a unique body of work, at once allegorical, fantastical, and thoroughly realistic. ❏

Yet he had visited Rome, seen Italian art, so his choices were informed; in fact, his later work is increasingly Italianate. *The Wedding Dance* takes a middle position in this development: the figures in the foreground are relatively large, and the composition is unified rather than episodic. But no figure gets much weight, and no one can stand out heroically against that high horizon line. ❏

seems more humorous than severe. For van Mander, it would be difficult for the observer to contemplate most Bruegel paintings "with a straight face. However still and morose he may be, he cannot help chuckling." ❏

peasant festival, Peter Paul Rubens' *Kermis.* ❏

home, classroom and gallery use.

In addition to more than 100 halls and galleries for permanent and special exhibitions, the museum houses an auditorium, a lecture and recital hall, and an art reference library holding nearly a quarter million books, pamphlets, and periodicals. ❏

MUSEUM HOURS
Wednesday–Friday:
11 a.m. to 4 p.m.
Saturday and Sunday:
11 a.m. to 5 p.m.

ADMISSION
Admission charged.
Free to members.

THE WEDDING DANCE

THE ARTIST

➤ According to van Mander's book, Bruegel was apprenticed to the artist Pieter Coecke van Aelst. But there is no proof of this, and the artists' styles are dissimilar. His apprenticeship finished, Bruegel traveled. Northern Europe was considered backward in comparison to post-Renaissance Italy, and all artists visited Italy if they could. Bruegel's trip lasted at least a year. There is a painting of Naples and a drawing of the town of Reggio on fire, probably from a Turkish raid in 1552. In 1553

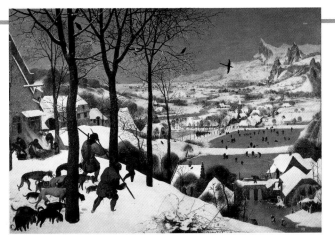

Hunters in the Snow, 1565. In this Flemish scene of hunters returning home with a fox, an Alpine landscape appears incongruously in the background.

Bruegel visited Rome; a later figure of his seems modeled on one by Michelangelo in the Sistine Chapel. He returned north through the Alps. Several drawings of them survive, and Alpine peaks sometimes appear in otherwise Flemish scenes, such as *Hunters in the Snow*, 1565.

Back in Antwerp, Bruegel collaborated with the engraver Jerome Cock, producing drawings to be made into prints. He worked for a time in the style of Hieronymus Bosch; Cock actually printed one drawing, *Big Fish Eat Little Fish*, 1556, under Bosch's name, appropriating the earlier artist's popularity.

Van Mander describes Bruegel as "a competent man, not much given to talk." A practical joker, he liked startling friends with "spooky sounds and tricks." The "Peasant Bruegel" label

THE TECHNIQUE

➤ that points us into the scene. The angles of elbows and knees and patches of cloth harmonize this architecture. In a palette mostly of reddish browns, brownish reds, and creams, light and our attention are spread around the picture by a speckling of whites and blacks. The painting almost shifts from image to pattern, a quilt of repeating shapes and colors.

The lack of a central focus reflects Bruegel's time and place—the time, a period in ways still medieval; the place, northern Europe. Contemporaneous Italian painting glorified its people—outlined them against low horizons and portrayed them as handsome, dominating figures. Bruegel, though, particularly early on, liked to show a sea of people in miniature. The figures are realistic, sometimes grotesque.

THE SUBJECT

➤ apocryphal, but Bruegel did make many sketches of peasants inscribed *naer het leven* (after the life).

None of Bruegel's developed works can be taken as simple reportage, however. Even in his time, people saw his images as puzzles to be deciphered. For van Mander, Bruegel's compositions, even those of "comical subjects," were "strange and full of meaning." Many of his images are allegorical, referring to literary sources, as well as to Flemish proverbs and sayings that are now difficult to reconstruct. Above all, he was informed by the teachings of the Church.

It has been suggested, in fact, that the peasant-dance paintings are morality plays—*The Wedding Banquet*, for example, with its table of eaters and drinkers and its hungry bagpiper, addressing the sin of gluttony. In *The Wedding Dance*, the swollen crotches of the men in the foreground suggest that Bruegel's theme here is lust. But the criticism

The Banque '68, detail. guests sha tiful ta country we dark-dre sits cons under a pa

THE PROVENANCE

➤ codpieces of the male dancers in the foreground had been painted out, to be revealed only when the painting was cleaned.)

Bruegel's sons Pieter Bruegel the Younger and Jan, both well-known painters in their own right, made copies of several of his works, *The Wedding Dance* among them. The painting was also the basis of a number of print versions, one of which, by Pieter van der Heyden, bears the inscription "P. BRVEGEL INVENT." It probably also inspired another celebrated 17th-century image of a Lowlands

THE MUSEUM

➤ court. Rivera, a leading Mexican muralist, began work on the cycle in 1932. Using a 15th-century recipe for fresco, he completed the 27 panels in eight months.

The museum has an active special exhibitions program. Past features have included collections of photographs of American Indians, illustrations from 12th- to 19th-century India, John James Audubon's watercolors for *The Birds of America*, ancient Peruvian jewelry and artifacts, and print series by Francisco José de Goya, William Hogarth, and David Hockney.

Aside from special exhibitions, the museum also offers craft workshops, lectures, demonstrations, tours to artist's studios and to other art museums, and a software system of art games for

THE WEDDING DANCE BY PIETER BRUEGEL

THE ARTIST

The Artist and the Connoisseur, 1565. Scholars have speculated that the painter in this drawing may be a Bruegel self-portrait.

Pieter Bruegel the Elder has been considered the towering figure of 16th-century Flemish art for only the last 100 years or so. Admired in his time, he was later labeled "the Peasant Bruegel," because he painted rural life and was believed to have come from the peasantry. Thought "vulgar" late into the 19th century, Bruegel was ignored for years while documents concerning him were disappearing. Hence his life remains obscure. And while he left no confirmed self-portrait, it is tempting to identify him with the painter in *The Artist and the Connoisseur*, 1565—or at least to

In Bruegel's time, the large seaport city of Antwerp was home to over 300 artists.

think he sympathized with this put-upon man. Tragically, a third of his works are believed to have been lost.

Bruegel's first biographer, Carel van Mander (writing 35 years after the artist's death), says he was born in the village of Brueghel, near Breda. Three

Dutch and Belgian villages of Brueghel, near two different Bredas, fit this description. Bruegel became a master in the Antwerp artists' guild in 1551. Since the guild accepted nobody under 25, he was born no later than 1526. ➤

THE TECHNIQUE

The Wedding Dance is built of triangles, mainly the wedge in the painting's heart, limned by the panel's base and by the clear lines between spectators and dancers that run from bottom left and right to the tree in the center background. This wedge out of the picture creates two more triangular spaces at upper left and right. The structure is geometric, solid, anchored by three verticals—the dark-clad spectator at front left, the bagpiper at front right, the tree at the main triangle's tip. Yet how powerfully Bruegel suggests motion, crowd, music.

The effect is both compositional and chromatic. In the picture's middle, dancers' linked and upheld arms create a row of gently peaked arches, a subtle, sinuous progress ➤

THE SUBJECT

The Wedding Dance is one of Bruegel's several peasant wedding and festival scenes, which include the *The Wedding Banquet* of 1567 or '68. In the latter work, a dark-dressed woman with her hair down and crowned with a wreath is clearly the bride. In *The Wedding Dance*, then, the bride must be the dark-dressed woman similarly coiffured, dancing just left of the picture's center. And the cloth strung from trees in the background, with a paper crown hung at its center, must mark her seat, as it does in *The Wedding Banquet*.

According to van Mander, Bruegel enjoyed going with a friend to "village fairs or weddings, wearing peasant garb. They came to the wedding bearing gifts like everyone else and claiming to be members of the family of the bride or groom. Bruegel took pleasure in studying the appearances of the peasants...He also knew how to represent these peasant men and women most exactly." The story may be ➤

THE PROVENANCE

The Detroit Institute of Arts acquired *The Wedding Dance* (also known as *Wedding Dance in the Open*) in 1930 from a private collector in England. Only in that year was the painting recognized as a genuine Bruegel. Other versions of the scene exist; the most similar of them is in the Koninklijk Museum in Antwerp. Although that painting too seems to be a Bruegel, parts of it were probably reworked by a later hand. (When the Institute bought the Detroit work, it too showed signs of repainting, and was poorly preserved; and the prominent ➤

THE MUSEUM THE DETROIT INSTITUTE OF ARTS

The Detroit Institute of Arts is located at 5200 Woodward Avenue in Detroit, Michigan. It opened in 1927 in a building designed in Italian Renaissance style. Two wings have been added to accommodate its large and varied collections.

Among its most renowned holdings are paintings of the German Expressionists. There are also important collections of Flemish, Italian Renaissance, and French Impressionist paintings.

The museum's large collections also include art from African, Oceanic, and New World cultures.

A powerful and unique centerpiece of the museum is the monumental fresco cycle, *Detroit Industry*, by Diego Rivera. The murals are painted on the four walls of the museum's center ➤

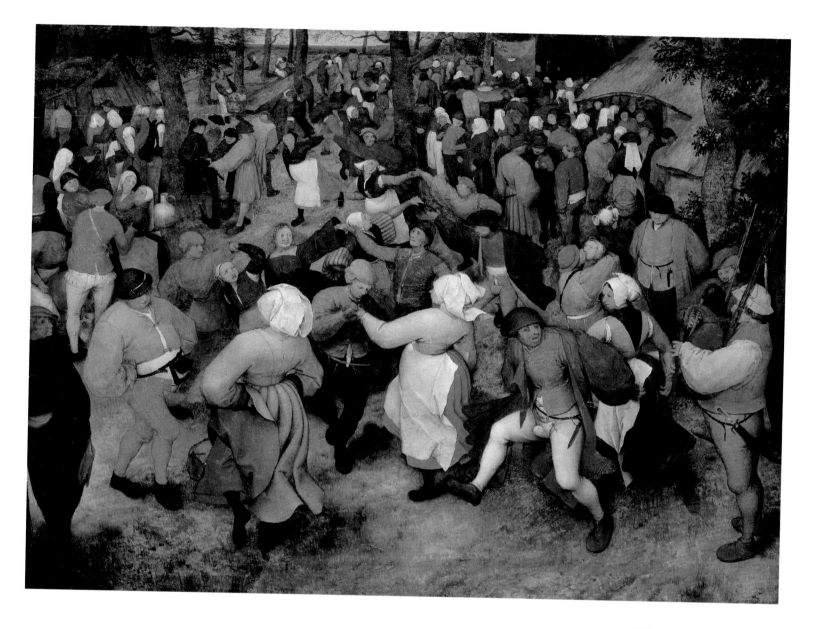

THE WEDDING DANCE
by Pieter Bruegel, 1566
oil on wood panel
47 x 62 in. (119 x 157 cm.)
The Detroit Institute of Arts
Detroit, Michigan

garments expected of her. (Yet the woman was beautiful, and won.) And once, when he was walking with a wealthy merchant's son who took shelter to protect his expensive clothes from the rain, Korin pointedly continued slowly along the road, even stopping to talk to a beggar.

Korin's gifts were such that once he began working seriously he quickly attained respect. In 1701 the court bestowed on him the title *hokkyo*, a rarely granted Buddhist rank honoring artists of achievement. But in 1704, broke, he moved to Edo (present-day Tokyo). Perhaps he had alienated the Kyoto authorities and his family by outrageous behavior, but he was more likely following

a rich patron and friend of his, Nakamura Kuranosuke, who had moved there. (Nakamura, the subject of Korin's only surviving portrait, was later caught counterfeiting money; some think Korin was involved in the scheme, but this is conjecture.) In Edo an aristocratic family eventually took him on as a retainer. But he was unhappy there; in a letter home, he wrote about how hard it was to "walk to a samurai lord's house and paint several paintings, and then be criticized."

In 1709 Korin returned to Kyoto. By the time he died, in 1716, he had retired into nominal priesthood. His bequest included stacks of promissory notes and pawn tickets. ❑

Korin's patron Nakamura Kuranosuke by the artist and his brother Ogata Kenzan.

each screen are identical: a dark curve of water at the outside edge forms an abstract arabesque, which continues its inward flow through the irregular line of the birds' bodies. The pointing beaks and the spangled row of feet restate this line above and below. Each

screen's innermost panel is empty, and each group of birds has a leader who gets all or most of a panel to itself. The two screens mirror each other, yet are not identical; each is a subtle variation on the other, like two verses of a song. ❑

heads and beaks above, and black-and-gray bodies in a bulbous row. There is an unmistakable wit to those beaks, all parallel to the picture plane.

Somehow Korin fills these simplified figures with idiosyncratic character. Stately yet also ungainly, they move to their meeting— a convo-

cation of tribes. The left-hand screen has nine cranes, the right-hand one 10; one bird will have no partner. ❑

Like other Japanese artists, Korin often painted on personal or household objects. On one side of this fan, he painted chrysanthemums by a stream; the other side shows a scene from Japanese literature.

Charles Lang Freer (front row, wearing a hat) stands beside wealthy Japanese art collector Hara Tomitaro and Hara's wife and daughter during a 1907 trip to buy art in Japan. Other friends of Freer's stand in the back row, including an art dealer (center).

year, the work was purchased by Oriental Art Gallery in New York City, which sold it in 1956 to the Freer

Gallery of Art in Washington, D.C. ❑

Also at the Freer is an important collection of works by 19th- and 20th-century American artists, many of whom were Freer's personal friends. This part

of the collection includes American paintings, prints, and drawings. It highlights an installation called "Harmony in Blue and Gold: the Peacock Room," which

displays an exuberant 19th-century interior design scheme for a London dining room by Whistler. ❑

MUSEUM HOURS
Monday–Sunday:
10 a.m. to 5:30 p.m.

ADMISSION
Free

CRANES

The kimono worn by the courtesan in this print, ca. mid-1790s, illustrates Japan's elaborate fabric tradition. Korin's background in fabric design shaped his approach to art.

➤ Soken, himself more artist than businessman, was able to leave his sons healthy legacies on his death in 1687. But six years later Korin had exhausted his funds and had to borrow from his brother, Ogata Kenzan. In 1696 he had to sell his house, a large part of his inheritance.

Kenzan too was an artist—a calligrapher and ceramist. He was a practicing Buddhist, more sober than his older brother who was sinking into debt and pawning the family heirlooms. Yet both men, raised to take art as a pastime and pleasure, were ultimately forced to make it support them. After Kariganeya closed in 1697, they went into business together, Korin designing textiles and painting calligraphy and images on Kenzan's pottery.

The period called the Genroku, when Japan's wealth was shifting from the daimyo to the merchant classes, was a worldly, affluent moment in the culture. In 1691 a Dutchman visiting Japan wrote, "Kyoto is the center of Japan's various arts, production, and business...Brocades, gorgeous dyed fabrics, exquisite carvings, musical instruments, lacquerware, and magnificent paintings are produced and sold.... These products are famous throughout the land." Korin's attitude to the prosperity around him was ambiguous and perhaps somewhat bitter. He was given to the kind of gesture that cryptically mocks its witnesses: at an elaborate picnic, for example, where other guests ate from valuable lacquered picnic boxes inlaid with precious metals, Korin unwrapped his food from plain bamboo leaves—which turned out to have been gold-leafed on the inside. Then he tossed the leaves away in the river. When he orchestrated a woman's entry in a beauty pageant, he dressed her simply, in white with a black jacket, while her servant wore the rich

THE TECHNIQUE

➤ It is a sumptuous pair of objects: the ground that the cranes walk across is gold leaf, and the ripples in the stylized tongues of water in the screens' upper and outer corners are touched with silver (now tarnished to gray or black). That the work announces itself as furniture, a category that Western painters often like to think their work escapes, doesn't undo its preciousness.

Nor, for that matter, its aesthetic quality. Korin grew up around Japan's gorgeously sophisticated fabric tradition, and his work has qualities of fabric design, moving away from picture toward pattern. In *Cranes*, Korin has no interest in his birds' environment; their habitat is a flat sheet of gold. The elements of

THE SUBJECT

➤ of six-panel folding screens like *Cranes*, is among his best-known works.

Korin favored patternlike arrangements, linear compositions, and areas of flat color. (These qualities in Japanese art influenced 19th-century European artists involved in Western painting's shift from illusionism into abstraction.) Korin's birds are *nabez-uru*, cranes that spend most of the year on the Asian continent but migrate to Japan for the winter. The crane is an often-painted symbol of longevity in East Asia; Korin is known to have made life sketches of such birds. Yet he reduces them to a combination of nearly identical elements—stalklike legs below, mainly vertical necks and mainly horizontal

THE PROVENANCE

➤ century, when two of his followers, artists Sakai Hoitsu (1761–1828) and Sozuki Kitsu (1796–1858), made copies of it. It was seen for the first time outside of Japan from September to October 1936, when it was shown at the Museum of Fine Arts in Boston in an exhibition called "Art Treasures from Japan." It was on loan from Kihichiro Okura, a Japanese collector. That same

THE MUSEUM

➤ for the building of a museum to house the collection—the Freer Gallery of Art.

The Freer is primarily a museum of Asian art. In its collections are folding screens from Japan, ancient jades and bronzes from China, ceramics from 12th-century Korea, illuminated manuscripts from Persia, and religious paintings and sculptures from India.

The gallery also owns the Washington Manuscript of the Gospels, a famous early Christian biblical manuscript made in Egypt during the 4th or 5th century and purchased by Freer in the early 1990s.

CRANES BY OGATA KORIN

Ogata Korin's signature and seal from a detail of the fan shown on page 56. No known portrait exists.

The late 17th-century painter Ogata Korin is an important figure in Japanese art history. Preferring to paint subjects from nature and from classical literature (as opposed to the cosmopolitan scenes of city pleasures that grew popular in his era), he gave these themes a new refinement and direction.

Korin was born in 1658, in Kyoto (then Japan's capital and imper-ial seat), into cultured, affluent circumstances. A great-grandfather had been a member of a collaborative community of artists called Takagamine, organized around his brother-in-law, the important painter Hon'ami Koetsu. He had also founded a family business of designing expensive kimonos. In Korin's time the elegant store, Kariganeya, was run by his father, Ogata Soken.

The young, Korin studied painting, but not seriously. A rich man's son, he wanted to socialize with his peers, go to the theater, and pursue his delightfully hectic romantic life. Though he probably contributed fabric designs to the family business, his role there was more filial than professional. Kariganeya, however, was to fall on hard times. The store had been the official supplier of dresses to the empress Tofukumonin; after she died in 1678, its contacts at the court dried up. The family had also made loans to the feudal lords, the daimyo, that were not repaid. ➤

City views like *Street Scene in the Yoshiwara* by Hishikawa Moronobu were popular in Korin's day. He painted scenes from nature and literature instead.

THE TECHNIQUE

In Western tradition, a painting is usually a rectangle of canvas of whatever size, daubed with colored pigments, framed, then hung on the wall. Korin, an artist of a completely separate tradition from the Western, painted not "paintings" but functional objects such as fans, kimonos, scrolls, doors, wrapping paper, medicine boxes, plates, and large folding privacy screens for rooms. One might wonder whether it isn't less eccentric, more self-explanatory, to paint these things than to paint canvas rectangles for the wall.

Cranes fills one side each of two six-panel paper screens, designed to be set so that the two groups of birds seem advancing to meet. ➤

THE SUBJECT

Unlike many artists of the worldly Genroku period, Korin painted time-honored themes in Japanese art—flowers and birds, or subjects from classical Japanese literature. There was an aristocratic element to these choices, which honored the traditional structures of Japanese society at a time when those structures were in flux. Yet perhaps because he lived at such an era of change, Korin could not take his themes as given. Receiving them at a certain distance, he treated them freshly, making them more abstract and condensed. Painting a famous episode from the 11th-century *Tales of Ise*, for example, in which the hero stops on a bridge by a riverbank covered with irises, Korin painted the flowers only. The result, *Irises*, a pair ➤

THE PROVENANCE

Although Korin's seal and signature appear on *Cranes*, they differ slightly from accepted versions elsewhere, leading some scholars to question the attribution. But the screens are clearly in the style of the artist's late work, and any doubts about the artist's claim to the work haven't developed far. The work, in any case, seems to have been well-known and presumably accepted as Korin's in the 19th ➤

THE MUSEUM FREER GALLERY OF ART

The Freer Gallery of Art, part of the Smithsonian Institution, is located on Jefferson Drive at 12th Street, S.W., in Washington, D.C. The museum opened in 1923; major renovations were completed in 1993.

The museum is named after Charles Lang Freer, a successful businessman who became interested in collecting art. Among his earliest acquisitions were a series of James McNeill Whistler etchings and a small 17th-century Japanese fan. As his interest grew, he traveled to the Far East, expanding his knowledge and his collections. In 1906 he arranged to give his collections to the Smithsonian. He also provided ➤

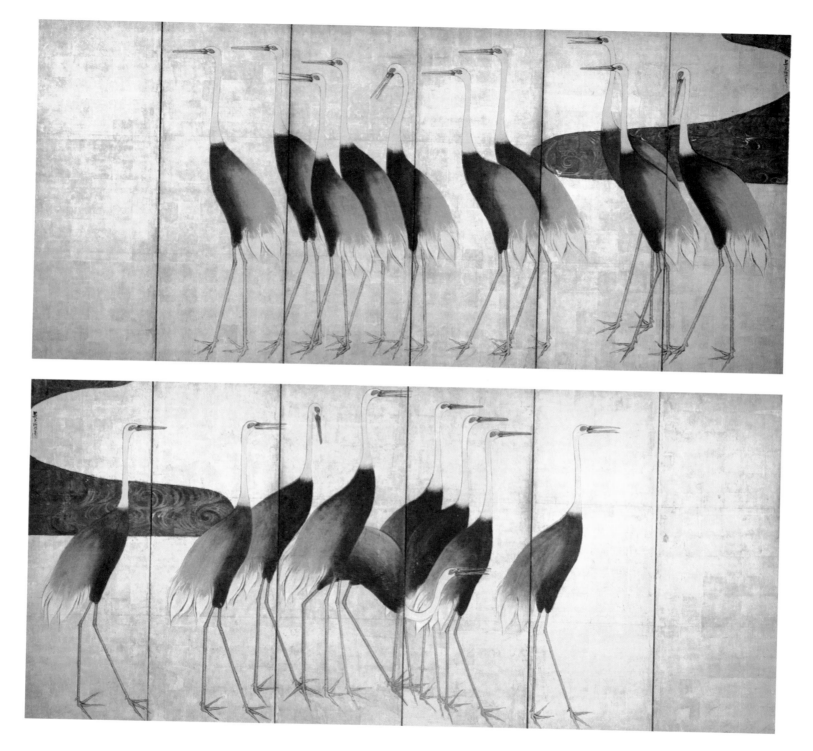

CRANES
by Ogata Korin, 17th–18th century
ink, color and gold on paper
Each screen: 65⅝ in. x 12 ft. 2 in. (166 x 371 cm.)
Freer Gallery of Art
Washington, D.C.

Venice parish of San Lio. That he had left his parents' home has led some historians to suppose he had married. Ginevra Bocheta, then, whom he certainly married around 1485, when he was in his 50s, may have been his second wife. Ginevra had died by 1498; a son, Alvise, died in 1499.

Traces of Bellini's personality come across in the tale of the important patron Isabella d'Este's attempt to commission a scene of classical mythology from him. She asked him first in 1496; nine years later, after she had told him she would settle for "something vaguely antique," she had to take a Madonna and Child. Through an intermediary whose words survive, Bellini had let her know that his subjects had to be "left to his own imagination," and that he was accustomed to "roam at will in his paintings." He would work to no one's prescription.

When the great German artist Albrecht Dürer visited Venice in 1506, he found Bellini "still the best in painting," and courteous and generous to a visitor from abroad. In the last decade of his life, Bellini had more commissions than he could finish. On the day he died—November 29, 1516—a Venetian wrote in his diary, "This morning Giovanni Bellini died, an excellent painter whose reputation is high throughout the world; and old though he was, he worked wonderfully." ❏

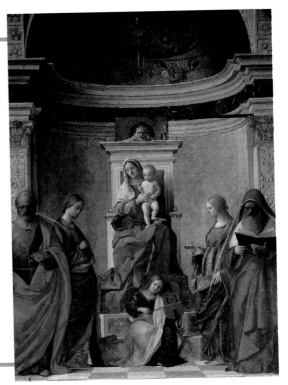

Madonna and Saints, 1505, is considered Bellini's last great altarpiece of the Madonna. Though it has been removed from its original frame, the painting still hangs in the San Zaccaria church in Venice.

cell, which is echoed in the parallel slopes of the faraway hills—runs from lower left to upper right. This line divides the painting into two triangles, the lower, rightward of the two darker than the one above it, emphasizing the upper landscape's golden glow. (Note the line of light that hems a couple of those distant hills.)

The dark lower-right triangle also balances the painting's peculiar perspectival asymmetry and is itself balanced by the bright shape of the lectern, its flat surfaces facing the light. The wood picks up some of the radiance that is coming. And if the rock where the saint stands has not yet caught the light elsewhere in the painting, the shadow he casts tells us it is on its way. ❏

figure of the angel. It is as if the holiest things could not be shown—or as if the sacred were not containable in a physical body but were a part of the landscape, a presence in the air, infusing everything seen, as light does.

Another reading of the painting is that Francis is greeting the sun, to which he had written a hymn. (The piece of paper tucked into his rope belt identifies him as a writer.) But what time of day is it? The lighter zone of blue in the sky above the distant hills suggests a near dawn—but that's not where Francis is looking. And if that were the source of the painting's illumination, his shadow would run directly toward the painting's viewer. An account of the Stigmatization that Bellini probably knew places it at night, an hour or so before sunrise. That would explain why, in the farther landscape of fields and town, only a single shepherd is about. It is the seraph's light that makes the land bright. ❏

l'oeil piece of parchment that the wind seems to have caught against a clump of bare twigs in the left foreground.

In about 1845 the painting was bought in Italy by William Buchanan, a British art dealer. After auction in London and passing through the hands of various art dealers, it was acquired by the American businessman Henry Clay Frick in 1915. ❏

The Enamel Room, contains 16th- and 17th-century enamels from Limoges, France, the showpiece being *The Adoration of the Shepherds* by Jean de Court. ❏

MUSEUM HOURS
Tuesday–Saturday:
10 a.m. to 6 p.m.
Sunday: 1 p.m. to 6 p.m.

ADMISSION
Admission charged.
Children under 10 not admitted.

ST. FRANCIS IN THE DESERT

THE ARTIST

➤ investments. When he was about 40, a contemporary described him as "dignified by celestial honors."

As a young man Bellini worked alongside his brother and father; in 1459 the three collaborated on a now-lost altarpiece. But his early art is influenced less by Jacopo than by the Paduan painter Andrea Mantegna, who lived in Venice for a period in the 1450s. Mantegna was Bellini's brother-in-law, husband of his sister Nicolosia. The artists must have known each other well; once they both based versions of the same biblical episode, the *Agony in the Garden*, on the same drawing—a sketch by Jacopo Bellini—

as if in friendly competition.

In 1474 Gentile Bellini received an important position—restoring and replacing the murals in the Sala del Maggior Consiglio, the hall of the great council in the palace of the doge, the ruler of Venice. Shortly after, the Ottoman sultan Mehmet II invited the doge to send an artist to work at his court. This apparently friendly invitation came at a time when Venice and the Ottomans were competing sharply in the eastern Mediterranean. It was Gentile who was

appointed to go on this sensitive errand (in part, it is thought, to act as a Venetian spy). When he left in 1479, Giovanni took over his job in the council hall.

For the next 30-odd years, Giovanni worked regularly in the doge's palace. (Unfortunately, all his paintings there were destroyed by a fire in 1577.) By 1483 the state had named him a "painter of our Dominion," a recognition of

excellence. He was clearly admired and rewarded at the highest levels.

With varying degrees of certainty, over 220 surviving paintings are attributed to Bellini; his artistic progress can be tracked in these works' development. The documents of his career, however, throw little light on his character or on his personal life. In 1459, we know he was living in the

THE TECHNIQUE

➤ Saint Francis, horizontal lines in the rock and the descent of the clifftop from right to left mark the vectors with which these lines converge on the vanishing point—somewhere at or beyond the painting's upper left edge. Saint Francis too is looking up and to the left—at what, we can't see.

The visual heart of the picture seems to be somewhere outside it.

What there is in the panel's upper left is light. It's partly in the paint: Bellini layers oil and tempera in transparent glazes to create an atmosphere of crystalline, vibrant clarity. But the effect is also structural. Contradicting the perspective lines running from lower right to upper left, a powerful diagonal—the line of rock that frames Francis'

THE SUBJECT

This detail of the upper left corner of *St. Francis in the Desert* shows rays of light breaking through the clouds.

➤ red marks, and his cell in the cliff resembles his actual retreat, which Bellini may have visited. Francis had also ridden up Mount Alverna on a donkey, like the one Bellini paints.

There is also that light, a natural presence standing in for a supernatural one. At the painting's top left corner is a crack in the

clouds—or perhaps a crack in the sky—from which almost imperceptible bright rays glance down toward the saint. Though immaterial, they seem forceful enough to bow the laurel tree on the picture's left side. It could be that in displacing the perspective vanishing point, the picture's focus, Bellini also displaced the

**Bellini's
of Venic‹
Loredan,
worked ‹
palace f‹
a painter
paintings**

THE PROVENANCE

➤ velously finished and studied." Did Marcantonio mean that the painting was begun by Bellini and finished by someone else? Or was he saying that Bellini began the painting on Michiel's commission but fin-

ished it for another patron, perhaps Contarini? Whatever he meant, most critics believe the painting is entirely Bellini's. Indeed the artist's signature—in its Latin form, "Ioannes Bellinvs"—appears on a trompe

THE MUSEUM

➤ The collection is strong in European painting: Dutch paintings include works by Johannes Vermeer and Rembrandt; from England there are portraits by Thomas Gainsborough and land- and seascapes by J. M. W. Turner and John Constable; France is repre-

sented by the Boucher Room with eight panels called *The Arts and Sciences* depicting cherubs engaged in artistic pursuits—and by the Fragonard Room with its romantic series by Jean-Honoré Fragonard, *The Progress of Love.*

ST. FRANCIS IN THE DESERT BY GIOVANNI BELLINI

THE ARTIST

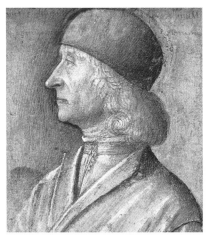

A contemporary portrait of Giovanni Bellini by Vittore Carpaccio.

Giovanni Bellini is a great master under two different art-historical headings—the Italian Renaissance and the superb tradition of the city of Venice. He is also an easy painter to love, for beyond its formal and coloristic brilliance his work has a grace, a warm spirituality, that is utterly endearing. When Bellini paints a Madonna and Child, say, the figures have not only the beautiful gravity of the religious subject, they have a serene human tenderness.

Bellini was born into a distinguished artist family; his father was the painter Jacopo Bellini. His elder brother, Gentile Bellini, would also be an artist of fame. The year of Giovanni's birth is

Madonna of the Meadows, ca. 1505. Bellini's paintings of the Virgin and Child were so popular that he and his studio produced over 80.

uncertain; it was probably 1433 or '34, but some scholars place it as early as 1430.

Bellini won respect early. His first surviving work, a small *Saint Jerome in the Wilderness*, is dated around 1450, when he was 20 at most. Within a few years he was receiving commissions for large altarpieces that represented sizeable financial ➤

THE TECHNIQUE

In Renaissance terms, *St. Francis in the Desert* is oddly askew. Renaissance perspective is usually centered: from each side of the picture, converging lines, explicit or suggested, aim at a vanishing point equidistant from the painting's left and right sides. The composition is balanced around this hub. In *St. Francis*, the perspectival

lines are all on the painting's right. Clearest in the horizontal posts of the trellis, they are picked up by the posts in the nearby lectern, by lines in the rock face (such as the line of vegetation just left of the saint's head), by the edge of the escarpment near the donkey, and by the leftward-rising hillside just beyond the distant shepherd. Above ➤

THE SUBJECT

In the year 1224 Francis of Assisi, founder of the Franciscan monastic order, spent 40 days fasting on the slopes of Italy's Mount Alverna in Umbria. There he is said to have experienced a miracle—to have been visited by a seraph, who imprinted on him the Stigmata, the wounds in hands, feet, and side that Christ endured on the Cross.

Chapter of the Order of the Crescent, possibly by Bellini, illustrates the symmetrical perspective associated with Renaissance art.

Bellini's *St. Francis in the Desert* probably pictures this event. There is room for doubt, since Bellini omits the seraph. But Francis does seem caught in some visionary rapture. His hands show faint ➤

THE PROVENANCE

Most scholars believe that *St. Francis* was painted between 1479 and 1485, but no record of it exists before 1525, when, in the Venice house of Taddeo Contarini, one Marcantonio Michiel saw a

painting of which he wrote, "The panel in oil of St. Francis in the wilderness was the work of Zuan [Giovanni] Bellini, begun by him for M. Zuan Michiel, and it has a landscape close by, mar- ➤

THE MUSEUM THE FRICK COLLECTION

The Frick Collection is located at One East 70th Street in a New York City mansion that was the former home of Henry Clay Frick, a Pittsburgh steel tycoon.

The mansion was designed by Thomas Hastings; John Russell Pope, designer of the National Gallery of Art's West Wing and the Baltimore Museum of Arts,

made additions to the building. Opened to the public in 1935, the museum preserves the feeling of an elegant residence. ➤

Henry Clay Frick, ca. 1915.

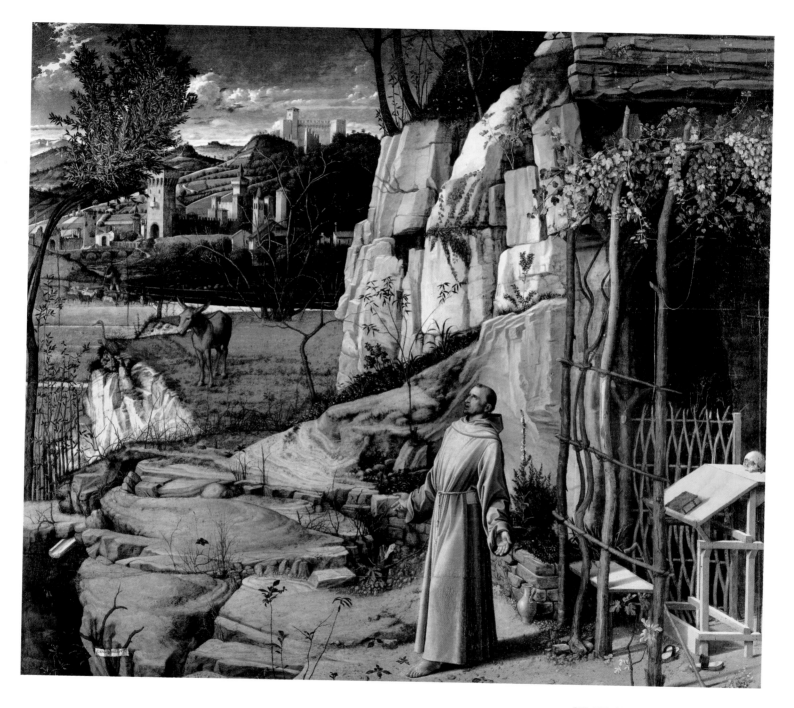

ST. FRANCIS IN THE DESERT
by Giovanni Bellini, ca. 1480
Tempera and oil on poplar panel
49 x 55⅞ in. (124.4 x 141.9 cm.)
The Frick Collection
New York, New York

It remained to conquer London, where Gainsborough moved in 1774, when he was 47. There he faced disadvantages: he lacked patrons in the city and was on jousting terms with the powerful Royal Academy. Gainsborough violently disapproved of the way paintings were hung at the Academy's exhibitions—jammed frame to frame, floor to ceiling, like wallpaper. To survive these conditions, artists would paint "exhibition pictures," loudly colored and with-

...ved music; here he ...ormal musical gath- ...'s house.

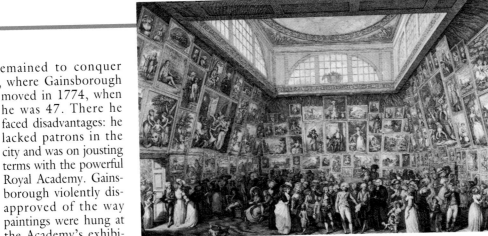

An 18th-century engraving shows how paintings were displayed at London's Royal Academy.

out subtlety. This Gainsborough refused to do. Still, although little is recorded of his first years in London, he is known to have been prosperous in the city by 1777. There he socialized with playwrights and actors and kept up a keen but distant and respectful competition with portraitist Sir Joshua Reynolds.

Successful as he was, Gainsborough never fully reconciled himself to the life of a portraitist. He once wrote to a friend, "I'm sick of Portraits and wish very much to…walk off to some sweet village, where I can paint landskips and enjoy the fag end of life in quietness and ease.…My comfort is I have five viols-da-gamba."

Gainsborough continued to find consolation in music and to play it for the rest of his life. He died of cancer in 1788. ❏

studio, or even work by candlelight. Private houses in those days were ill lit, and he designed his images to compensate. Often, his paintings seem to glow in the dark.

What Gainsborough wanted from Van Dyck was a grand manner. Compare *The Blue Boy* with earlier works, such as the family self-portrait *Thomas Gainsborough, His Wife and Daughter*, of 1751–52. Comfortably dressed, the artist sits cross-kneed. The occasion is domestic, a family stroll in the woods; the girl turns toward her mother, whose dress puffs up lumpily about her. *The Blue Boy*, on the other hand, is all gravity. The pose is dignified and considered. Much attention has gone to the folds of satin, with their liquid, mercurous fluidity. The divide between the two paintings is the divide between Gainsborough the country squire and the aristocrat as he'd like to see himself—not just elegant, but thoughtful and noble. ❏

...ted the ...arles II ...d style. ...deliber- ...'s work ...ve his ...ondon.

used canvas on the easel. All the more likely, then, that the sitter was a personal friend, and that the painting was done for the artist's own ends. It is also possible that *The Blue Boy* was an exercise on a sumptuous scale. It comes from the period when Gainsborough was teaching himself the Flemish grand style; one can imagine him receiving his old friend's child as a guest, and, for practice, saying to him, "Come, let me make you into a Van Dyck!" ❏

Boy Meets Girl

Opposite *The Blue Boy* in the Huntington Gallery hangs *Pinkie*, by Sir Thomas Lawrence. There is nothing to connect their genesis: Lawrence was a baby when Gainsborough was painting Jonathan Buttall. But paired as girl-meets-boy, they have come to be seen as a couple.

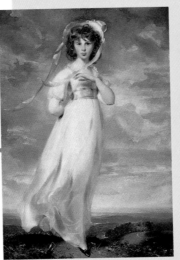

When Pinkie—or Sarah Goodin Barrett Moulton—was sent from Jamaica to England to go to school in 1792, her grandmother Judith Barrett missed her enough that two years later she commissioned the girl's portrait.

Sadly, Pinkie died in 1795, before her grandmother received the portrait. It is not clear, in fact, whether the painting ever arrived in Jamaica, for 10 years later it was in London, in the possession of the girl's brother, Edward. Later this man was to have a distinguished daughter: had Pinkie lived, she would have been the aunt of the poet Elizabeth Barrett Browning.

a coat of discolored varnish was removed from the painting. This cleaning dramatically changed its appearance, particularly its color: in the 19th century, it seems Gainsborough's blue boy was green. ❏

MUSEUM HOURS
Tuesday–Friday:
1 p.m. to 4:30 p.m.
Saturday–Sunday:
10:30 a.m. to 4:30 p.m.

ADMISSION
Free.

THE BLUE BOY

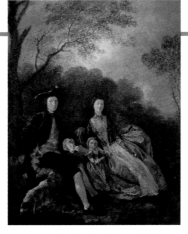

Thomas Gainsborough, His Wife and Daughter, 1751-1752. This family portrait reflects the artist's early, informal style.

Gains
sketc
ering

THE ARTIST

➤ and woods and drew pictures for his friends in exchange for contributions to homework. He was clearly talented, and when he was 13, his father apprenticed him to an engraver in London. By 1745 Gainsborough was helping out in London artists' studios and working as a restorer. This, along with studies at the St. Martin's Lane Academy, was his formal training.

Gainsborough visited Sudbury regularly. During one of these trips, he met Margaret Burr, whom he would marry in 1746. The couple spent their 20s in London, Sudbury, and finally the Suffolk wool town of Ipswich.

Despite the birth of two children, they lived in a cramped house that they rented cheaply; Gainsborough took any painting job he could find.

Yet Gainsborough apparently enjoyed Ipswich. He loved to play the violin and the viol, and he belonged to a club of music-makers whose meetings orbited convivially around liquor (a life-long taste of the artist's). In Ipswich Gainsborough took to wearing a wig—an affectation of social rank. Among his musician friends, his wig was "a fund of amusement as it was often snatched from his head and thrown about the room."

He had no high ambition for his artistic talent at first. His earliest patron, Philip Thicknesse, found Gainsborough's neighbors ignorant of his talent—"as he was himself." Gainsborough most wanted to paint in the landscape genre (commissioned to paint a portrait, he would sneak in a landscape as scenery), but Thicknesse persuaded the artist to move in 1759 to the fashionable spa of Bath, to open a portrait studio. There he was an immediate success: from charging five guineas a portrait, Thicknesse wrote, "it is scarce necessary to say how rapidly, nor how justly, he raised his price." Seven years later Gainsborough was living on Bath's most expensive street.

THE TECHNIQUE

➤ ments of both the boys' stances in the Van Dyck. Also, Gainsborough's boy is wearing the outdated costume of a cavalier—the dress in which Van Dyck depicted the family and the court of Charles I in the 1630s. Gainsborough did not, however, merely copy Van Dyck's style. A striking element of *The Blue Boy* is the contrast of light and dark—the way the face, for example, stands out whitely against the shadowy sky; the blue of the satin picks up highlights and sheens; and the advanced left foot, again highlighted, pulls the bottom of the canvas forward toward the eye. Gainsborough sometimes painted in semidarkness; he would close the shutters of his

In *George an*
Villiers, Van I
foster sons o
in his tradem
Gainsborough
ate study of V
as he prepare
portrait busin

THE SUBJECT

➤ and there is no evidence to date the painting firmly, or to reveal its reason for being—the picture seems to show a family friend of Gainsborough's.

X-ray photographs of the painting reinforce this view, for *The Blue Boy* was not the first image on this canvas: beneath the face is the beginning of another portrait, of a man older than Jonathan Buttall. It is unlikely that Gainsborough, in the presence of a customer spending a tidy sum for a portrait, would have set a

THE PROVENANCE

➤ bought by Robert, the 2nd Earl of Grosvenor (and later the Marquis of Westminster).

The painting stayed in the Westminster collection until 1921, when it was bought by the American railroad magnate Henry E. Huntington for $728,000. Before being shipped to the United States,

THE MUSEUM

➤ in 1927. The Art Collections are housed in three separate buildings. Of these, it is the Huntington Gallery, originally Huntington's home, that contains Gainsborough's *The Blue*

Boy. Other popular paintings at the Huntington include Gilbert Stuart's *George Washington*, Joshua Reynolds' *Mrs. Siddons as the Tragic Muse*, and Mary Cassatt's *Breakfast in Bed*.

The holdings of the library include a Gutenberg Bible and a manuscript of Geoffrey Chaucer's *Canterbury Tales*. The Botanical Gardens cover 130 acres and were created by Huntington himself. ❑

THE BLUE BOY BY THOMAS GAINSBOROUGH

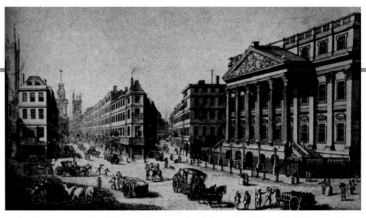

This street scene by Thomas Bowles depicts a bustling mid-18th-century London. Gainsborough first lived in the city while training to be an artist.

THE ARTIST

Thomas Gainsborough, self-portrait in 1787, a year before his death.

Thomas Gainsborough's *The Blue Boy* is probably the most popular painting ever to come out of England. Much reproduced on chocolate boxes, playing cards, cocktail napkins, crockery, glassware, ashtrays, and in all kinds of advertising, it both encourages and survives its celebrity.

Gainsborough was one of a formidable group of painters who revolutionized 18th-century English art. Before them, the English had usually patronized other European artists; in 1632, for example, to upgrade his image, Charles I imported the Flemish master Anthony Van Dyck to paint his and his family's portraits. But by the 1700s London had its own painters who served a robust middle class and their growing demand for luxury goods. By the end of the century, Britain could lay claim to a national school of painting.

Gainsborough was born in 1727 to an established merchant family in the small town of Sudbury, 50 miles northeast of London. His father, though not born a gentleman, often dressed like one. As a boy, Gainsborough sketched in Sudbury's fields ➤

THE TECHNIQUE

Gainsborough probably painted *The Blue Boy* around 1770, during his time in Bath. He was already wealthy, but the idea of London must have been in his mind—he and his family moved there four years later—and he knew that to prosper there he would have to deploy a more sophisticated style. The obvious model was Anthony Van Dyck, the Flemish artist who had lived in England in the 1630s, establishing a benchmark for English painting to match. Gainsborough decided to make a deliberate study of the Antwerp master. Visiting houses in the neighborhood of Bath that contained Van Dycks, he sketched the works and even painted copies of them.

In his finished work, Gainsborough rarely imitated preexisting paintings by others. But *The Blue Boy* appears to be modeled on Van Dyck's *George and Francis Villiers*. The painting combines ele- ➤

An x-ray photo reveals a mysterious portrait under *The Blue Boy*.

THE SUBJECT

Gainsborough didn't much like doing portraits; he didn't like having to flatter a subject in oils, though the subject was, after all, a paying customer. When painting a lady, he used to say, he'd begin by ignoring her: he'd draw the most beautiful creature he could conjure from his imagination, then work this image around to a place where the sitter could see a resemblance, at which point the portrait was declared done.

The Blue Boy presents a different case. The boy in question is thought to be one Jonathan Buttall, the son of an affluent London ironmonger who was a personal friend of the artist. Whether or not the senior Buttall commissioned *The Blue Boy*— ➤

THE PROVENANCE

The subject of *The Blue Boy*—the ironmonger's son, Jonathan Buttall—inherited his father's iron business and property, including the Gainsborough. He ran into financial difficulty in the 1790s, and his possessions were sold at auction. *The Blue Boy* passed through several owners before it was ➤

THE MUSEUM THE HUNTINGTON ART COLLECTIONS

The Huntington Art Collections are located at 1151 Oxford Road in San Marino, California. They are part of an institution that includes the Huntington Library and Botanical Gardens, which are on the same 207-acre property. The institution was founded in 1919 by the railroad businessman Henry E. Huntington, who bequeathed it his large collection of books and art on his death ➤

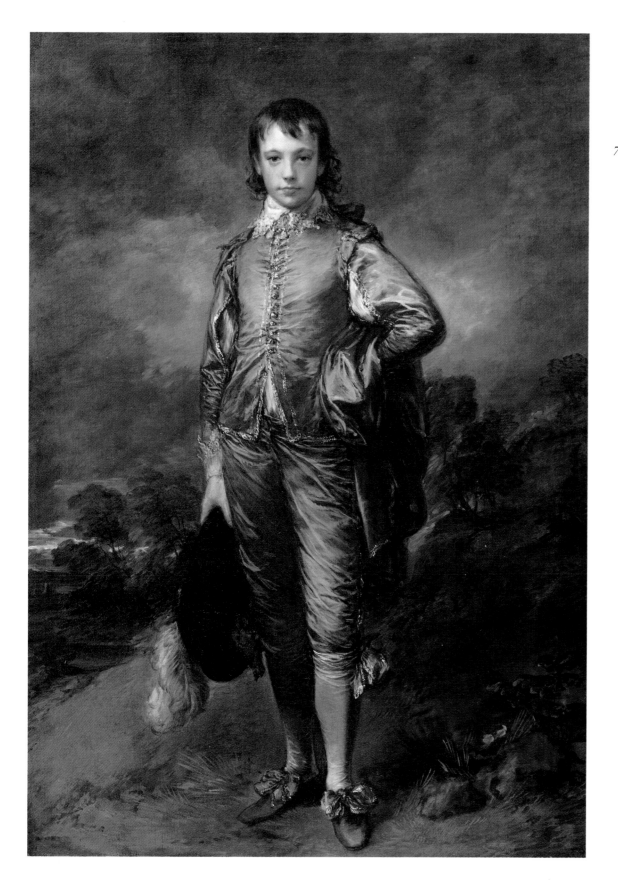

the work, Rembrandt's career took a downturn—perhaps in part because of Holland's factionalized political and religious life in those years, but clients also found the artist difficult. Said to have been "a most temperamental man," inclined to "disparage everyone," he had a reputation for avarice: there is a story that his students would paint coins on the floor to trick him into trying to pick them up. In 1656 he was forced to liquidate his property to save himself from bankruptcy.

Rembrandt created a remarkable autobiography out of self-portraits, of which he made over 30. There is a critical game of following his moods through these paintings; the late ones are sad. Rembrandt's reputation endured, particularly abroad; but sometime in the late 1660s he is said to have had to break open his daughter's moneybox to eat.

He died in 1669 at age 63 and was buried at a church called the Westerkerk. Both Titus and Hendrickje had died before him, and were buried in the same place, where they all joined Saskia. Originally buried elsewhere, her body had been moved to the Westerkerk when Rembrandt sold her tomb. ❑

ample, loosely bunched sleeves of Aristotle's shirt. (Painters of many periods have seen the drapes of cloth as opportunities for *tour de force* advertisements of skill.) Even the dark background, though, is discreetly various, suggesting how the light on the figure reflects faintly back into the shadows without penetrating them.

This backdrop must be a curtain—we can tell by the way it cuts off the alcove on the left, where Aristotle keeps his books. Though Rembrandt captures every drift and puff of fabric in the philosopher's shirt, the curtain hangs smooth. Rembrandt wanted the viewer's eye to focus on the subject without distraction. To leave the backdrop unmodulated, however, would have set the figure adrift in an indefinable space. The books anchor the space, making it specific. But their presence is quiet—they leave the philosopher's authority alone. ❑

be troubled by a photograph of a nuclear explosion?

That would be a very modern reading. If Aristotle weren't proud of Alexander's feats, he likely wouldn't wear his medal. Nevertheless, as a father of philosophy contemplates a father of poetry over the tiny head of a father of military and political action, the viewer may well ponder the values of the different human spheres. Don Ruffo himself, a man with deep interests in philosophy and the arts, was also an active politician. ❑

A Trio for Don Ruffo

A Greek bust of Homer. Rembrandt probably owned a similar copy in plaster.

Rembrandt sent patron Don Ruffo in Messina the Aristotle painting in 1654. Don Ruffo loved it so much that it posed a problem: what to hang alongside it? The only solution: more Rembrandts.

In 1661 another Rembrandt arrived in Messina—an Alexander. The painting had been enlarged by tailoring together four pieces of canvas and painting over the seams. Rembrandt claimed that if the work were properly lit, the seams would be invisible. Don Ruffo was not amused. Rembrandt redid the painting—billing his client for the cost.

In 1663 Rembrandt sent Don Ruffo a painting of Homer. The stone head and gold medal in *Aristotle* now had painted counterparts.

Alexander the Great, detail, dated 1655. Some scholars believe this may have been the first version sent to Messina.

Metropolitan Museum of Art in New York City in 1961, for the then-record price of $2.3 million. The work drew historic crowds; on weekends, the lines waiting to see it extended out of the museum onto Fifth Avenue. ❑

shops, apprenticeships, and fellowships are available, as well as reference library services. ❑

ARISTOTLE WITH A BUST OF HOMER

➤ hat is inscribed, "After my wife, when she was twenty-one years old, the third day of our betrothal, the 8th of June 1633." The woman was Saskia van Uylenburgh, a cousin of Rembrandt's agent and landlord. A legal document of 1638 finds him boasting that he and Saskia are "blessed richly and ex superabundanti with wealth," adding parenthetically, "(for which they can never be sufficiently grateful to the Almighty)."

Saskia had four children—all but one, Titus, dying in infancy. She herself died in June of 1642, probably of tuberculosis. A

Portrait of Rembrandt's new wife, *Saskia in a Straw Hat*, 1633. After her death, Rembrandt sold her tomb to pay his debts.

widow called Geertghe Dircx, who had been hired as Titus' nurse, eventually became Rembrandt's mistress, and he gave her some of Saskia's jewelry—which Saskia, in her will, had left jointly to him and to Titus. Geertghe claimed Rembrandt also promised to marry her. By 1649, however, he had replaced her with a younger woman, Hendrickje Stoffels—they would later have a daughter—and Geertghe had

sued for breach of promise. A court ordered Rembrandt to support her. Unfortunately for

Geertghe, the settlement involved an agreement that she bequeath Saskia's jewelry back to Titus. When she began to pawn the jewelry, Rembrandt moved to have her jailed—and won.

In 1642 Rembrandt had finished *The Night Watch*, perhaps his best-known painting—a panoramic portrait of a company of civil guards. (The canvas darkened over the years; cleaning has revealed that it is not a night scene at all.) Each of the 16 guards shown had paid Rembrandt 100 or so guilders each, depending on his prominence in the picture. Soon after finishing

The Night W[atch] Captain F[...] Cocq or[...] tenant [...] company o[...] By the tim[...] guards c[...] the portra[...] no wa[...] their duti[...] ceremonial[...] Rembrandt[...] success in[...]

THE TECHNIQUE

➤ ness—the long apron, which supports the head like a column, and the wide hat are seemingly magnifications of the obscurity around them. Light also touches the sleeves of Aristotle's shirt, and, more gently, the bust of Homer. To build a painting from the play and contrast less of color than of light and dark is the technique known as *chiaroscuro*. The 16th-century Italian painter Caravaggio was its first master; Rembrandt was certainly his equal.

Color, in fact, is fairly restricted in *Aristotle*. Besides the velvet blacks, it is almost entirely browns and yellows. But those are compound and subtly diverse. Unlike many earlier painters, Rembrandt disliked relatively flat fields of color; his brush was constantly mixing and remixing paints on the palette, so that what seems consistent is in fact a complex blend. This is clearest in the

THE SUBJECT

➤ pher's gold chain bears the profile of the great Macedonian general Alexander. Aristotle had been Alexander's tutor and had taught him Homer. Moreover, in the *Poetics*, Aristotle had said he admired Homer above all poets.

Rembrandt, then, was bringing together three men connected in history.

Alexander admired Homer too: he thought the *Iliad* a bible of military how-to and is said to have slept with a copy of it under his pillow, next to his dagger. Sensing the poet's mind

through his hand on the bust, Aristotle is full of thought. Does the philosopher regret the destruction he has unleashed on the world through his student—as Einstein might

A detail of the left shirt sleeve in A[...] shows how Rembrandt blended pa[...] suggest light striking folds of cloth[...]

THE PROVENANCE

➤ Most of Don Ruffo's collection stayed together until the 18th century. *Aristotle with a Bust of Homer* was

probably sold in Naples sometime before 1815 and passed through the hands of several British aristocrats before being bought

by the American dealer Joseph Duveen in 1907. It eventually reached the

THE MUSEUM

➤ Highlights include paintings by Vermeer, Franz Hals, and Rembrandt, the French Impressionists and Post-Impressionists, as well as art and artifacts from classical Greece and Rome and from ancient Egypt. In fact, the

Metropolitan has over 50,000 Egyptian works—more than any museum outside Cairo—and houses the Temple of Dendur, an Egyptian monument from the 1st century B.C.

Among the many famous

paintings in the museum are Jacques Louis David's *The Death of Socrates*, Emanuel Leutz's *Washington Crossing the Delaware*, Gilbert Stuart's *George Washington*, John Singer Sargent's *Madame X*, and El Greco's

View of Toledo.

Over 30 special exhibitions are staged each year. Three highly popular exhibitions in the past were Treasures of Tutankamun, The Vatican Collections, and Van Gogh in Arles. Lectures, work-

ARISTOTLE WITH A BUST OF HOMER BY REMBRANDT HARMENSZ VAN RIJN

THE ARTIST

Rembrandt Harmensz van Rijn in one of over 30 self-portraits, 1659.

Aristotle with a Bust of Homer is a great Rembrandt, epitomizing what is loved in so many of his paintings—their dramatic restraint, the melancholy treatment of light and shade, and, above all, their appearance of thoughtfulness, compassion, and noble introspection. For many years it was assumed that these virtues had to be the painter's own. Unfortunately, recent scholarship casts Rembrandt as close to a scoundrel.

Born in 1606 in Leiden, Holland, the son of a prosperous miller, Rembrandt Harmensz van Rijn went to a good school,

then, briefly, to Leiden University. He spent the early 1620s as an artist's apprentice; by 1625 he was a professional painter.

Beginning around 1627–28, the Dutch Prince Frederik Hendrik commissioned several works from Rembrandt. In 1631 Rembrandt moved to the larger city of Amsterdam. The following year he painted

Dr. Tulp's Anatomy Lesson, 1632. A rapt audience of city officials watches as the doctor dissects an executed criminal.

Dr. Tulp's Anatomy Lesson, a portrait of a well-known surgeon (also the city treasurer) and other local dignitaries. The work won Rembrandt many portrait commissions.

A beautiful Rembrandt drawing of a woman in a straw ➤

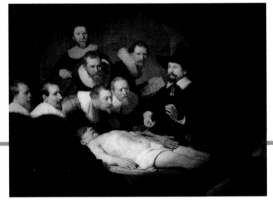

THE TECHNIQUE

Rembrandt's early work is in a sense iconoclastic—he broke with the pictorial codes of his day. When he did an etching of Diana, the classical goddess of the hunt, he gave her fleshy legs that showed the marks

Diana at Her Bath, 1630–31. This early etching challenged classical ideals. In it, Rembrandt rendered the Roman goddess of the hunt middle-aged, coarse, and overweight.

of her garters. By the time of *Aristotle with a Bust of Homer*, however, he had perfected a grand manner, a solemnity of mood, of which this painting is a particularly fine example.

Much of the work is in shadow, the frame for a softly glowing core. Light falls on the philosopher's face, which is encased in dark- ➤

THE SUBJECT

Some time around 1652, Don Antonio Ruffo of Messina, Sicily—a wealthy and sophisticated patron of the arts—commissioned a painting from Rembrandt. Perhaps he said he wanted a picture of a philosopher; the correspondence has been lost. But it was in any case Rembrandt who chose Aristotle. When

Don Ruffo received the picture, in fact, he didn't know who it showed, writing, "It seems to be an Aristotle or an Albertus Magnus."

Actually, Rembrandt had given

Ruffo three classical figures for the price of one. Aristotle rests his hand on a bust of the poet Homer. (Rembrandt is thought to have owned a copy of an ancient bust of Homer.) Furthermore, the medallion on the philoso- ➤

THE PROVENANCE

Before he died in 1681, Don Ruffo stated in his will that 100 favorite paintings from his collection be kept together and passed on to

each succeeding eldest son. *Aristotle with a Bust of Homer* was among the paintings in this special collection. As bad luck would have

it, each of Ruffo's sons was taken by the plague in 1743, and the collection passed to another branch of the family. ➤

THE MUSEUM THE METROPOLITAN MUSEUM OF ART

The Metropolitan Museum of Art is located in Central Park at 82nd Street and Fifth Avenue in New York City. It ranks among the world's largest and most prestigious art institutions.

The museum was founded in

1870 and moved to its present site in 1880. The original Gothic-Revival building is now surrounded by additions, making the complex over a million square feet large. The building's present Italian Renaissance facade, fin-

ished in 1926, took more than 25 years to complete; it was designed by the famous New York firm of McKim, Mead, and White, which also designed the Brooklyn Museum of Art.

The museum's founders

were a group of artists, businessmen, and financiers, who started with a collection of 174 European paintings. Today the museum holds over two million works that span 5,000 years of human history and civilization. ➤

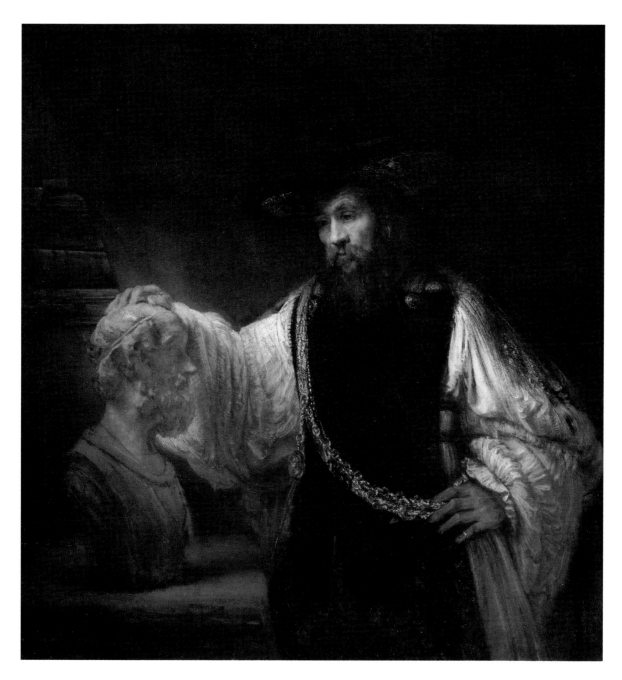

"all control exercised by reason" and "all aesthetic or moral preoccupations." In 1927 Magritte and Georgette moved to Paris to meet the Surrealists—Breton, Joan Miró, Salvador Dalí, and the rest. This period ended when Georgette wore a crucifix to dinner with Breton, who wouldn't tolerate a competing religion.

In 1930 the Magrittes were back in Brussels, where René opened an advertising design studio in a shed in his garden. Meanwhile he was still painting and gradually grew successful. By the mid '30s he was able to give up advertising;

by the decade's end his work had shown in cities all over the world.

He had the "nice steady bourgeois life" he had wanted, as quiet as his art was disturbing. When not working, he'd shop for groceries, play chess, and take Georgette and a succession of pet Pomeranians to the movies. To paint, he'd stand his easel in a corner of his dining room. And he'd wear a suit and tie.

Magritte joined the Belgian Communist Party three times—and left it three times. He was not essentially a political artist. During World War II, though, when he was briefly a refugee in Vichy France, the horror of the

La Clairvoyance, a self-portrait. One of Magritte's artistic quirks was wearing a formal suit and tie while he painted at his easel.

war temporarily changed the direction of his work. He wrote Breton, "This sense of chaos, of panic, which Surrealism hoped to foster so that everything might be called into question was achieved much more successfully by those idiots the Nazis....I now propose a search for joy and pleasure." But cheerfulness didn't come naturally to Magritte, who eventually returned to his enigmas.

By the 1950s and '60s Magritte was internationally famous.

In 1953 alone he exhibited in six European and American cities; the following year, he represented Belgium at the Venice Biennale. Magritte died in Brussels in 1967. Surreally, a Brussels street is named after him—in a neighborhood where he never lived. ❏

...woman on ...ly hidden by ...n front of ...painting, ...e's life, is a ...e that occu-...t his career: ...e woman.

rally pure eggshell blue, and shades of gray—a more limited range than is usually available to the eye. But suppose we did find ourselves on a rocky shore like this one, in weather like this: wouldn't we see

His mother's death may have marked him in another way: the raison d'être of his painting, he said, was mystery. He believed that "all beings are mysterious," and that "the world is a defiance of common sense."

In a classic early Magritte,

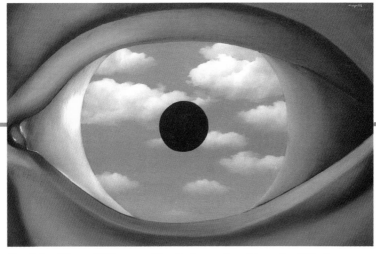

The False Mirror, 1928—an enigmatic face reduced to a cloud-filled eye.

these colors? Except for the obvious unrealities of figures, ship, and rock—that is, except for everything—*The Wonders of Nature* could be a postcard from a seaside resort. ❏

The Lovers, 1928, a man and woman kiss, but their heads are encased in cloth. In *The Wonders of Nature* Magritte replaces his lovers' faces altogether—with the faces of fish, which, unlike mothers, can breathe underwater. ❏

The work passed from the artist to a New York City gallery, probably soon after it was painted. It was bought by Chicago attorney and collector Joseph R. Shapiro, who co-founded the Museum of Contemporary Art, Chicago; he donated *The Wonders of Nature* to the museum in 1982. A version of the painting appears as a mural at the Casino Communal in Le-Zoute, Belgium. ❏

Nature, popular paintings at the museum include Leon Golub's *Reclining Youth*, Andy Warhol's *Troy Donahue*, Ed Paschke's *Adria*, and Francis Bacon's *Study for a Portrait*. ❏

THE WONDERS OF NATURE

THE ARTIST

rest of his schoolwork was 27 percent. Art was clearly the career of choice. Several years later, after studying at the Academie Royale des Beaux-Arts in Brussels, Magritte began exploring the painting of the time—Futurism, Cubism, abstraction. In the end he decided that a work of "purely formal pictorial effects" was "not worth

Magritte and his mother, ca. 1899.

looking at." Neither was he attracted to the "expression of feelings," as in the emotionality of German and Flemish Expressionism. Caught between unacceptable options, his work took several years to mature.

In 1920 in Brussels, Magritte bumped into a young woman he had known in his early teens, Georgette Berger. A year later he was telling a friend of his desire "to make Georgette as happy as possible...in the calm of a nice steady bourgeois life." In 1922 he and Georgette married. To support himself, Magritte took a job designing wallpaper.

Love Song by Giorgio de Chirico helped Magritte to find his mature style.

A few years later, Magritte saw a reproduction of Giorgio de Chirico's *Love Song*, 1913, an unlikely streetscape including a classical bust, a rubber glove, and a green ball, devices that would soon appear in his own work. Now he was inspired "to paint objects with all the details they show us in reality"—not through abstraction and stylization, in other words,

but matter of factly. That way he would reveal their true strangeness.

About this time Magritte also began a long association with Surrealism. The principal, Paris-based coven of Surrealist artists was run by André Breton like a church, complete with heretics, excommunications, and a pope (himself). It was Breton who had codified Surrealist art, proposing it exclude

THE TECHNIQUE

to the two impossible figures on their rock bench; a middle ground made of blue water, including the sailing ship that doesn't so much float on water as extend it into the sky; and the sky itself, equally blue, filled with puffy white clouds. Other Surrealist painting, like that of Dalí or Miró, is full of strange physical distortions and hauntingly indeterminate spaces. Magritte, though, proceeds literally. The outlines are clear and firm, the arrangement direct and frontal. If

human/piscine creatures made of stone existed, this is what they would look like.

The sense of depth is odd, though, or perhaps just claustrophobic. The two figures are very close to the picture plane, and between them, the ship, and the clouds we can't see very far into the space. The palette, too, is a little queasy, because it is abnormal in its restriction to white, an unnatu-

THE SUBJECT

For other Surrealists, however, the point of their impossible juxtapositions was to bypass the rational mind. Magritte's Surrealism, though, was supremely rational. The contradictions in *The Wonders of Nature* are as carefully plotted as a map: we have air-breathing fish, cold-blooded lovers, animate stone, a boat of water.

There is a human background to Magritte's philosophical short circuits, however, that he scarcely discussed. His mother had commit-

ted suicide by drowning. When her body was found, her nightdress was rumored to have floated up around her head, hiding her face. The story may have been a fiction, or a fantasy, but it entered Magritte's imagination deeply. He was obsessed by the hidden, and several times painted women with their faces hidden by cloth. One of these pictures, from 1928, he significantly called *The Central Story*. Elsewhere he painted faces otherwise obscured—by a floating apple, say—or completely absent.

Free Hand, 1 horseback is trees that ar and behind h from late in F variation on a pied him thre the hidden o

THE PROVENANCE

painting was called *Song of Love*. However, early documentation has been uncovered about a painting entitled *The Wonders of Nature* with the same

dimensions and described as showing "petrified mermaids"—suggesting the work has been long misnamed. The aura of mystery is very Magritte.

THE MUSEUM

den were designed by German architect Josef Paul Kleihues.

The museum's permanent collection provides a survey of

continuing developments in contemporary art. In addition to painting, sculpture, drawings, and photography, the museum collec-

tion includes conceptual art, performance art, film, video, and audio works.

Besides *The Wonders of*

Josef Paul Kleihues' design for the new museum building.

THE WONDERS OF NATURE BY RENÉ MAGRITTE

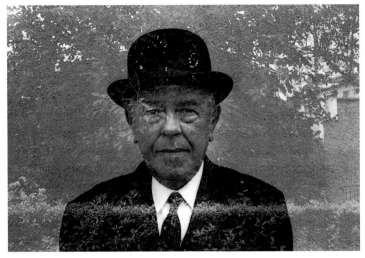

René Magritte by Duane Michals, 1965.

René Magritte produced some of the most disorienting paintings of the disorienting 20th century. Yet far from alienating us, he has thoroughly colonized our imaginations. The advertising industry, for instance, which bombards us with images daily, is steeped in Magritte, whom it visually quotes to publicize everything from televisions and typewriters to calculators, cars, and cosmetics. Even when not borrowed directly, his work exerts vast influence.

Magritte was born in 1898 in Lessines, Belgium; his father was a merchant. As a child he sometimes played in an abandoned cemetery, exploring the underground vaults; climbing back into the light one day, among broken columns and dry leaves, he came across "a painter …who seemed to me to be performing magic." The meeting inspired his desire to be an artist.

If magical, the graveyard experience was also morbid—as was a later, more terrible event. In 1912, when Magritte was 14, his mother committed suicide by drowning herself in the river Sambre. Echoes of her death appear in many of his paintings.

At the time, Magritte was attending school at the Lycée Athenée; his grade in art class was 85 percent. His average for the ➤

THE TECHNIQUE

Magritte's art is enigmatic, mysterious, impossible, but he spoke and wrote about it often, and his remarks are illuminating. Here's one of them: "To the extent that my pictures have any value, they do not lend themselves to analysis." Warned, the viewer proceeds.

As a friend of Magritte's once declared, "Magritte is a great painter, Magritte is not a painter." Though Magritte painted with great skill, painting as such didn't excite him; he had no interest in the sensuous, intricate pleasures of how paint can lie on canvas. "I always try to make sure that the actual painting isn't noticed, that it is as little visible as possible," he said once. And he compared his work to the kind of writing that has "the simplest tone," the fewest tricks of style, "so that the only thing the reader is able to see…is the idea."

The viewer looks, then, at the image, not at the quality of its making, and, in *The Wonders of Nature*, sees: a foreground completely made of rock, down ➤

THE SUBJECT

The Surrealists relished a line from the poet Le Comte de Lautréamont: "As beautiful…as the chance encounter of a sewing machine and an umbrella on a dissecting table." Sewing machines, umbrellas, and dissecting tables usually have no reason to come together; the combination has no logic. Thus Magritte couples disconnected objects such as, in the famous *Time Transfixed*, 1938, the steam train that emerges from a fireplace. The fish's heads with human legs and trunks in *The Wonders of Nature* are equally startling. Magritte's childhood experience of painting as magical would stay with him; his images make things happen that could not. (A self-portrait of 1951 is titled *The Magician*.) ➤

THE PROVENANCE

Recent research shows that *The Wonders of Nature* was probably painted in 1953, the same year that it was shown in Brussels as part of an exhibition on mermaids in art. There is some question about the exact date; in the past it has been variously dated anywhere from 1948 to 1954. For decades the ➤

THE MUSEUM MUSEUM OF CONTEMPORARY ART, CHICAGO

The Museum of Contemporary Art, Chicago, opened at 237 East Ontario Street in 1967. Founded by a group of Chicago area art enthusiasts, it was the first contemporary art museum in the Midwest. The popularity of the museum led to an expansion in 1979, and it will move to an even larger facility at 234 East Chicago Avenue in 1996. The newest building and its sculpture gar- ➤

Time Transfixed shows Magritte's love for illogical combinations.

THE WONDERS OF NATURE
by René Magritte, 1953
oil on canvas
30½ x 38⅝ in. (77.5 x 98.1 cm.)
Gift of Joseph and Jory Shapiro
Museum of Contemporary Art
Chicago, Illinois

ture, and a few clams I dug out of the bay with my toes."

In 1947, however, Pollock had begun producing his signature works: large canvases covered with swirling skeins of paint dripped and poured on them as they lay on the floor. In August 1949 these paintings would lead *Life* magazine to ask in a famous article, "Jackson Pollock: Is He the Greatest Living Painter in the United States?" (A few months before, the same magazine had called one of these works "a pleasant design for a necktie.") Meanwhile, Pollock had temporarily managed to quit drinking. He was at his peak.

Yet he never shook his terrors. The teenage Pollock had written, "People have always frightened and bored me consequently I have been within my own shell." By and large, he never outgrew his inarticulate silences—except when drunk. Yet as Krasner said, "If he thought of something he'd just go ahead and do it"—things like punching his fist through windows and overturning supper-laden dining tables. A poetic friend described Pollock as a "dog running outside the world."

In 1950 Pollock agreed to appear in a documentary film by Hans Namuth, who had made an extraordinary series of photographs of him at work. The moment the three-month shoot ended, Pollock opened a bottle of bourbon. A friend saw the filming as deeply destructive: Pollock's work had depended on spontaneous, instinctive gestures, which the camera had ruined for him by making him perform them self-consciously. Pollock himself said he thought there was something to the Native American idea that to photograph a man is to steal his soul.

Pollock's paintings of 1951–52 depart from those of his best-known period: many are in black and white and, more controversially, return to figurative imagery. In 1953 Pollock hadn't produced enough new works for a show. He worked little in subsequent years and talked regularly of suicide. He died in 1956 in a car crash, drunk at the wheel. ❑

1953.
painting,
s a vision
s "not

what he saw as the unconscious operating force in his work to myth and the collective mind of all mankind.

Some of Pollock's contemporaries understood this. To others, he was "Jack the Dripper"—an artist whose paintings weren't worthy of the name. Pollock himself knew he had crossed some categorical divide. Looking at *Lavender Mist*, 1950, a work now considered canonical, he once asked Krasner not a predictable artist's question—"D'you think this painting's a good one," for example—but something more poignant: "Is this a painting?" ❑

what his work expressed, Pollock once replied, "My times and my relation to them." He also wrote of wanting to depict the "experience of our age in terms of painting—not an illustration of—(but *the equivalent*.)" Pollock wanted his art to *be* experience, not a description of it. The engulfing yet mysteriously ordered universe of paintings like *No. 1*, then, may support the most cosmic readings. It's also entirely personal. As Pollock said, "Every good artist paints what he is." ❑

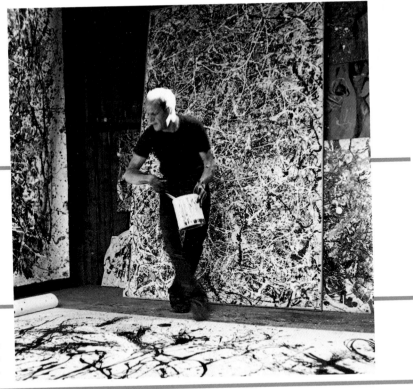

In this 1950 Hans Namuth photograph, Pollock moves around a canvas in a dance, flinging paint as he goes. He would title the painting *Autumn Rhythm*.

"People have always frightened and bored me consequently I have been within my own shell."

dance, video, music, and sound.

Special exhibitions are mounted continuously. Among the special exhibitions have been a video installation showing clown characters and a mixed media installation using live participants to explore contemporary issues such as women's choice and sexual identity. ❑

MUSEUM HOURS
Tuesday, Wednesday,
Friday–Sunday: 11 a.m. to 5 p.m.
Thursday: 11 a.m. to 8 p.m.

ADMISSION
Admission charged.
Free to museum members and children under 12.

NO. 1

THE ARTIST

➤ didn't help. Depression unto despair would always grieve Pollock, along with another teenage trial, liquor. A spectacular drunk, he was to one later friend "an alcoholic *in excelsis*." To another, he seemed to have spent his life looking into a driving rain.

In 1930 Pollock followed Charles to art school in New York City. When he quit the school in 1933 he found no work except janitorial jobs and had so little money that he sometimes stole food. His paintings of this period were mostly in the then-popular Regionalist style of artists like Thomas Hart Benton, with whom Pollock studied for a time. Pollock also worked briefly with the Mexican artist David Alfaro Siqueiros, who sometimes laid panels on the floor and poured, flicked, or threw paint on them. For Siqueiros, though, these techniques were incidental; for Pollock they would later be vital.

In 1938 Pollock's alcoholism temporarily put him in the hospital. The following year he began a Jungian psychoanalysis. He would pursue various therapies and psychotherapies on and off until his death.

Early in 1942 Pollock exhibited in a group show alongside the painter Lee Krasner. The two soon moved in together. Krasner was, simply, more functional than Pollock; she had wider art-world connections and a better technical understanding of modern art. Pollock's relationship with her nourished both his ideas and his career. In late 1945 the couple married and moved to rural Long Island. They had no money: as late as 1948 Pollock had to pay a food bill with a painting. (The storekeeper may have accepted it more out of kindliness than faith in its value). That year Pollock sold one work and would remember, "We lived a year on that pic-

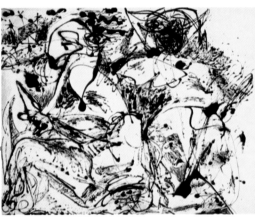

Portrait and
Pollock desc
his last self-
of himself w
sober."

THE TECHNIQUE

➤ paint into the picture without touching it. This apparent surrender of control was paradoxically quite deliberate. It was even a logical outgrowth of his post-Regionalist work, which reflected his interest in modern art and his search for art's origins in the unconscious. Pollock vastly respected Pablo Picasso, once challenging someone who had criticized one of Picasso's works to "step outside and fight it out." He also admired the Surrealists and the Mexican muralists Siqueiros and Diego Rivera. Many of his paintings are also inspired by mythology and neolithic, African, and Native American art. He was looking for ways to escape the confines of Western history.

The drip paintings did that. Radically new, they honored no tradition but the modern one of aesthetic innovation. Most important, they sidestepped conscious plan. "When I am in my painting, I'm not aware of what I'm doing," Pollock said. A self-described Jungian, he would have related

THE SUBJECT

➤ senberg wrote, "At a certain moment the canvas began to appear to one American painter after another as an arena in which to act— rather than as a space in which to reproduce, re-design, analyze, or 'express' an object, actual or imagined. What was to go on the canvas was not a picture but an event....The spectator has to think in a vocabulary of action: its inception, duration, direction—psychic state." Pollock himself said something like this in a note, "*No*

Sketches. acceptance of *what I do*—." Another note describes his works as "energy and motion made visible." In a sense, the subject of a painting like *No. 1* is the dance Pollock has done to make it—and everything that action implies about him.

And perhaps about everything else. Asked

THE PROVENANCE

➤ Sidney Janis Gallery in New York. It was bought by Mr. and Mrs. Arthur Cinadar of New Jersey who at some point sold it to Rita and Taft Schreiber of Beverly Hills. In 1989 Mrs. Schreiber donated the painting to the Museum of Contemporary Art in Los Angeles in memory of her late husband. ❏

THE MUSEUM

➤ Central Avenue is a renovated warehouse designed by architect Frank Gehry.

Examples of Abstract Expressionism and Pop art form the foundation of the museum's permanent collection, which includes works by Pollock, Andy Warhol, Joan Miró, Mark Rothko, and Roy Lichtenstein. In addition to paintings, sculpture, prints, drawings, and photographs, the museum features other contemporary art forms such as combinations of painting, theater,

NO. 1 BY JACKSON POLLOCK

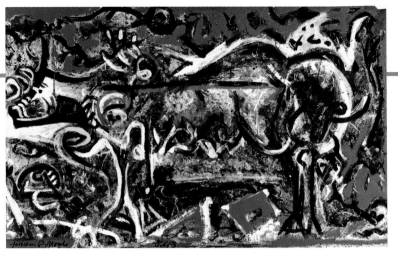

Pollock painted *The She-Wolf*, 1943, after a visit from his mother. This early painting begins to loosen the bonds between shape and subject matter.

THE ARTIST

"Jackson broke the ice": so admitted Jackson Pollock's main competitor in the Abstract Expressionist generation of painters, Willem de Kooning. In the late '40s and '50s it gradually became clear that these artists had changed American art forever.

And even de Kooning, a heavyweight among heavyweights, acknowledged that it was Pollock's radical abstractions that had led the way.

Born in 1912 in Wyoming, the fifth son of a small farmer, Pollock grew up in Arizona, northern California, and the Los Angeles area. When he was 11, his eldest brother, Charles, who had left home to study

Jackson Pollock near the end of his life.

painting, sent him some art magazines. Reading them, Jackson later wrote Charles, he decided that "being a artist is life its self."

Perhaps Pollock wanted to escape a miserable adolescence: "youth to me," he wrote, "is a bit of damnable hell." But art ➤

THE TECHNIQUE

For works like *No. 1*, Pollock began, in his own account, by discarding the easel convention: "I prefer to tack the unstretched canvas to the hard wall or the floor." The reason: "this way I can walk around it, work from the four sides and literally be in the painting." Finally, "I continue to get further away from the usual painter's tools such as easel, palette, brushes, etc. I prefer sticks, trowels, knives and dripping fluid paint."

What this meant, as Namuth's photos document, was a remarkable jazzlike dance—balletic, dramatic, and muscular—improvised by painter and pigment around and across the horizontal canvas. Holding a paint can in one hand and a stick or similar tool in the other, Pollock would drop and spatter ➤

THE SUBJECT

Works like *No. 1* are difficult for some viewers because they contain no distinction between figure and ground and because the paint often overruns the picture's edges as if it wanted to keep going forever. The work shuns painting's usual appearance of choice—the sense that the artist has picked or invented a motif for us to

focus on. For many, in brief, Pollock's work is chaotic. But he reacted angrily to this criticism, and paintings like *No. 1* are hardly haphazard. It is a tight organic network, the colors spread equally over the canvas, the looping lines always leading on and around, never coagulating. It's also a record of Pol-

lock's body, the obvious result of his physical movement.

In a celebrated discussion of Abstract Expressionism, the critic Harold Ro-➤

THE PROVENANCE

Pollock painted *No. 1* in 1949 when he was at the height of his career and experiencing a rare period of sobriety. He had begun numbering his paintings a year earlier and each year he would begin a new set of

numbers; thus there are several Pollock paintings with the same numbered titles from different years.

After completing the painting, Pollock consigned it to the ➤

THE MUSEUM THE MUSEUM OF CONTEMPORARY ART, LOS ANGELES

The Museum of Contemporary Art was founded in 1979 and devotes its collections to works created since 1940. It is housed in two buildings in Los Angeles that

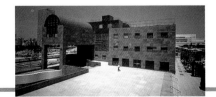

are about a mile apart.

The building at 250 South Grand Avenue at California Plaza was designed by one of Japan's greatest

architects, Arata Isozaki. It consists of barrel, cube, and pyramid shapes that are constructed of glass, aluminum, and sandstone. The building at 152 North ➤

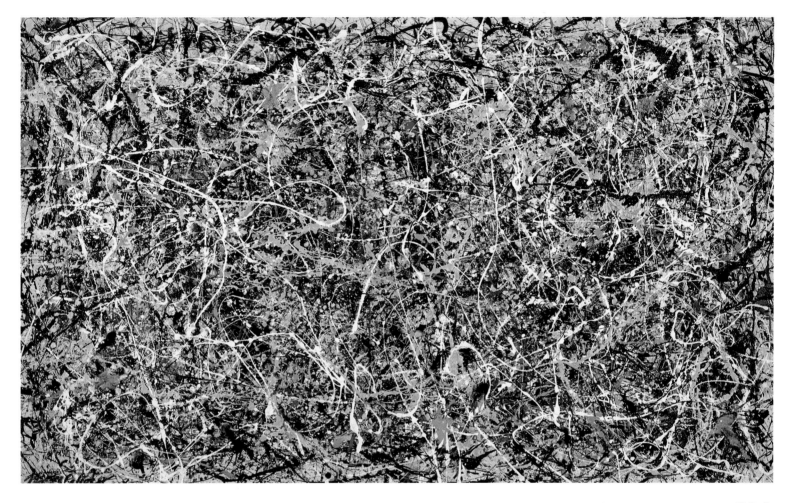

NO. 1
by Jackson Pollock, 1949
Enamel and metallic paint on cotton fabric
63 x 102 in. (160 x 259.1 cm.)
The Rita and Taft Schreiber Collection
The Museum of Contemporary Art
Los Angeles, California

(..., left) ...in pre-...ag of the ...of events ...removal

leave for London. He was reunited with his family in October 1775.

The family resided in fashionable Leicester Square, opposite Reynolds. Copley was finally able to paint non-portrait subjects. In 1779 he was elected to the Royal Academy on the strength of *Watson and the Shark*, 1778, the work that made his English reputation.

Yet Copley was never as esteemed as he wished to be in London. He never, for example, won the patronage of the king; his single commission from George III was attacked in the press, and he never got another. In 1781 he unwisely timed an exhibition of his epic *Death of the Earl of Chatham* to compete with that year's Royal Academy show, cutting deeply into its audience (and into its receipts) and making money but also long-term enemies in the art world.

The Death of the Earl of Chatham, 1779–81, was based on an actual event: speaker William Pitt collapsed during a heated debate in the House of Lords in 1778.

In 1782 on hearing of Britain's withdrawal from America, Copley proudly worked the Stars and Stripes into a portrait he was painting. He often thought of going home, but in 1795 he sold his Boston farm on Beacon Hill; he then discovered that the area would be the site of the new State House. Late in life, Copley would often complain that a property he had sold for a few thousand pounds was now worth 100,000.

Copley's skills gradually deteriorated, and he grew quarrelsome and bitter. Because of his art-world feuds, another artist wrote, "Copley has done more injury to the arts and the character of artists than any man of his time." When he died in 1815 at the age of 77, he thought his American paintings, which he had once considered crude, better than the English style he had worked so hard to refine. ❑

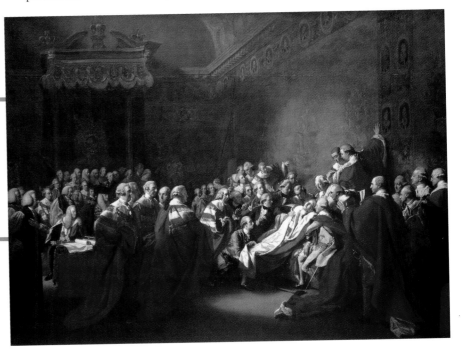

the boy's body and arm rising from lower left to right, then the line of the boat rising from center right to left, then the harbor line and sailing ship running into the picture's depth, parallel to the boy's body. Yet despite this careful unity, the construction suggests two worlds—a spot of terror, and competing light and darkness, within an evenly lit scene, which is oblivious to the matters of life and death it nonetheless contains. ❑

age Copley was when his kindly stepfather and teacher Peter Pelham died. Copley may not have been present for Watson's nightmarish ordeal, but his powerful treatment of it has real emotional weight. And on some metaphoric level the painting may stand for all the dangers and trials of facing trauma—the trials of growing up. ❑

tion it was auctioned in 1864 and bought by Charles Hook Appleton of Boston, who took it back to Copley's hometown. Little is known about Appleton, except that he left the canvas to his daughter, Mrs. George von Lengerke Meyer, who gave it to Boston's Museum of Fine Arts in 1889. The second, smaller copy of *Watson and the Shark* by Copley is in the Detroit Institute of Arts. ❑

Cassatt, and John Singer Sargent. Its European collection has more paintings by Impressionist Claude Monet than any other art institution outside of France.

The museum-affiliated art school at 230 The Fenway awards degrees in the fine arts. ❑

WATSON AND THE SHARK

THE ARTIST

> tion rather than a fortune." (Though he added, "If I could obtain the one while in the pursuit of the other, I confess I should [be]...far from being indiferent.") In 1766, then, Copley sent a portrait of his half-brother, Henry Pelham, to the important British painter Joshua Reynolds. Impressed, Reynolds felt that if Copley were exposed to Europe before his "little way at Boston" corrupted his taste, he could be "one of the first Painters in the World." But Copley wasn't ready to travel.

In the tense buildup to the American Revolution, Copley stayed neutral. His portrait sub-jects included both the British general Thomas Gage and radical colonial leaders like Paul Revere and John Hancock (who would flee discussions of the artist's bill with claims of a "violent head-ack"). In 1773 Copley was forced to negotiate between the factions in the Boston Tea Party. (His father-in-law—he had married in 1769—had imported the tea thrown into the harbor.) But after Copley entertained an English sympathizer, only to see a mob gather outside his house, he had to wonder what would have hap-pened if his visitor hadn't already left: "I must either have given up a friend to the insult of a Mob

or had my house pulled down and perhaps my family murthered."

Perhaps to scout prospects elsewhere, in June of 1774 Copley final-ly went to London, where he was pleased to find that "the practice of Paint-ing...is easier than I thought it had been." After a few weeks he moved on to Italy, visiting Rome, Florence, and other cities to study the old masters. While traveling, he heard of the Revolution's opening skirmishes at Lexington and Concord. He wrote to his wife, telling her to

Copley's portrait of silversmith Paul Revere, 1768–ca is among several that he painted of important color Revolutionary Boston. Revere's famous contempora Boston Massacre, 1770 (above, right), depicts the that would lead to the Revolutionary War—and the of Copley's family from Boston to London.

THE TECHNIQUE

> again in the wave above the boy's knee. That wave converges with the oar to the left and matches the undulating diagonal of the shark's body on the right to focus the eye on the central tableau.

Color and contrast are crucial to the picture's drama. The waters are a murky green, falling around the shark into a stygian black. More blackness on the picture's left frames the boy's very white body. In the boat, the men wear grays and browns, a muted palette highlighted by

areas of white and of sharp contrast—the dark brown coat and white shirt of the man with the boat hook, for example. Also, his and the black man's hard outlines are sharply contrasted against the sky.

That central pyramid, so full of action—anxious faces, straining arms, fluttering cloth—is the more vivid by contrast with the back-ground, a flat horizon and calm sky broken by stubby spires and motionless masts. A vector of zigzags leads us into the background—

THE SUBJECT

Brook Watson with his walking cane and peg leg in a satirical 1803 etching by Robert Dighton.

> may show tragic events—wars, the deaths of great men—but they are meant to be ennobling and cathartic; few are as sus-penseful and

as disturbing as this one. As a boy, Copley had lived on Long Wharf, a quay sticking nearly half a mile into Boston Harbor, surrounded by water and boats. He is said to have hated living there; in fact, he is said to have hated the sea and to have

feared it. The story of Watson's shark attack may have given him some particular shudder. Also, when Watson was bitten—notice Copley's ambiguous rendering of the boy's right leg, which might almost just be obscured in the dark water—he was about the

THE PROVENANCE

> collection and was bequeathed by him to a hospital in the south of England. That painting is now in the National Gallery of Art in Washington, D.C. But Copley painted at

least two copies, of which this is one. (It was painted the same year as the original.) He left it to his son, Lord Lyndhurst (John Singleton Copley, Jr.), from whose collec-

THE MUSEUM

> Native American on a horse, his head raised and arms swept back. The rotunda of the building is elaborately embellished—the skylights, moldings, murals, and decoration were all done by John

Singer Sargent from 1917 to 1925.

Of particular interest in the museum's collections are its hold-ings of ancient Egyptian art and artifacts, which were gleaned

from the museum's joint excava-tions with Harvard University. Also outstanding are its collec-tions of textiles, costumes, and American silver (which includes Paul Revere's works).

Represented American paint-ers at the museum include Cop-ley, Gilbert Stuart, Winslow Homer, Mary

A Paul Revere teapot from the co lection of American silver. This m have been the same pot Copley painted in Revere's portrait (abov

WATSON AND THE SHARK BY JOHN SINGLETON COPLEY

THE ARTIST

John Singleton Copley, self-portrait, ca. 1776–1780. By this time, the artist had left Boston and was embarking on his English career.

John Singleton Copley revolutionized 18th-century American art. Many of his fellow New Englanders, in the Pilgrim and Puritan tradition of frowning on European indulgences, saw painting as frivolous. Then their children rediscovered what they had rejected, as children often will. Taking his lessons from Europe, Copley singlehandedly lifted American art to new levels of skill.

Copley was born in Boston around 1738. His mother was widowed when he was a child, and in 1748 she married Peter Pelham, an engraver and painter. Copley was already interested in

art, and Pelham was happy to be his teacher.

Unfortunately, Pelham soon died, and the family's financial needs made Copley a working artist when he was 15. By studying European engravings and books, he learned fast and prospered. In 1753 he was portraying innkeepers and their wives; by 1758 his subjects (and patrons) included the wealthiest families in New England.

Copley's portrait of his half-brother, Henry Pelham, 1765, won him recognition in England. This painting is now known as _Boy with a Squirrel_.

Portrait painting was then the only acceptable kind of art in Boston, where, Copley wrote, "Was it not for preserving the resemblance of particular persons, painting would not be known." Yet he was ambitious and wanted to take on the great themes. His aim was always "of improveing in that charming Art which is my delight and gaining a reputa-➤

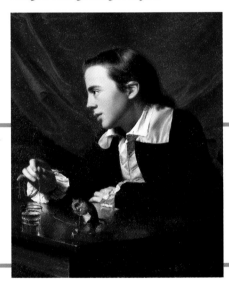

THE TECHNIQUE

Copley's English work is technically more virtuosic than his American portraits, with freer brushstrokes and a subtler, lighter palette. _Watson and the Shark_, made when he had been in London about three years, is probably his best piece.

The image rests solidly on a doubled pictorial platform: at the bottom, the shark and the endan-

gered boy; above them the boat, like a pedestal on a dais. That pedestal in turn supports a pyramidal construction of figures, defined on the right by the plunging boat-hook, on the left by a flowing line running along the black man's arm, through the heads of the rowers, and down the stretched bodies of the men reaching for the boy. It is picked up ➤

THE SUBJECT

Watson and the Shark shows an incident in Havana Harbor in 1749: Brook Watson, an English boy then 14, was bitten by a shark while swimming and lost a leg. He survived to become a successful merchant and, eventually, the lord mayor of London. Watson commissioned Copley to paint the attack; the artist

had not seen it. But Copley did scrupulous research, as was his habit. The fortifications in the distance, for example, are Morro Castle, a feature of the harbor still.

As a representation of a historical event, _Watson and the Shark_ falls into the genre of the history painting. But it is an unusual

example of the kind, for it shows not a famous scene from the classics or the Bible but an event from within Copley's own lifetime, and one on an individual scale, affecting only its protagonists.

Another novelty in _Watson and the Shark_ is its terror. Other paintings of the period ➤

THE PROVENANCE

The version of _Watson and the Shark_ in the Boston Museum of Fine Arts is a copy of the original commissioned by Watson for his own ➤

"America, which has been the seat of war and desolation, I would fain hope will one day become the school of fine arts."

THE MUSEUM MUSEUM OF FINE ARTS, BOSTON

The Museum of Fine Arts, Boston, is located at 465 Huntington Avenue. Established in 1876 in a building in Copley Square, the museum moved to the neoclassical building at its

present location in 1909. The West Wing of the museum, added in 1981, was designed by I. M. Pei, who also designed the East Wing of the National Gallery of Art in Washington, D.C., and

a glass pyramid for the courtyard of the Louvre in Paris.

In front of the Huntington entrance is Cyrus Dallin's sculpture entitled "Appeal to the Great Spirit"; it depicts a ➤

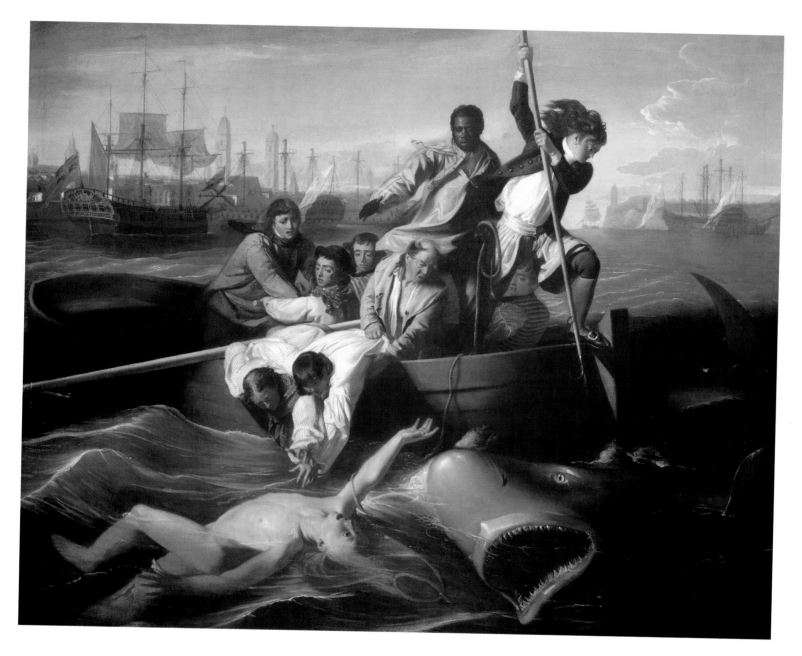

WATSON AND THE SHARK
by John Singleton Copley, 1778
oil on canvas
72 x 90¼ in. (192.9 x 229.2 cm.)
Gift of Mrs. George von Lengerke Meyer
Museum of Fine Arts
Boston, Massachusetts

ing hearth in one's soul," van Gogh wrote Theo, "and yet no one ever comes to sit by it. Passersby see only a wisp of smoke rising from the chimney and continue on their way."

With Theo's help, van Gogh persuaded Gauguin to visit Arles. What happened next has become legend: heightening tension between the two men ended with the nightmarish December night when van Gogh, in the first of several mental collapses, cut off his ear lobe and gave it to a prostitute. (His illness has never been satisfactorily explained; diagnoses have ranged from epilepsy, syphilis, porphyria, alcoholism, and schizophrenia to malnutrition and vitamin deficiency.)

For some months van Gogh stayed in an Arles hospital, scared to leave. In May of 1889 he voluntarily entered an asylum in nearby Saint-Rémy-de-Provence. The treatment consisted principally of confinement and two-hour baths, but he was allowed to paint. Indeed, between his first breakdown and his death in July 1890, he worked furiously when able, creating over 400 paintings and drawings.

Theo had found a sympathetic doctor for him in Auvers-sur-Oise, near Paris. There van Gogh painted 60 canvases in two months. Then on July 27 he shot himself in a cornfield. He died

Sunflowers, 1888. This van Gogh canvas sold for a then-record price of $40 million at auction in March, 1987. During his lifetime, van Gogh sold one painting for about the equivalent of $80.

two days later. Signac would recount, "The bullet went through his body....He walked two kilometers, lost all his blood, and finally died at his inn." The painter Claude Monet's words were less matter-of-fact: "How could a man who so loved flowers and light, and has rendered them so well...have managed to be so unhappy?" ❑

oon in The ws how paint—in reaks.

The color is intense, the moon as yellow as sunshine, the stars' aureoles a range of shades down to pure white. Not a patch of paint is flat: van Gogh has extended the Impressionist brushstroke of short dabs of pigment into longer side-by-side streaks.

Netherlands. And if this is Saint-Rémy, it has been moved from the north of the hospital to the south, displacing what in *Mountainous Landscape behind the Asylum* is a field of wheat.

This is unusual for van Gogh, who generally subscribed to the Impressionist code of

Color sketch of a corridor at Saint-Paul's hospital at Saint-Rémy, 1889. Van Gogh would leave the asylum the following year for Auvers.

These streaks constitute everything seen and control how the work is read. Nothing is still or solid; hills and landscape all share in the sky's whorls and fluxes of energy. If van Gogh seems to anticipate the modern physics of matter, he also expresses a spirituality that is cosmic in the most literal sense. ❑

truth to nature. Yet his vision was always more personal than objective. He had written, in April 1888, "The imagination...alone can lead us to the creation of a more exalting and consoling nature than the single brief glance at reality...can let us perceive." ❑

American show at the Museum of Modern Art in New York City in 1935.

Lillie P. Bliss, a society dame who became an avid art collector after seeing the

1913 modern art exhibition, the Armory Show, acquired *The Starry Night* some time before 1941, when she left it to the Museum of Modern Art in a bequest. ❑

10,000 films and four million film stills. The architecture and design department displays artifacts related to functional design. ❑

THE STARRY NIGHT

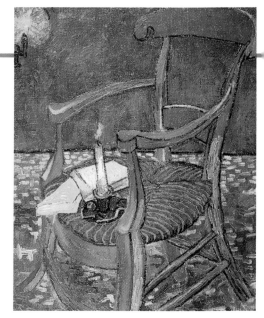

Gauguin's Armchair, **1888. Gauguin lived with van Gogh in Arles for a short time in 1888, until van Gogh's instability severed the relationship.**

THE ARTIST

The Yellow House in Arles, where van Gogh rented the right wing for living quarters and a studio. This photograph shows the house's later incarnation as a cafe; the building was destroyed during World War II.

► time, and that was in his last year. He was largely supported by his brother Theo, who, following the family tradition, was an art-dealer in Paris. The brothers were close; hundreds of Vincent's letters to Theo survive, invaluable not only as records of the artist but collectively as an extraordi-nary essay on art and life.

In 1886 van Gogh moved to Paris. Here he met many artists of the Impressionist and Post-Impressionist generations— Camille Pissarro, Henri de Toulouse-Lautrec, Georges Seurat, Paul Signac, Paul Gau-guin. Later, Pissarro would remember thinking that van Gogh would "either go mad or leave the Impressionists far behind. But I did not suspect that both these presentiments would prove correct."

In Paris, van Gogh's palette lightened and brightened. Besides learning about contemporary French art, he came to love *japonerie* (things Japanese), then in vogue. In February 1888, when he left Paris for the south-ern town of Arles in Provence, it was partly to find in nature the brilliant color of Japanese prints. He also hoped to build a commu-nity of artists living and working together. Loneliness had been his intimate: "One may have a blaz-

THE TECHNIQUE

► pass before he got to the work (*Starry Night over the Rhône* was an intermediate version), but his technique hadn't changed.

He seems to have worked fast, the bare can-vas sometimes showing between rapidly laid-down brushstrokes. (When using color he didn't have to mix on the palette, van Gogh often hurried pigment onto the canvas straight from the tube.) The work shares the vigor of the process. Despite the mobility of its upward-twisting branch-es, the cypress tree on the left helps to anchor both viewer and picture with its rootedness; otherwise we would hang dizzily above this nighttime val-ley, caught in the movement of that animate sky.

A detail *Starry N. van Gog* **thick, flo**

THE SUBJECT

► entering the Saint-Rémy asylum—he worked not from nature itself but from his own paint-ing. His bedroom at the hospital overlooked a wheatfield and, beyond it, the craggy hills called the Alpilles, and he certainly spent time at that window. The room van Gogh worked in, how-ever, had a different view. To paint *The Starry Night*, he is believed to have used two canvases then in the studio, *Mountainous Landscape behind the Asylum* and *Wheat Field*. From the for-mer he took the contour of the Alpilles, from the latter the cypress tree.

As for the village, the church recalls build-ings van Gogh had known years earlier in the

THE PROVENANCE

► ings. Theo approached art dealer Paul Durand-Ruel to stage an exhibition of Vincent's works, but the dealer wasn't interested. Ill and depressed, Theo died six months later. The first major showing of van Gogh's work would take place in 1892 in Amsterdam; the first major

"Cypresses are always occupying my thoughts....The tree is as beautiful of line and proportion as an Egyptian obelisk."

THE MUSEUM

► painters: Paul Cézanne, Vincent van Gogh, Paul Gauguin, and Georges Seurat. It moved to its present quarters in 1939, but the building has been enlarged several times since.

The painting and sculpture collection contains works done since 1880. Separate galleries are assigned to Henri Matisse, Pablo Picasso, Constantin Brancusi, and the Abstract Expressionists.

The museum also has fine collections of photography, illus-trated books, and film. The film department consists of over

THE STARRY NIGHT BY VINCENT VAN GOGH

THE ARTIST

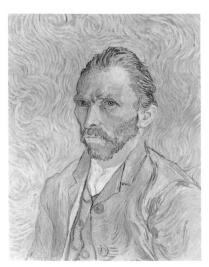

Vincent van Gogh, *Self-Portrait*, 1889, painted while the artist was at the asylum at Saint-Rémy.

Suffering, mad, brilliant, unrecognized until too late: this popular image of the artist is rarely lived out in reality. But it fits Vincent van Gogh perfectly. This may explain his fame, which, however, needs no such support: his intelligence, sincerity, and the naked intensity of his responses breathe through his work.

Van Gogh was born in 1853 in the Dutch village of Groot Zundert, where his father was pastor. He seems to have been a cheerful child, until, at age 12, he was sent to a boarding school. Here he was thought shy and made no close friends.

When van Gogh was 16, his uncle Cent, who worked for the art dealers Goupil & Cie., got the boy a job in the firm's branch in The Hague. Four years later Goupil transferred him to London. Here he had a romantic setback, falling for his landlady's daughter, who did not love him. His letters home began to include meaningful quotations from poetry and the Bible. Reassigned to Goupil's Paris office, he was eventually fired. (He'd been discouraging customers from buying paintings he thought inferior.) He was entering a period of fanatical Christianity, which would pass, and of eccentricity, which would only deepen.

Taking the ministry as his vocation, van Gogh undertook the necessary studies, but failed in them. Stubborn, he became a lay preacher, but was too intense—he scared his parishioners—and was fired again. It was only in 1880, when he was 27, that he decided to become a painter. For the next several years van Gogh wandered, staying with his parents, or studying art haphazardly in different cities, or sketching in the country. He had another romantic disappointment and lived for a while with a sometime prostitute. His diet at one point was stale bread, potatoes, and street-vendors' chestnuts. His father considered certifying him insane.

Only one of van Gogh's paintings sold during his life-➤

THE TECHNIQUE

Van Gogh's art was largely self-taught; he took academic classes, but only sporadically. (He did look critically at all sorts of paintings, and his comments on them are both acute and surprising—posterity and he don't always agree on their quality.) In April 1888, writing from Arles, van Gogh told a Paris friend how his technique had been developing: "My brush-

stroke has no system at all. I hit the canvas with irregular touches of the brush, which I leave as they are. Patches of thickly laid-on color, spots of canvas left uncovered, here and there portions that are left absolutely unfinished, repetitions, savageries…." At the time, van Gogh was already pondering a painting of a night sky. Over a year would➤

THE SUBJECT

The Starry Night was a painting long contemplated and long postponed. In May 1888 in Arles, van Gogh wrote Theo, "I wonder when I'll get my starry sky done, a picture that haunts me always." The following month he repeated that question in another letter, adding a quotation from a novel: "'The most beautiful pictures are

those one dreams about when smoking pipes in bed, but which one will never paint.' One must attack them nonetheless, however incompetent one may feel before the unspeakable perfection, the glorious splendors of nature."

Yet when van Gogh finally began *The Starry Night*—in June 1889, a month after➤

THE PROVENANCE

In February 1890—only months before van Gogh's death—his brother Theo sent him an article from *Mercure de France* by Paris art critic Albert Aurier. This glowing review

would be the only major appraisal of van Gogh's works during his lifetime.

When van Gogh died, Theo had in his possession over 500 of his brother's paint-➤

THE MUSEUM THE MUSEUM OF MODERN ART

The Museum of Modern Art is located at 11 West 53rd Street in New York City. It opened its first exhibit in an office building in 1929, shortly after the Stock Market Crash. The subject of that exhibit were four, then little-known Post-Impressionist➤

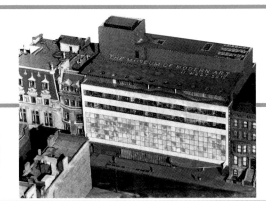

Aerial view of the museum building shortly after it opened in 1939.

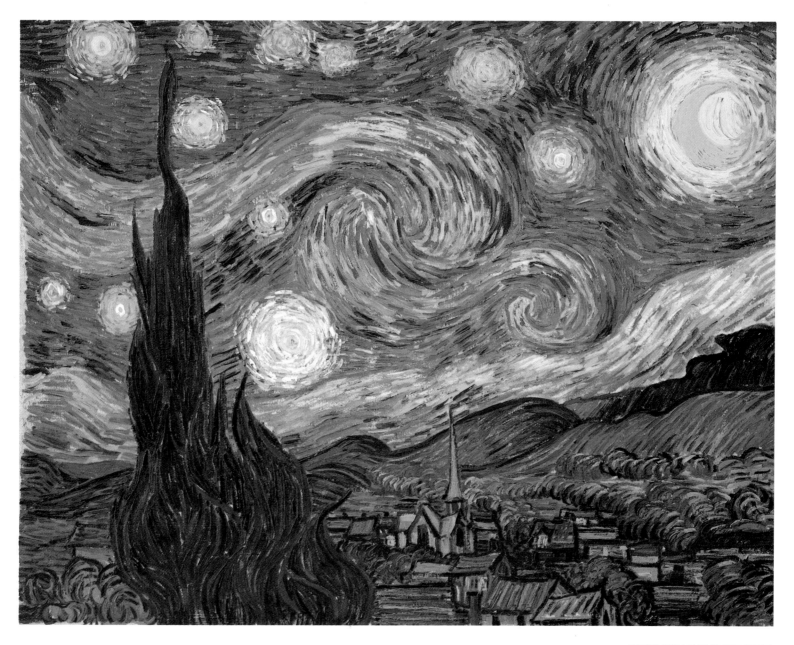

THE STARRY NIGHT
by Vincent van Gogh, 1889
oil on canvas
28¾ x 36¼ in. (73 x 92 cm.)
Bequest of Lillie P. Bliss
The Museum of Modern Art
New York, New York

ibility. A critic of the 1866 painting *Storm in the Rocky Mountains, Mt. Rosalie,* for example, had done some math on the work, estimating the height of its peaks at "ten thousand miles or so. Impossible." (The world's tallest mountain peak, at Mount Everest, is about 5 miles.) And when Bierstadt proposed painting panels for the Capitol in Washington, D.C., at a cost of $40,000 each, he was turned down. "The demand seemed...so exorbitant and so at variance with the spirit of patriotism," said a Congressional report, "...that the proposal was promptly rejected."

In 1869 it was noted: "Next

to the Civil War, the fiercest conflict of modern times is the controversy now raging among the art-critics....[I]t is the fashion, on the one hand, to extol Mr. Bierstadt as one of the best of masters; and, on the other hand, to defame him as one of the worst of pretenders." In moderated form, the latter view prevailed. As French Impressionist painting, with its freshness and immediacy, began to gain international favor, Bierstadt's huge, theatrically composed scenes fell from the public eye.

Bierstadt spent everything he

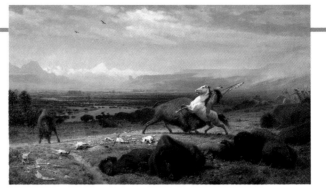

Last of the Buffalo, 1888, shows Indians hunting buffalo. Encroachment of white settlers on the plains had decimated this animal that was so vital to Indian life.

earned. He built a mansion in the Hudson Valley, then had to rent it out. He speculated in mining and land, patented a railway-car design, sold guns. In 1889 his *Last of the Buffalo* was rejected by the committee selecting work for an exhibition in Paris, but the painting sold for $50,000. Even so, in 1895 he auctioned everything he

owned to settle his debts. Because he had married a millionairess after his first wife's death in 1893, his lifestyle remained unaffected.

Bierstadt died in New York City in 1902. Though his style had begun to lose critical favor in the last decades of his life, he painted up to the end. ❑

Bierstadt wanted to emphasize the progress of the wagon train. Were the sun in the center, the wagons and horsemen heading for it would be at a sharper angle to us, and less visible; here they are near broadside on. And their

Traveling west became easier for Americans after the opening of the first transcontinental railway in 1869. The Northern Pacific route advertised in this poster opened in 1883.

visual line through the picture is a good deal longer when they move from bottom right to middle left than if they were aimed at the picture's center. Bierstadt knew the mechanics of composition well—so well, in fact, that in some pictures compositional machinery is virtually all there is. ❑

Europe about the great continent's then relatively unknown regions, Bierstadt's paintings reinforced the manifest destiny idea; they showed the land as available for the taking. In 1868, when another painter presumed

to show a western scene, a critic joked that Bierstadt had already "copyrighted nearly all of the principal mountains." And the year before, when Bierstadt exhibited *The Domes of the Yosemite,* a reviewer wrote, "We recommend our readers to go at once and see the work. They will feel that the world is progressing and the Americans are a great people." ❑

chairman of the board of the National Cowboy Hall of Fame, bought the painting from the Cleveland Automobile Club in 1971. Ackerman donated the painting directly to

the National Cowboy Hall of Fame the same year.

An almost identical painting, *The Oregon Trail,* 1869, is at the Butler Institute of American Art in Youngstown, Ohio. ❑

like recreation of an Old West town, complete with a real sod house, activities for children, and events such as the Championship Chili Cook-off. ❑

EMIGRANTS CROSSING THE PLAINS

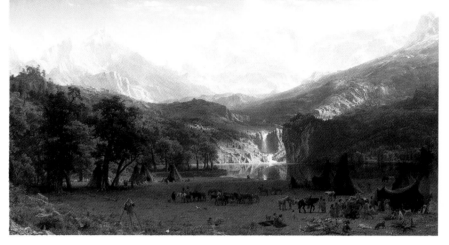

Rocky Mountains, Lander's Peak, 1863, Bierstadt's first great success, depicts the mountains that would become the artist's trademark subject matter.

THE ARTIST

➤ back, "Such fine effects...I have never before seen. Our own country has the best material for the artist in the world."

Now that he had his subject, he rose meteorically. In 1860 he exhibited a western landscape. The following year, a socialite was calling him "probably the most talked-of artist in New York." In 1862 a friend tried to buy a Bierstadt painting before they commanded "fabulous prices." By 1863 when he traveled west again with a popular author by the name of Fitz Hugh Ludlow, he was a public figure. And in 1864 a reviewer wrote that his *Rocky Mountains, Lander's Peak* placed him "in the first rank of American genius." The painting sold for a record $25,000.

He now moved in the highest circles. While honeymooning in Europe in 1867–69 after mar- rying Ludlow's divorced wife, he met Napoleon III, Franz Liszt, and Queen Victoria. He also became a knight of the French Legion of Honor. Meanwhile, though, others had begun to suspect Bierstadt's cred-

THE TECHNIQUE

➤ arrangement that is placed at a corner (usually the left) to help create the picture's sense of depth.

It is the landscape of the romantic sublime, but reduced to stock devices. *Emigrants Crossing the Plains* tempers these elements, though. Often in Bierstadt's works, a very big mountain fills up the background. In *Emigrants Crossing the Plains*, Bierstadt wanted to show the road west as open to the pioneers. So he clustered his mountains to the right and lined them up, creating an avenue for the wagons to follow. And he flattened the rest of the landscape, implying an unobstructed path to the west—symbolized by a glorious, rosy setting sun.

The mountains, like a V on its side, point straight to the perspectival vanishing point in the picture's middle; they are answered on the left by the trees' bases and tops, which draw another, rougher, sideways V. The sun, however lies not where the V's meet but off to the left.

THE SUBJECT

➤ only amounted to a knot of ribbons, or the glimpse of a petticoat. I never saw so many bright and comely faces in an emigrant train...every group a genre piece." This scene inspired *Emigrants Crossing the Plains*.

Like most Americans of his time, Bierstadt believed in "manifest destiny," the idea that the United States should "overspread the continent" with its "multiplying millions." In a pamphlet publicizing *The Rocky Mountains, Lander's Peak*, Bierstadt attached to

the site of that painting the hope that on it "a city, populated by our descendants, may rise, and in its art-galleries this picture may eventually find a resting-place."

As they satisfied public curiosity in the eastern United States and in

THE PROVENANCE

➤ After Stone's death, the painting was passed on to several family members until it was purchased in 1941 by the Cleveland Automobile Club. The club loaned the painting to the Department of State in Washington, where it was displayed for two and half years before returning to the auto club.

Jasper D. Ackerman of Colorado Springs, Colorado, a banker and

THE MUSEUM

➤ Russell, paintings by Henry F. Farny and William R. Leigh. The museum also contains a growing contemporary art collection on western subjects. Perhaps its most famous sculpture is *The End of the Trail* by James Earle Fraser, designer of the buffalo-Indian head nickel.

Other holdings include the Joe Grandee Collection, which consists of 19th-century frontier artifacts. The Rodeo Hall of Fame exhibits pictures and memorabilia of the greatest rodeo athletes, and the Hall of Great Westerners commemorates explorers and ranchers. Singers Roy Rogers and Dale Evans are featured in Hall of Great Western Performers. Actor John Wayne has his own gallery featuring film memorabilia and his personal art collection.

Also at the museum is a life-

EMIGRANTS CROSSING THE PLAINS BY ALBERT BIERSTADT

THE ARTIST

Albert Bierstadt, ca. 1870.

Albert Bierstadt was one of 19th-century America's great showmen. Though he traveled widely, he is mostly associated with one subject: the mountainous West. He is also associated with one device: pictures of giant size, their power a product of their scale.

Bierstadt was born in Germany in 1830. His family emigrated to New Bedford, Massachusetts, when he was two. A childhood schoolmate would remember him as "a boy who no one thought would ever amount to anything." His first contacts with art are lost; a painter who met him later, Worthington Whittredge, would say he had

Olevano, **an Italian village scene, was painted when young Bierstadt traveled in Europe.**

had "little or no instruction."

In 1853 Bierstadt returned to Germany to study at the famous academy in Düsseldorf. There he asked fellow Americans Whittredge and Emanuel Leutze to recommend him to a teacher. Unimpressed by his work, they politely declined. Whittredge thought him "the most timid, awkward, unpolished specimen of a Yankee you can well imagine." While Bierstadt didn't enroll in the academy, he worked along-

side its students—and worked hard. Even Whittredge finally prophesied his success.

After traveling through Italy, Bierstadt returned to the United States in 1857. In 1858 he showed a large Swiss landscape in a New York exhibition. (A prescient critic remarked, "The same ability on a smaller scale would be more roundly appreciated.") The following year Bierstadt visited the Rocky Mountains, the first of many trips west. He wrote ➤

THE TECHNIQUE

As early as 1864, when Bierstadt's career was in soaring climb, a critic remarked of him that though he worked from real life sketches, "with singular inconsistency" he idealized his compositions "so that, though the details of the scenery are substantially correct, the scene as a whole often is false." Bierstadt was sometimes formulaic, recombining the same elements from landscape to landscape: a relatively dark foreground; a bright light somewhere deep in the picture; a dramatic mountain or three; and a standard foreground device such as a rise, rock, or, in *Emigrants Crossing the Plains*, a cow-sheep-tree-stump ➤

THE SUBJECT

When Bierstadt traveled west in 1863, the popular author Fitz Hugh Ludlow accompanied him. Ludlow published accounts of the trip and later made a book of them. The passage for May 30 reads, "About two o'clock, we passed a very picturesque party of Germans

going to Oregon. They had a large herd of cattle and fifty wagons, mostly drawn by oxen, though some of the more prosperous outfits' were attached to horses or mules.

The people themselves represented the better class of Prussian or North German peasantry.... Some of them wore canary shirts and blue pantaloons; with these were intermingled blouses of claret, rich warm brown, and the most vivid red. All the women and children had some positive color about them, if it ➤

THE PROVENANCE

Bierstadt painted *Emigrants Crossing the Plains* in 1867, when he was in Europe. Amasa Stone of Cleveland, Ohio, purchased it from the artist in 1868 for $15,000. It seems that Stone bought the painting before it was even completed; according to a bill of sale written by Bierstadt in Paris in November 1868, the painting would not be delivered to Stone until August the following year. ➤

THE MUSEUM NATIONAL COWBOY HALL OF FAME AND WESTERN HERITAGE CENTER

The National Cowboy Hall of Fame is located on Persimmon Hill at 1700 Northeast 63rd Street in Oklahoma City, Oklahoma. Opened in 1965, the museum was the brainchild of

Chester A. Reynolds, a Kansas City businessman who wanted to preserve the heritage of

the American West. The museum is sponsored by 17 western states.

Historical works include Frederic Remington paintings and sculptures, the paintings and illustrated letters of Charles M. ➤

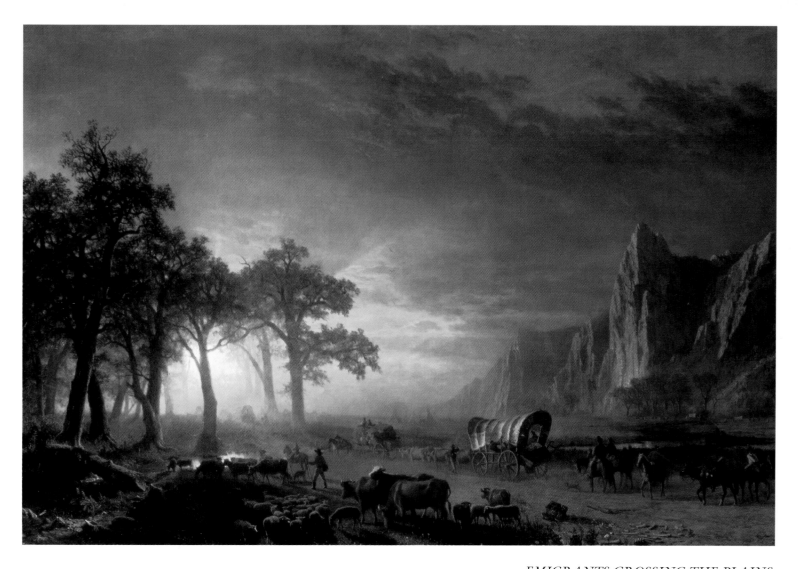

EMIGRANTS CROSSING THE PLAINS
by Albert Bierstadt, 1867
oil on canvas
67 x 102 in. (170.2 x 259.1 cm.)
National Cowboy Hall of Fame
and Western Heritage Center
Oklahoma City, Oklahoma

teen paces while squinting your eyes." Meanwhile there was a moment when Renoir had a net worth of three francs, this at a time when a pound of coffee cost three francs 20 centimes.

Renoir didn't enjoy the role of rebel. After reapplying to the Salon in 1878, he disentangled himself from the Impressionist group; in 1882 he said he wanted to be "removed from the revolutionary aspect, which scares me." His disillusion was more than strategic. After a trip to Italy, and exposure to the Italian old masters in situ, he was questioning the Impressionist aesthetic. "I had wrung Impressionism dry,"

he would recall, "and had come to the conclusion that I knew neither how to paint nor how to draw." His work of the later 1880s forsakes the dappled light of Impressionism for a clearer, harder line. Yet early in the 1890s he would return to softer contours, writing, "I have now gone back permanently to the old gentle and light way of painting."

On his Italian trip Renoir was accompanied by Aline Charigot, a dressmaker and model whom he would later

Renoir continued painting outdoors after moving to Cagnes in 1907. Crippled by rheumatism and arthritis, he persisted despite excruciating pain.

marry. His finances remained precarious throughout the 1880s, but by 1895 he was comfortable enough to buy a house in Aline's home town in Champagne. Unfortunately, he had begun to

suffer from rheumatism, which would turn into crippling arthritis. After regular stays in the warmth of southern France, the Renoirs moved to Cagnes, near Nice, in 1907.

Miraculously, Renoir continued to work. In his later years he was wheelchair-bound and couldn't move his fingers; he wedged a brush between them and kept painting. He even produced sculpture, using a rod to point lines in clay for an assistant to model. Renoir died in 1919. He had painted a flower study that morning; on putting down his brush, he had said, "I feel I've learned something today." ❏

Mixed Flowers in an Earthenware Pot, ca. 1869. Renoir painted flowers as a form of "mental relaxation."

on the grass. Even the path—a tawny expanse of gravel, its arching upper edge giving the picture's formal construction a dynamic

arabesque asymmetry—contains yellows, pinks, mauves, and blues, and the grass has touches of blue and greenish yellow. Renoir claimed to paint "like a child," but his simplicity was misleading. Describing his technique, he once said, "I look at a nude, I see thou-

sands of tiny tints. I must find the ones that will make the flesh on my canvas live and quiver." The eye that would break up that living skin—or, here, a flat path or a swath of green grass—into "thousands of tiny tints" was Renoir's deceptive gift. ❏

head is enhaloed by more flowers across the picture's top. These and the gentle curve of grass are like a cradle around her back. The path in the lower right quadrant is the painting's brightest area, suggesting an unseen open space beyond the

Children are favorite subjects for Renoir; he sketched these portraits of the Bérard children in 1881. Their parents were among his staunchest patrons.

picture frame. This is the direction in which the girl gazes—from the flowers and greenery of the garden out into a different place and time. ❏

A GIRL WITH A WATERING CAN

La Grenouillère, 1869, by Renoir; he and Monet spent a summer painting together near this popular leisure spot on the Seine.

THE ARTIST

➤ into sales, however, and he often traded pictures for food and supplies.

Meanwhile his work was becoming more radical. Like Monet, Renoir was painting outside, using fresh, bright colors to capture natural light, and portraying contemporary life rather than classical figures and heroic themes. The summer Renoir and Monet spent working around La Grenouillère, a restaurant on the Seine, in 1869, has been called the "official birth of Impressionism." Both painters used the same short brushstrokes and pure colors; their styles were so close, in fact, that 40 years later Monet couldn't tell which of a pair of their paintings from this era was his. A letter of Renoir's describes his almost daily visits to Monet's, where "we don't always eat, but I am happy all the same."

The Salon soon began to reject Renoir steadily—in 1873, for example, because his color was "so new as to be disconcerting." That year Renoir, Monet, and other artists began to organize an alternative. This show, in the spring of 1874, was the first in the series now known as the Impressionist exhibitions.

At first Impressionism was neither a critical nor a popular success. At an Impressionist auction in 1875, the audience expressed such violent disapproval that the police showed up. For one critic these were paintings "that you must look at from fif-

THE TECHNIQUE

➤ orthodoxy of his day. For the artistic establishment of the time, color was subservient to line and drawing; Renoir's old teacher Charles Gleyre thought bright color "devilish." A critic of an early Impressionist exhibition wrote of the "firework display" from Renoir's "crazed palette." Even early on at the École des Beaux-Arts, Renoir would remember, one of his teachers "was fairly beside himself on account of a certain red that I had used."

Perhaps he remembered that teacher as he touched in the glowing ribbon in the hair of his little girl with a watering can, making that red more vital still by framing it against a patch of the dark purple he used for the shadows in the upper flower bed and

THE SUBJECT

➤ dance halls, its restaurants. He also painted portraits, and above all he painted women and children. He once said he was enchanted by children because "their mouths utter only the words which animals would utter if they could talk." Perhaps he meant that for him, children—and maybe women also—lived in some space that had nothing to do with ordinary social discourse and exchange, which was, of course, more complex and darker than he pictured it.

In 1898 the man who then owned A Girl with a Watering Can, Count Batthiany, said that it showed his wife, Sellière, when she was five. In the painting, Sellière has just watered her garden and picked her daisies. Her feet and the hem of her dress touch the cloud of flowers at the lower left, and her

THE PROVENANCE

➤ reliable way for an artist to earn money. Batthiany eventually sold the painting to a Paris dealer. It was in an aristocratic private collection until 1929, then passed through the hands of various dealers until 1931, when it was bought by Chester Dale of New York, who left it to the National Gallery of Art in his will. Dale died in 1962, and the painting came to the National Gallery the following year. ❑

THE MUSEUM

➤ Ginevra de' Benci by Leonardo da Vinci (the only example of this master's work outside of Europe), as well as a large collection of French Impressionist and Post-Impressionist paintings.

The National Gallery's East Building opened in 1978. Designed by I. M. Pei, it is a modern, angular building housing contemporary works and special exhibits. A Henry Moore sculpture is near the entrance; an Alexander Calder mobile hangs from a beam in the skylit entrance hall. Works by Joan Miró, Robert Motherwell, and David Smith are among the contemporary artists represented here. A special gallery displays a group of Henri Matisse paper cutouts.

The National Gallery regularly schedules lectures, films, concerts, and special exhibits. ❑

A GIRL WITH A WATERING CAN BY PIERRE-AUGUSTE RENOIR

THE ARTIST

Portrait of Pierre-Auguste Renoir by Frédéric Bazille, 1867. Like Renoir, Bazille was an early Impressionist.

A defining artist of French Impressionism, Pierre-Auguste Renoir enraged audiences of his time by his innovations but endeared himself to later ones by his cheerfulness. To look at his work, you'd think late-19th-century Paris was almost entirely a place of theater-going, dancing, riverside luncheons, charming children, and, above all, pretty women. Indeed the novelist Marcel Proust thought he had changed the way women were seen: "Women who go by in the streets are different from their predecessors—now they are Renoirs."

Renoir was born in 1841, in Limoges. His parents, who moved the family to Paris when he was small, were a tailor and a seamstress; Renoir's own first training, begun when he was 13, was as an artisan, painting the decorations on crockery. (His workmates nicknamed him "little Rubens," for the 17th-century Flemish painter Peter Paul Rubens.) Later in life Renoir would still like calling himself *un ouvrier de la peinture*, a workman of painting.

Even as a literal *ouvrier*, though, Renoir took evening classes in drawing and walked the halls of the Louvre. In 1861 he entered the classroom of the academic painter Charles Gleyre, where, the following year, he met Alfred Sisley, Frédéric Bazille, and Claude Monet, all future Impressionists. (Though Bazille died before the term "Impressionism" was coined, he is considered one of the group.)

In 1864 and 1865 Renoir showed at the important annual Salon exhibition, the official showplace of French art. Rejected in 1866, he was included for several years following. Professional recognition failed to translate ➤

THE TECHNIQUE

Painted in 1876, *A Girl with a Watering Can* shows Renoir's Impressionist technique at its most assured and pure. The mottling of short brushstrokes and the suggestion of radiant light were trademarks of his and Monet's version of the school. (The Impressionist group was actually quite disparate.) Another touchstone is the modeling of the forms. Rather than first defining them with a clear line, then painting them in, in the classic way, Renoir has built them up out of color. In many places then, their outlines are permeable, one shape melting into another—note the cottony blur where the girl's hair meets her temple, or where the path meets the border of the grass. The picture has an overall soft-focus vibrancy.

Renoir's palette was one of his principal departures from the ➤

THE SUBJECT

Renoir's teacher Charles Gleyre, the artist would remember, was "of no help to his pupils" except in that he left them pretty much to their own devices. But he did provide Renoir with an oft-told story by snapping at his student once, "No doubt it's to amuse yourself that you are dabbling in paint?" Renoir replied, "Why, of course. And if it didn't amuse me, I beg you to believe that I wouldn't do it!" Renoir's painting was and would remain about pleasure. "A picture," he believed, "should be something likeable, joyous, and

pretty—yes, pretty. There are enough ugly things in life for us not to add to them."

In practical terms, that meant that Renoir painted subjects as unshaded as possible by doubt or sorrow. In the 1870s, when he did *A Girl with a Watering Can*, he liked painting scenes of Paris life, but they were almost always of the city's pleasures: its theaters, its ➤

THE PROVENANCE

A Girl with a Watering Can, painted in 1876, is probably a commissioned portrait, and since its owner in 1898, Count Batthiany, said that it showed his wife, Sellière, as a child, Renoir was presumably hired by Sellière's parents to paint their daughter. Renoir was in financial straits around this time; painting portraits was a ➤

THE MUSEUM NATIONAL GALLERY OF ART

The National Gallery of Art consists of two buildings that are located near the United States Capitol between 3rd and 7th Streets on Constitution Avenue. The original West Building, designed by John Russell Pope and built in the classical style, opened in 1941. Financier and art collector Andrew W. Mellon funded construction of the building and donated his collection of paintings, which included works by Rembrandt and such masterpieces as Raphael's *Alba Madonna* and Botticelli's *Adoration of the Magi*. Also at the museum is the portrait of ➤

A Washington newspaper announces plans for a national art museum, 1937.

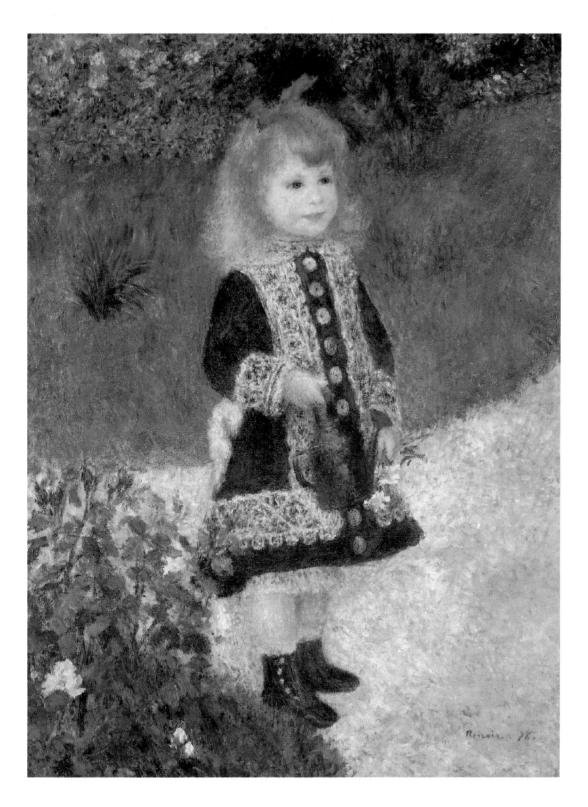

A GIRL WITH A
WATERING CAN
by Pierre-Auguste Renoir, 1876
oil on canvas
39 ½ x 28 ¾ in
(100.3 x .73.2 cm.)
Chester Dale Collection
National Gallery of Art
Washington, D. C.

In May 1606, in a tennis match, Caravaggio lost money to a man named Ranuccio Tommasoni. They argued, and struck each other with their rackets. In a later meeting they progressed to swords: Caravaggio slashed Tommasoni's thigh, then killed him after he fell to the ground. This was murder, and Caravaggio became a fugitive.

By October he was in Naples, outside Roman law. He prospered there, but the following summer he went to the island of Malta, then run by the semi-religious military order called the Knights of Saint John. Apparently Caravaggio wanted a knighthood, which he won by painting portraits of the order's leader. But by the fall of 1608 he had insulted a fellow knight and was back in prison.

After an escape by rope ladder, Cara-

vaggio fled Malta for Sicily, where he spent nearly a year. He was convinced, though, that he was pursued. (The order of knights had expelled him "like a foul or putrid limb," and was known for its vengefulness.) Back in Naples in October 1609, he was attacked and his face was slashed at a waterfront inn.

In 1610, Caravaggio's friends in Rome arranged absolution for the killing of Tommasoni, allowing him to return home. He sailed first to Port'Ercole, north of the city, where he was briefly jailed in a case of mistaken identity. When he was released two days

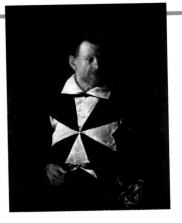

later, he discovered that his boat, with all his possessions, had vanished. Ill (probably with malaria) and very angry, Caravaggio ran down the beach in the blazing sun, hoping to catch the boat along the shore. Instead, he fell into a raving fever. Put to bed, he died within days at Port'Ercole. It was July 18, 1610; he was 38. ❑

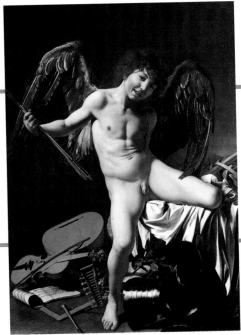

Victorious Amor, 1601–2. A merry and frankly naked Cupid treads on instruments symbolizing the earthly world. This painting won Caravaggio admirers and was often copied.

awkwardness—one leg pulled under, the other angled out, the trunk unbalanced—yet also an unforced gravity that the light supports, casting the eyes in deep shade.

Head of Goliath, the bodiless head that David holds by the hair is Caravaggio's own.

Caravaggio put another desperate self-portrait in the *Martyrdom of Saint Matthew*, of 1599–1600, where he seems to have cast himself as the Ethiopian king who ordered Matthew's killing. He painted this well before the death of Tommasoni, but he had always

lived wildly; there are rumors that he murdered a man while he was still a teenager in Milan. Late in life he is said to have remarked,

Another Caravaggio controversy depended on the identity of his models: in *The Death of the Virgin*, for example, had a prostitute modeled for the Virgin Mary? Did he have to paint the woman's puffy skin, or, in another religious scene, the model's dirty feet? No such complaints are recorded of *Saint John the Baptist*, and the model is lost to history. ❑

"All my sins are mortal."

Did Caravaggio see retribution for his own crimes in John's fate? He returned to the man so often. Profane yet devout, and fiercely proud, he may have trembled at John's resonating promise, "One mightier than I cometh, the latchet of whose shoes I am not worthy to unloose." ❑

in Malta, where the present work was bought by the British Lord Aston at some point before

1751. It passed down through Aston's family until 1951, when it was put on the market and purchased jointly by art dealers Edward

Speelman & Sons and Agnew's. The Nelson-Atkins Museum of Art bought the work from Agnew's in 1952. ❑

Chinese Temple Gallery.

The Henry Moore Sculpture Garden show works by the contemporary English artist. ❑

MUSEUM HOURS
Tuesday–Thursday: 10 a.m. to 4 p.m.
Friday: 10 a.m. to 9 p.m.
Saturday: 10 a.m. to 5 p.m.
Sunday: 1 p.m. to 5 p.m.

ADMISSION
Admission charged.
Free to children 5 and under.
Free to everyone on Saturday.

SAINT JOHN THE BAPTIST

➤ made pictures to be sold cheaply in the street. Eventually he was befriended by a powerful cardinal of the Church, Francesco del Monte, in whose house, the Palazzo Madama, he was living by 1595.

Del Monte was homosexual, and Caravaggio's early Palazzo Madama paintings tend to show bare-shouldered boys offering fruit or wine, or playing music, the proverbial food of love. (Caravaggio's own private life is unrecord-

The Martyrdom of Saint Matthew appears on the right wall of the Contarelli Chapel in the church of San Luigi dei Francesi. It was one of the first oil paintings for a Roman chapel; earlier paintings had been done in fresco.

ed, but while he never painted a female nude, he painted bare male skin often, and carefully.) After 1599, however, his subjects were almost exclusively religious. That summer, he began decorating the Contarelli Chapel, in the church of San Luigi dei Francesi. These paintings of scenes in the life of Saint Matthew made him famous. Caravaggio was as controversial as he was admired.

Three churches, one of them the papal basilica of Saint Peter's, rejected works commissioned from him because they offended religious and aesthetic proprieties. Meanwhile he was threateningly eccentric. That he wore his expensive clothes into tatters, and was said to be "very negligent in washing," mattered less than his lengthy record of assaults and public brawls. By 1603, a writer in distant Holland had heard that he was "always ready to argue or fight." "Satirical and proud," he moved with a belligerent clique said to have a disturbing motto: "*Nec spe, nec metu*"—neither hope nor fear.

➤ Actually Caravaggio did look hard at earlier art. But, destructive always, he subverted his examples by insisting on the physical body he saw, down to the dirty fingernails. His *Amor Vincit Omnia* (*Victorious Amor*) seems based on a Michelangelo fresco but has a bla-

tant sexuality sublimated in its model. The figure in *Saint John the Baptist* echoes antique sculpture, but Caravaggio has replaced classical nobility with the brooding intensity of a real man.

Dark, the painting is set outdoors, yet

John's body shines. Is he in moonlight? That would explain the peculiar duskiness of the red cloth, the illumination that brightens his skin but nothing else. John leans from upper left to lower right, a diagonal braced by the line of his staff and by the parallel shadow across his body. The pose has a naturalistic

➤ the Baptist, painted in Malta in 1608. It was Salome's dance for Herod, ruler of Palestine, that secured the prophet's death; at least once, perhaps twice, Caravaggio showed her receiving John's head in a bowl.

He examined a kindred violence in *Judith Beheading Holofernes*, in a decapitated head of *Medusa*, and in *David with the Head*

of Goliath. And something like beheading is threatened in *The Sacrifice of Abraham*, where Abraham moves a knife toward Isaac's neck. There is surely some personal meaning here. In fact, in the *Beheading of Saint John the Baptist* Caravaggio wrote his name in the blood pooling under John's throat—the only signature that survives. And in *David with the*

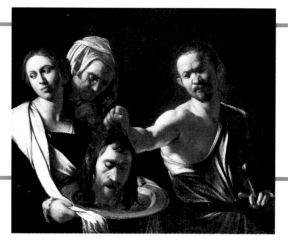

Salom[e] head [of] Baptis[t], [exe]cution from 1[...] of Car[...] [reli]gious [...] realist[...] blood

➤ When Costa died in 1639, an inventory of his possessions mentioned Caravaggio's *Judith Beheading Holofernes* and also "another picture with the image of Saint John the Baptist in the desert painted

by the same Caravaggio." The Costa family owned property

➤ contributions from the estate of Mary Atkins, a Kansas City schoolteacher, enabled the museum to open in 1933.

The Nelson-Atkins contains works from all periods and countries, but it has a particularly fine collection of Asian art. The Chi-

nese Temple Gallery, featuring Buddhist sculpture and paintings, is a leading attraction.

The museum's Western

paintings include the Caravaggio shown here, Claude Monet's *Boulevard des Capucines*, and Willem de Kooning's *Woman IV*.

SAINT JOHN THE BAPTIST BY MICHELANGELO MERISI DA CARAVAGGIO

THE ARTIST

An engraved portrait of Michelangelo Merisi da Caravaggio.

Balancing beauty and scandal, Michelangelo Caravaggio flowered brutally and fast, and died much too young. Scholars talk of a late-period Caravaggio, when his work, already original and profound, arrived at an unearthly clarity; yet he never reached 40.

He was born Michelangelo Merisi, probably in 1571, probably in Milan, to a family from the nearby town of Caravaggio. (The suffix "da Caravaggio"—from Caravaggio—eventually stuck to him permanently.) His father was a marquis's affluent functionary. The Merisis lived in Milan until 1576, then went home.

In April 1584 Caravaggio returned to Milan to train as a painter. The apprenticeship, if he finished it, would have ended in 1588. By some accounts he left Milan after "discords." In May of 1592 he was in Caravaggio for the settlement of his parents' estate—an inheritance large enough to last a while, even in Rome, where he had moved by the fall. Whether improvident or unfortunate, though, he was soon "poor and ragged." He painted first for a miserly Vatican lawyer, then ➤

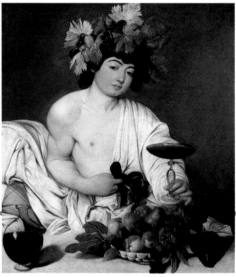

Bacchus, Caravaggio's vision of the classical god of wine as a bewigged youth.

THE TECHNIQUE

Art cannot be controversial by itself; it is the people it shocks who make it so. Caravaggio's Roman critics are long dead, and the basis of their quarrel with him may surprise: his use of a live model.

Thus the painter Giovanni Baglione heard it said that Caravaggio "had destroyed the art of painting" because "young artists followed his example and painted heads from life." Another artist, Annibale Carracci, is said to have thought one of his works "too natural." "The moment the model was taken from him," an early biographer claimed, "his hand and mind became empty." For his peers this meant he lacked *disegno*, compositional skill and inventiveness, and knowledge of aesthetic precedent. ➤

THE SUBJECT

The Gospels tell that "the child grew, and waxed strong in spirit, and was in the deserts till the day of his shewing unto Israel." This child was John, prophet of Christ's coming. Caravaggio painted him several times, once as a merry boy, in a pose to delight del Monte. The present picture depicts

Cardinal Francesco del Monte (*left*), one of Caravaggio's most influential patrons, took him into his home in 1595.

John as a young man. His staff becomes a cross; rough foliage signals a rustic place, a wilderness, and John's fur wrap the kind of clothing one might wear there.

John himself looks thoughtful, even troubled, and his body is caged in darkness. Perhaps he foresees the end described in the powerfully tragic *Beheading of Saint John* ➤

THE PROVENANCE

That a copy of *Saint John the Baptist* was once installed in a church near Genoa financed by the Costa family suggests that the painting may have been commissioned by Ottavio Costa, a Genoa banker and a patron of Caravaggio's. (On at least one other occasion, Costa gave away a copy of a Caravaggio original he kept for himself.) ➤

THE MUSEUM THE NELSON-ATKINS MUSEUM OF ART

The Nelson-Atkins Museum of Art is located at 4525 Oak Street in Kansas City, Missouri. Named for William Rockhill Nelson and Mary Atkins, it is housed in a neoclassical-styled building amid 20 acres of parkland.

Nelson, founder of the *Kansas City Star* newspaper, wanted to create a major art institution in the Midwest. His personal wealth and collection, together with ➤

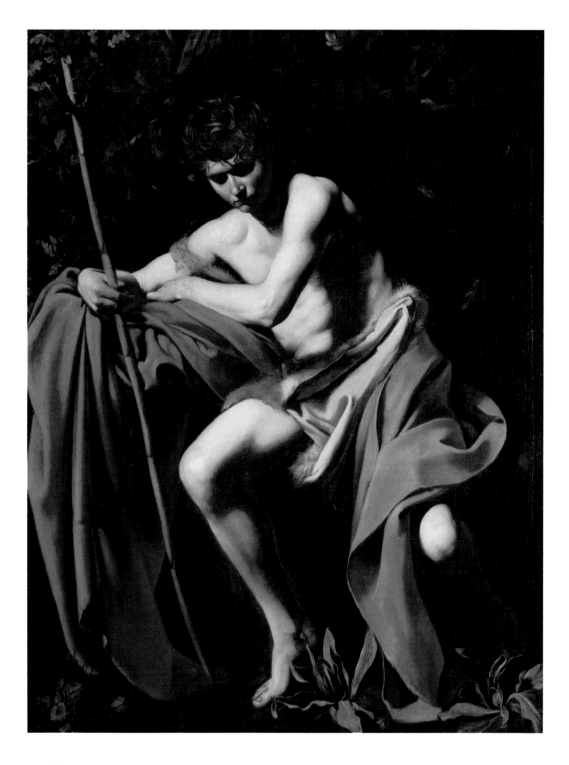

ism." In the early '50s Diebenkorn moved around the country. But California remained home, at a time when many American artists felt that successful careers were impossible outside New York City.

Not only did Diebenkorn and his peers put West Coast painting on the map, they raised the stakes. One day in 1955, Diebenkorn threw a canvas in his car, found a spot, and painted an on-site view of houses and the San Francisco Bay. Abstract Expressionism filled the galleries, but Diebenkorn had begun working representa-

tionally. He had reached an impasse in abstraction: "I sensed an emptiness—as though I were a performer." What would be called Bay Area Figuration—its artists principally Diebenkorn, Bischoff, and David Park—was one of American art's initially controversial attempts to develop beyond Abstract Expressionism.

Despite living on the West Coast, Diebenkorn became well known. California museums showed him early, and by 1964, when he was still in his early 40s, he had had a retrospective in Washington, D.C. A few years later he would represent the U.S.

at the Venice Biennale.

In 1967, after moving to Santa Monica to teach at the University of California, Los Angeles, Diebenkorn began the "Ocean Park" works—a bravura return to abstraction. He would spend much of the rest of his life on this series, which seems mysteriously evocative of place at the same time that it rephrases the ideas of abstract painting with magisterial concentration. Diebenkorn died in March 1993, after a long illness. ❑

them represent.

Part of the vocabulary of color is how some shades seem warm (the yellow-to-red scale), others cool (the blues and greens); and how warm colors seem to advance toward the viewer's eye, cool ones to recede.

tures' quality as "pure painting." So he returned to abstraction, and the "Ocean Park" series—in which, however, many viewers see the light and atmosphere of Santa Monica. Ultimately Diebenkorn would say that

tion; a dozen works are from the bequest of a private California collector. ❑

What signals that Diebenkorn's porch is in the foreground, that the sea is distant? The porch is a near-orange, the sea a dark blue. Color does the work of drawing—for there is little in that orange sheet to suggest depth, perspective, or even wood. ❑

when a painting was "alive and successful" it was equally abstract and representational: "A realistic or nonobjective approach makes no difference." ❑

Ocean Park No. 107, **1978—one in a series of late abstractions named after Diebenkorn's oceanside Santa Monica neighborhood.**

The Art Special Gallery and the Oakes Gallery display changing exhibits. Video art is shown in the Oakes Observatory. Estuary Park, a new 22-acre garden near the museum, has been opened to show large sculptures. ❑

MUSEUM HOURS
Wednesday–Saturday:
10 a.m. to 5 p.m.
Sunday: Noon to 7 p.m.

ADMISSION
Admission charged.
Free to museum members and children 6 and under.

FIGURE ON A PORCH

THE ARTIST

➤ for one semester to the art department of the University of California, Berkeley. The teaching here was rigorous and modern, but a poor preparation for his subsequent posting, a mapmaking assignment in Quantico, Virginia. Having supplied him with art materials, the army found his skills wanting (they mostly hired Walt Disney animators) and gave him little to do—a chance for him to paint.

On weekends, Diebenkorn and his wife, Phyllis, visited the Washington and Philadelphia

museums to see the modern masters. And he saw an art magazine featuring members of the budding Abstract Expressionist generation: "I didn't know who these people were, but they grabbed

Diebenkorn painted *Urbana #5 (Beachtown)* in 1953 during his initial fascination with nonobjective painting.

me." Diebenkorn became an abstract painter in Quantico—a debt that the world of art owes the U.S. Marines.

The war ended just before Diebenkorn was to fight in the Pacific. Returning home, he enrolled at San Francisco's California School of Fine Arts. In 1946–47, a grant designed to allow California artists to visit the East sent him to

Woodstock, New York, and to a house that seemed always snowbound. He and Phyllis visited New York occasionally, but mainly he worked long hours alone; it was a period, he would say, of "teaching myself to paint."

Diebenkorn spent 1947–50 studying and teaching at the California School of Fine Arts. These were the first glory days of Abstract Expressionism, which he followed from a distance, but California artists felt themselves estranged from New York: a colleague of Diebenkorn's, Elmer Bischoff, would remember their "strong feeling of self-sufficiency, not without chauvin-

THE TECHNIQUE

➤ fairly uniform field of vibrant mustard-to-orange at the bottom, above it a more broken belt of green, then the darker tier of blues and blue-greens. As these horizontals combine with verticals and diagonals,

they subliminally suggest a grid—a basic way of organizing a picture. (Diebenkorn has evidently studied the abstract grids of the Dutch painter Piet Mondrian.) The strongest of the verticals is the purple-and-black pillar representing the figure. Her skirt is one of several black patches—rough rectangles, trapezoids, and ovals—aligned in an oblique slash through the picture this disturbance of the grid's geometry pushes the painting toward nature, where grids are rare. But Diebenkorn hasn't given the black shapes any detail, and it's not clear what all of

THE SUBJECT

➤ hasn't created much similarity between image and subject. Less interested in a particular person or place than in art itself, he wants to know what kinds of mark paint can make without losing its meaning as description. The answer is surprisingly broad. During Diebenkorn's first abstract period, when he

was trying for "nonobjectivity" in what he called "a pure painting space"—pure paint and canvas, without identifiable objects—he would often find he had accidentally evoked a figure in a landscape. For a time he shunned the color blue, afraid of its associative power: his eye wanted to see it as water or sky.

Eventually Diebenkorn went in the direction of *Figure on a Porch*, tying together description and what he had learned from abstract art. At first, he found, "What constituted painting, for me, changed hardly at all." Later he came to feel that the psychological presence of human figures suppressed the pic-

THE PROVENANCE

➤ The Oakland Museum, an early supporter of Diebenkorn's works, now has a large collection spanning the artist's career. Many of the holdings have been gifts of the Women's Board of the museum associa-

"Temperamentally I have always been a landscape painter."

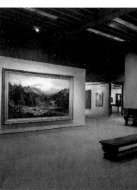

THE MUSEUM

➤ ing, a three-tiered complex of galleries, terraces, and gardens designed by Kevin Roche and John Dinkeloo, opened in 1969.

The art gallery, located on the third level, displays over 500 works of California art from the days of exploration to the present.

In the collection are paintings such as Albert Bierstadt's *Yosemite* and the Diebenkorn featured here, Depression-era pho-

tography by Dorothea Lange, and contemporary ceramics.

FIGURE ON A PORCH BY RICHARD DIEBENKORN

THE ARTIST

Modernist abstract art is nearly a century old, but some still see it as an artists' in-joke designed to fool us all. A painter like Richard Diebenkorn, though, shows us abstraction as a matter of study and discipline. Like many successful artists today, Diebenkorn lived a quiet life of hard work. "I'm really a traditional painter," he once said, "not avant-garde at all." Expanding on what was by his time an established practice, for a while he even stretched abstraction into its familiar opposite: landscapes, still lifes, and figure paintings.

The painter in his studio, 1986, by Marina Schinz.

Diebenkorn was born in 1922 in Portland, Oregon, where his father was a business executive. The family moved to San Francisco when he was two. Diebenkorn would remember of his schooldays that although he "didn't want to be different—I was." A solitary child, he painted as "a sort of elaborate note-taking with references to my private world."

Diebenkorn's inspiring maternal grandmother once told him, "It is one of the great professions of life: to be an artist." His father, on the other hand, didn't think

art "a respectable or worthy goal for a man." At Stanford University, under pressure to study medicine or the law, Diebenkorn was saved by World War II: the army, his father felt, would limit the damage of an art major. In 1943 Diebenkorn married, joined the Marine Corps Officer Training Program, and was transferred ➤

THE TECHNIQUE

"It is well to remember that a picture—before being a war horse or a nude woman or an anecdote—is essentially a flat surface covered with colors assembled in a certain order." So wrote French painter Maurice Denis, in a famous credo that Diebenkorn knew well. He himself spoke of discovering that "a painting's pictorial structure could be seen apart from its objective stimulus"—apart, that is, from the scene it described. *Figure on a Porch* seems to depict a particular place and moment, but its "objective stimulus," though unmistakable, is in fact minimally evoked. Its "pictorial structure," however, is typically declarative.

***Palo Alto Circle*, 1943, recalls Edward Hopper's New York in *Early Sunday Morning* (see pages 134–137)—but with a California twist of light.**

Figure on a Porch is a schematic stack of horizontal bands—a large, ➤

THE SUBJECT

If the landscape in *Figure on a Porch* easily breaks down into a grid of rectangles, the reverse is also true: as our eyes try to make sense of what they see, we instinctively struggle to resolve abstraction into a recognizable scene. Imagine finding the head of the woman in *Figure on a Porch* on a piece of paper by

itself: you'd think it was, for instance, a thumbprint. In the context of the painting, though, you understand that blot as a head.

So: a woman stands on a sundeck, looking out toward a long bay and the land on the other side. The shadows show that the sun is high, but the work's greens and darks, and the

weight of the opaque, solid-looking bars that signify sky and sea in the work's cool upper third, absorb and damp the light. They make the mood somber, perhaps lonely. If Diebenkorn has looked at Mondrian, he has also admired Edward Hopper.

Unlike Hopper, however, Diebenkorn ➤

THE PROVENANCE

Diebenkorn painted *Figure on a Porch* in 1959. The following year, it was given to the Oakland Museum of California by an anony-

mous donor through a program organized by the American Federation of Arts to assist museums create traveling exhibitions. ➤

THE MUSEUM OAKLAND MUSEUM OF CALIFORNIA

The Oakland Museum is located at 1000 Oak Street. Dedicated to the history and arts of California, the muse-

um comprises four halls: the Great Hall (displaying changing exhibits), the Hall of California Ecology, the

Cowell Hall of California History, and the Gallery of California Art.

The museum build-➤

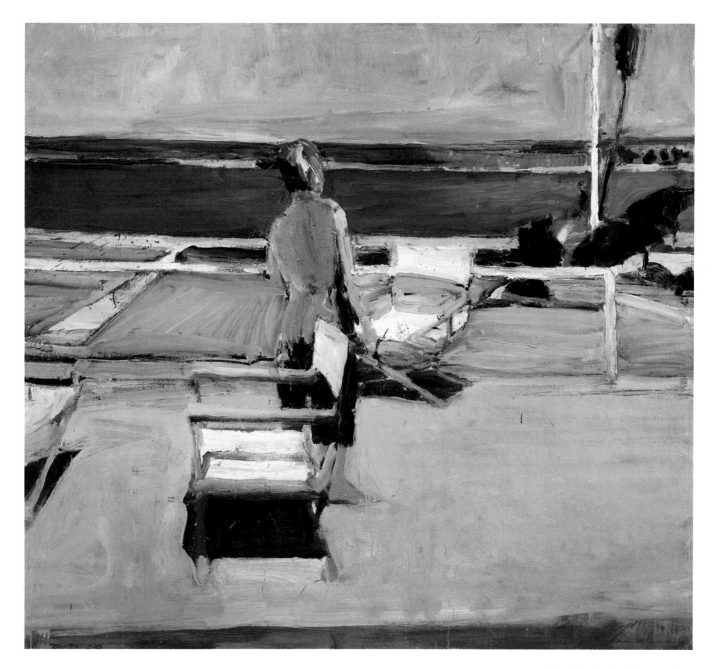

FIGURE ON A PORCH
by Richard Diebenkorn, 1959
oil on canvas
57 x 62 in. (144.8 x 157.5 cm.)
Oakland Museum of California
Oakland, California

pher, "As the most interesting part of my life is of no concern to the public, I must decline to give you any particulars in regard to it."

Homer's art focuses progressively less on people and more on nature. A turning point came in 1881–82, which he spent mostly in the English fishing village of Cullercoats on the North Sea, painting that harsh ocean and coastline, and also the village's women as they worked along the shore and watched the storms. (Homer loved storms—when the sea was calm, he called it a "damned pond.") On returning to the United States Homer moved to Maine. His father

and brothers had bought a house on a rocky knob of coast called Prout's Neck, where they spent the summers. In other seasons the place was isolated, windy, and cold. Converting the house's barn into his home and studio, Homer lived there year round. He traveled occasionally, painting in the mountains, visiting his family, or, in winter, sometimes escaping to

Winslow Homer (*left*) and his brother Charles fishing at Prout's Neck, Maine, in 1900. Homer's move to this secluded coastal village in 1883 gave him close contact with the sea, a subject that dominated his late paintings.

the Caribbean, but most of his time, he allowed, he passed "out of gun shot of any soul."

Homer's late work depicts wild land and sea, and humankind's dubious place in them. Eventually people virtually disappear. So it was in his life: though he cherished his family, other

visitors to his studio might not be asked in. Alone, he drank steadily: to a friend who asked him about the empty bottles around the house, he replied, "Don't know, John, I never bought an empty one in my life."

Homer's health failed in his old age, yet he was still painting in 1909. The following year he had a stroke. In bed a few weeks later, he sat up, asked for "a smoke and a drink," and died. ❑

Painted the year before Homer's death in 1910, *Right and Left* revisits the prey and predator theme of *Fox Hunt*. Here two ducks die from a single discharge of a double-barreled shotgun; the hunter and the gunblast are barely visible in the middle background.

example, to set the image sliding, unsettling the stillness that comes when the pictorial elements are on the same level within the frame.

All these characteristics appear in *Fox Hunt*, where the fox is a slantwise bar against a blank field, and the crows' wings are parallel diagonals. The whole space, in fact, is diagonal, defined by the

uphill slant of the fox's flight, which the painting's horizontal format compresses . The white of the snow is picked up in the waves, clouds, and distant light on water; against this white and steel-gray winter palette the fox is a washed-out brown. The picture also relates to magazine illustration in its narrative quality: the fox vulnerable in the snow to the crows' attack. ❑

them ain't crows." So he replaced his first attempts with birds painted from life, lured by scattered corn.

Homer always wanted this kind of accuracy. His dedication to painting outdoors and, early on, to scenes of contemporary life echoes French Impressionism, and he is sometimes seen as an American Impressionist. But

In this woodblock for *Harper's Weekly*, 1867, Homer used strong diagonals to create depth in a medium known for its pictorial flatness; the same technique adds dimension to *Fox Hunt*.

a certain grim Yankee matter-of-factness in Homer separates him from the French. For *Right and Left*, one of his last works, showing two ducks shot in midair by a hunter, he asked a neighbor to fire blanks up the Prout's Neck cliffs at him so he could see what a shotgun blast looked like from the receiving end. ❑

why I should paint any pictures.")

In 1900 Homer sent *Fox Hunt* and several other of his paintings to the International

in His Museum, and Benjamin West's *Death on a Pale Horse*. The museum's collection also includes the work of its most well-known students and that of

contemporary American artists.

The Morris Gallery is devoted to exhibiting new work by Pennsylvania artists. ❑

Universal Exposition in Paris, where he received honors. ❑

FOX HUNT

THE ARTIST

➤ gether too small for a man to have a large idea in," and lived by contributing prints to *Harper's Weekly* magazine. When the Civil War came he covered the military campaigns, emphasizing the tedium and melancholy of army life.

It was 1862 before Homer began to paint. Exhibiting his first two oils, both soldier scenes, he announced that if they didn't sell he'd return to full-time magazine work. Homer's brother Charles stepped in, buying both works, but keeping his identity secret. When Winslow found out years later, he was furious, but by then he was already a painter.

The war over, Homer spent 10 months in France. Little is known of his life there; his prints in *Harper's* reveal that he visited the Louvre, but if he looked at the new French art no record of his interest survives. Back in New York, Homer began painting an America at play—swimmers, sailors, croquet players. In the 1870s he broadened his range to include black farm workers in Virginia. When a Southern belle asked, "Why don't you paint our lovely girls instead of these dreadful creatures?" he replied, "Because these are the purtiest."

Homer visited Petersburg, Virginia, in the mid-1870s; several paintings from this period, including *The Carnival (left)*, depict the life of black laborers in the South after the Civil War.

Some writers have used Homer's portraits of women from these years as clues to his romantic life. He was sociable when younger, and a friend ascribed him "the usual number of love affairs," but he never married, and later grew solitary. A private man, Homer once told a potential biogra-

THE TECHNIQUE

➤ that a gifted artist would naturally turn to strengths. For the nearly 20 years that Homer was a magazine illustrator, a copyist would carve his drawings into the wooden block from which the image would be printed. Like all artistic techniques, the method affected the form: to make the copying easy, quick, and accurate, the illustrators leaned toward clean lines and large shapes, graphic contrasts reinforced by the routine of working in black and white. Unlike the metal plates used to print engravings, the wooden blocks resisted fine detail, encouraging artists to leave bare, ungradated areas that restricted their power to suggest depth and space. To avoid a flat, static image, they had to find other ways to animate the picture— strong diagonals, for

THE SUBJECT

➤ hungry crows gather to attack a fox trapped by thick snow. The fox faces away from the viewer, forestalling the sentimentality of direct engagement. He is caught in mid-step, and the birds are suspended above—the viewer is in the thick of the action. Meanwhile, a distant sea is calm and timeless.

To paint the work, Homer arranged dead crows and a fox pelt outside his studio in winter, to be frozen in place by the cold. The season, however, was unexpectedly warm: "The weather keeps thawing," Homer wrote in a letter, "and the crows get limp." When he showed the painting to the local stationmaster, the man remarked, "Hell, Win,

THE PROVENANCE

➤ first major sale to a public gallery and came at an opportune time, since his works had not been selling well. (In 1893 he had written to a Chicago dealer, "At present and for some time past I see no reason

"I do my own work. This is the only life in which I am permitted to mind my own business."

THE MUSEUM

➤ ornate High Victorian architecture.

The academy's golden period was in the late 19th and the early 20th centuries. Beginning with realist painter Thomas Eakins' tenure as an instructor in 1876, the academy trained some of America's greatest artists: Mary Cassatt, John Marin, Robert Henri, John Sloan.

The art museum's holdings are predominately American. Among the famous paintings from America's early masters are Gilbert Stuart's "Lansdowne" portrait of George Washington, Charles Willson Peale's self-portrait. *The Artist*

FOX HUNT BY WINSLOW HOMER

THE ARTIST

Winslow Homer in New York City, ca. 1880.

One of the 19th century's best American artists, Winslow Homer gave landscape painting a gritty Yankee directness. He wanted to capture the real. "When you paint," Homer once advised, "try to put down exactly what you see. Whatever else you have to offer will come out anyway."

Born in 1836, Homer grew up in and around Boston. His father Charles was an importer who, in 1849, sold his business, hoping to get rich in the California Gold Rush. The Homers, respectable but not wealthy, were soon less wealthy still. It would have been difficult for them to send Winslow to college, and he was a poor student anyway, always filling his books with drawings. So when Charles saw a newspaper advertisement reading "Boy...must have taste for drawing: no other wanted," he urged his son to apply.

At 19 Homer found himself making prints for a commercial lithographer. He hated the job and quit when his two-year apprenticeship was up. Liberated, he became a freelance magazine illustrator. In 1859 Homer moved to New York, took a studio a friend thought "alto- ➤

Homer covered the Civil War as a magazine illustrator. This color study shows a youthful Union cavalry soldier almost lost inside a uniform meant for an older man.

THE TECHNIQUE

"If a man wants to be an artist, he should never look at pictures." So Homer believed, vexing his relationship to art history. Where did his style come from? Some critics find influences in the Japanese prints that began to circulate in Europe and the United States after the mid-1850s, and that would deeply influence French painting. Homer could easily have seen them. In Paris in 1866–67, he could also have seen an exhibition by Édouard Manet, who had certainly thought about Japanese art. But little is known of what Homer saw in Paris, or of how he reacted to it.

There's another argument: that paintings like *Fox Hunt* are formally related to qualities of the woodblock print, limitations➤

THE SUBJECT

If the younger Homer enjoyed scenes of daily life and leisure, his later work is more concerned with the brute elements, and with the struggle for survival. Many of these paintings describe dangerous struggles, sometimes obvious, more often understated. In *The Gulf Stream*, 1899, a black sailor floats in a disabled boat, sharks surface greedily, and a tor-

nado nears. (Exasperated by squeamish viewers, Homer wrote to his dealer, "You may inform these people that the Negro did not starve to death. He was not eaten by the sharks. The waterspout did not hit him. And he was rescued by a passing ship.")

Fox Hunt clearly fits in Homer's Darwinian vision of survival of the fittest:➤

THE PROVENANCE

Homer painted *Fox Hunt* in 1893; it is one of only a few winter scenes among his works and is also the largest. Despite its grim topic, Homer called it a "*very beautiful* picture." The same year, it was shown at the annual art exhibition at the Pennsylvania Academy of Fine Arts in Philadelphia. The academy often purchased works from the exhibition; it bought *Fox Hunt* directly from Homer in 1894. It was Homer's➤

THE MUSEUM PENNSYLVANIA ACADEMY OF THE FINE ARTS

The Pennsylvania Academy of the Fine Arts is located on Broad and Cherry Streets in Philadelphia. Established in 1805, it is both an art museum and an art school—the brainchild of American painter Charles Willson Peale and 70 fellow Philadelphians interested in promoting the fine arts in the young American republic.

The present academy building, designed in 1871 by architects Frank Furness and George Hewitt and opened in 1876, is a commanding example of➤

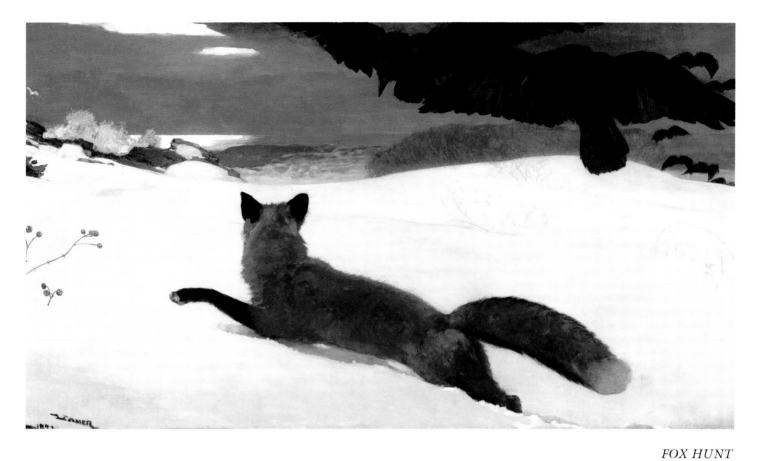

FOX HUNT
by Winslow Homer, 1893
oil on canvas
38 x 68½ in.(96.6 x 174.2 cm.)
Joseph E. Temple Fund
Pennsylvania Academy
of the Fine Arts,
Philadelphia, Pennsylvania

ally producing Cubist works, he had begun remodeling French neoclassicism and other earlier art. To some of the younger artists Picasso seemed conservative: the Surrealists admired him, but there were Dada artists who thought him "dead on the field of battle." The announcement was premature: Picasso had resource to spare.

With *La Danse*, 1925, for example, he began distorting his figures monstrously, in paintings not so much inspired as provoked by Olga. (Theirs was one of the great lousy marriages.) Later rearticulations of the body, though, are lovely, as when he painted his mistress Marie-Thérèse Walter, whom he met in 1927. There would be other women—Olga left in 1935—and he would often paint their portraits, not always kindly. He once described love as "two bodies wrapped in barbed wire, each tearing the other to pieces."

Despite a certain ferocity in Picasso's work and life, he had deep humanitarian sympathies. In 1937, these and his Spanish allegiance led him to paint *Guernica*, his great protest against the bombing of that town by Francisco Franco's Nazi-supported fascists during the Spanish Civil War. Spending World War II in Paris, Picasso would give German soldiers postcards of *Guernica*, exclaiming, "Souvenir!" In 1944, after the Liberation, he joined the French Communist Party, less for ideological reasons than as an antifascist—and also, perhaps, in search of lost community. In the Party, he said, "I am once more among my brothers."

Picasso never returned to Spain after Franco's victory. For years, however, his love of Mediterranean culture had often brought him to the south of France, where he finally settled for the remainder of his life. Though his innovations were largely over after the war, he continued to mine the styles he had invented with enormous imagination. Picasso lived until he was 91; there are drawings and prints dating to his last year. He died in 1973. ❑

n the
frica's
er see-
at a
907,
ree of
emoi-
o show

the grays between them.

Against the body's immovable sturdiness, how delicate the head is. The eyes are large, wide open, and black. Though asymmetrically placed, they have the geometric evenness of statuary, and the stillness. The face too, minimally modeled, is still. Whatever else that expression means, it is profoundly alert. ❑

archaic statue, sets him outside his time, outside Paris, outside the painting conventions he knew. Iberian art gave Picasso a space to stand in while he advanced the "sum of destructions" he imagined painting to be. Maybe he realized that to remake his tradition he had to move outside it—just as you leave a house before pulling it down. ❑

Picasso painted this monumental work (measuring over 11 feet by 25 feet) after the bombing of Guernica in April 1937 during Spain's civil war. Earlier that year, he had been asked to paint a mural for the Spanish Pavilion at the World's Fair in Paris; *Guernica* would be that mural. The bull, a recurring motif in many of his works, stands over the town's victims at left.

contained 170 works, including examples by Picasso, Braque, Henri Matisse, Piet Mondrian, and other modern artists. That year, the university moved to evict Gallatin to make room for an expansion of its library. Hearing the news, a curator from the Philadelphia Museum of Art persuaded Gallatin to loan his collection to the museum. Gallatin left the collection to the museum in a 1952 bequest. ❑

just a few blocks from the art gallery and houses the largest collection of Auguste Rodin's works outside of France. Here in the garden can be found a version of the famous sculpture *The Thinker*. ❑

MUSEUM HOURS
Tuesday, Thursday–Sunday:
10 a.m. to 5 p.m.
Wednesday:
10 a.m. to 8:45 p.m.

ADMISSION
Admission charged.
Free to members.
Free to everyone from 10 a.m. to
1 p.m. on Sunday.

son was to the Wright
, the pioneers of flight,
ism's faceted planes and
were just as much an
e—a new pictorial space,
donment of visual codes
ince the Renaissance.

World War I, Picasso's
ity fragmented. Many
ned the army; Picasso, as
a Span-
iard, was

exempt. He was vacationing with
Braque and the painter André
Derain when the war began: "I
took Braque and Derain to the
station....I never found them
again." Those artists who sur-
vived the front returned from it
changed. And while they had
been fighting, Picasso had grown
rich and famous: some American
soldiers on leave rated him along-
side the Eiffel Tower as the Paris
sight they most wished to see.

Designing sets and costumes
for the Ballets Russes in 1917,
Picasso had met a dancer, Olga
Koklova, whom he soon married.
Meanwhile, though still occasion-

waist's curve under the right
arm, the wedges of gray under
the left arm, and little else.
That gray is carried over
into the backdrop—except
for Picasso's skin and his
palette, in fact, the paint-
ing is white, black, and

turning to
oking for a
art's weary
at had won
purpose.
ot there to
of waging
works like

Self-Portrait with Palette,
he was fighting for art's
place in the world.

Perhaps his pose here
is a warrior pose: con-
tained, muscular, poised,
intense, aware. And that
impassive face, the face of an

earch means nothing in painting. To
find is the thing."

llection of works by
uchamp (including
nding a Staircase), the
ion of Vincent van
nflowers in the United

States, and a Japanese tea house
and garden—planted with live
bamboo.

The museum also adminis-
ters the Rodin Museum, which is

SELF-PORTRAIT WITH PALETTE BY

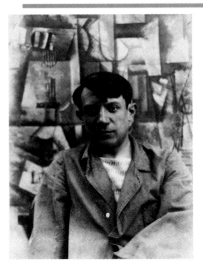

Pablo Picasso, 1912, in front of his painting *The Aficionado*.

THE ARTIST

Pablo Picasso is the patr
modern art, the dominati
ence, the one to beat.
knew it. A small bull of
he often painted bulls ar
taurs—he saw art literally
His energy was as tirele
imagination: sometimes
three canvases a day, he
many media, and even in
couple. It is impossible
ine modern art without h

Picasso was born in
Málaga, Spain. A child
he drew constantly.
words were "Piz, piz,"
"lápiz,"
pencil.

THE TECHNIQUE

In the spring of 1906 an exhibition of recently
excavated ancient Iberian sculpture opened at
the Louvre. Patriotically Spanish, Picasso saw
the show; shortly after, he took a vacation in
Gosol, a village in northern Spain. While there
he decided he was unhappy with a portrait he
had been working on, of the American author
Gertrude Stein, and painted the face out.

THE SUBJECT

Picasso painted self-portraits regularly when
he was young. But for a genre demanding
introspection and self-analysis, the masklike
face and averted eyes in *Self-Portrait with
Palette* are skimpy on psychology. Why did he
choose this style?

Picasso's concern with ancient Iberian
sculpture corresponded to an important idea
in moderni
tional Euro
to the mo
look outsi
either escap
Paul Gaug
van Gogh l
Portrait w

THE PROVENANCE

Painted in 1906, *Self-Portrait with Palette* stayed with Pi
1929, when he sold it to Albert Eugene Gallatin, a w
American collector of modern art. Two years earlier, Galla

THE MUSEUM PHILADELPHIA MUSEUM OF ART

The Philadelphia Museum of Art
is located at 26th Street and
Benjamin Franklin Parkway in
Philadelphia, Pennsylvania. The
museum was created as an out-
growth of the Center
sition in Fairmont Par
The building that was
play the industrial and
arts for the exposition

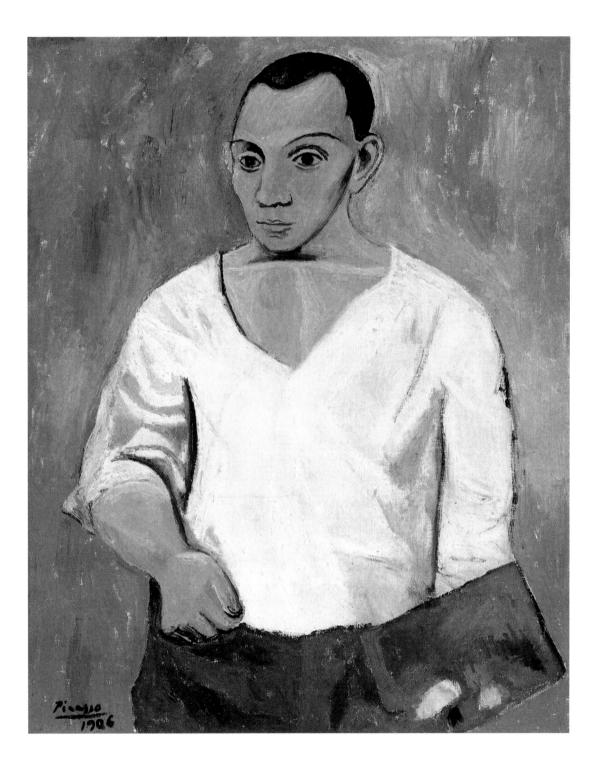

SELF-PORTRAIT WITH
PALETTE
by Pablo Picasso, 1906
oil on canvas
36¼ x 28¾ in. (92 x 73 cm.)
A. E. Gallatin Collection
Philadelphia Museum of Art
Philadelphia, Pennsylvania

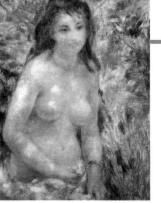

Nude in the Sunlight, 1875. Renoir found "tiny tints" in this woman's bare skin; a critic of this painting saw "rotting flesh, with green and purple patches."

would recall, or "broke the window panes, martyrized the model, disturbed the professor. I was always quiet in my corner, very attentive, very docile, studying the model, listening to the teacher." He would repeat some of Gleyre's precepts until he died (particularly the advice to "always choose very young models—decay starts at 18"). And yet, as he acknowledged, it was he who was called the revolutionary.

This was largely because of his color, that amazing eye that saw a woman's bare skin as "thousands of tiny tints." (A reviewer of 1876 suggested, "Try explaining to M. Renoir that a woman's torso is not a heap of rotting flesh, with green and purple patches, like a corpse in an advanced state of putrefaction.") Renoir admired the Romantic painter, Eugène Delacroix, a vibrant colorist who had earlier broken with establishment esthetics; he also admired Delacroix's neoclassical rival, Jean-Auguste-Dominique Ingres. In fact, he was steeped in earlier art. And his technique wasn't so new that he couldn't find himself in them: the 16th-century Venetian painter Titian, he said, was "forever stealing my tricks."

Ask Monet where he had learned to paint, and he, grandly, would claim the sky as his teacher, as if he had no forebears. More honest, Renoir would reply, "In museums, parbleu!" In 1919, the year he died, he visited the Louvre in a wheelchair to see its paintings again when they came out of storage after World War I. The fact is, a complete rupture in art is impossible; all revolutions arise from ideas available at the time. The most original artist is always mixing old and new. ❏

strongest form, for example, because its white cloth jumps out at you, is its table—which is off-center, and slightly askew from both the picture frame and the railing. Veronese's architectonic spectacles may have convinced 16th-century Venice, Renoir seems to say, but modernity demands a softer, more flexible order. ❏

Veronese's *Marriage Feast at Cana.* The table scene at the lower left may have inspired the composition of *The Luncheon of the Boating Party.*

Impressionist painter Gustave Caillebotte, straddling a chair at the lower right.

If Renoir's inspiration here is indeed Veronese's *Marriage Feast*, it may have amused him to liken Christ's apostles in that painting to this sociable bunch. Perhaps he linked Christ's miracle at Cana, the transformation of water into wine, to his friends' bottle-laden table; perhaps he even enjoyed the pun between "Cana" and his own work's French title, *Le Déjeuner des canotiers*. It is a dramatic display of the Impressionist declaration that the stuff of painting was neither the heroic nor the holy but everyday life. ❏

t of art rand-Ruel,

pressionists, including Claude Monet.) Durand-Ruel resold *The Luncheon* later in the same year, but not long after, he reclaimed it—apparently his client, a banker, failed to pay for it—and it stayed in his collection until his heirs sold it in 1923 to American collector Duncan Phillips for $125,000. The painting is now in the Renoir Room of The Phillips Collection art museum. ❏

caught fire.) The gallery also features works by modern artists such as Henri Matisse, Georges Braque, Paul Klee, Mark Rothko, and Richard Diebenkorn.

The Phillips offers lectures, gallery talks, workshops, and free chamber music concerts. ❏

THE LUNCHEON OF THE BOATING PARTY

THE ARTIST

➤ In the Impressionists' time, new industries, new technologies, and new cityscapes were transforming Western life. For many artists, painting, based on the kind of skilled handcraft that the industrial age was everywhere obliterating, was a refuge from modernity. (Renoir, when he was decorating porcelain as a teenager, was laid off when a machine came along to do his job.) Yet if painting was to survive in this brave new world, it was going to have to change. Thus Renoir became a rebel despite himself, using a novel style for ultimately preservationist ends.

The school of the academic artist Charles Gleyre, where Renoir took classes from 1861 to 1864, was a conservative place where students drew and painted from the nude model six days a week. And Renoir went there for a conservative purpose: he rightly thought it would help him get into the traditional École des Beaux-Arts. By contrast, Claude Monet only attended Gleyre's school to placate his father and

The first Impressionist exhibition catalog cover, 1874 (*left*). The site of the exhibition was the Paris studio (*below*) of the photographer Nadar.

had no interest in the École.

Stuffy but goodhearted, Gleyre taught *gratis*, charging students only a share of his expenses. The classes attracted a diverse set: "graybeards who had been drawing and painting there for thirty years...younger men, who in a year or two, or three or five, or ten or twenty, were bound to make their mark...others as conspicuously singled out for...the hospital, the garret, the river, the morgue, or, worse, the traveler's bag, the road, or the counters of their fathers' shops." Renoir stood out from this crowd. "The others shouted," he

THE TECHNIQUE

➤ *Marriage Feast at Cana*, which Renoir knew—it is at the Louvre. Indeed, Veronese was a favorite artist of his.

In compositional terms, *The Luncheon* shows well how Renoir combines old and new. He builds his picture against his outdoor restaurant's railing, from lower left to upper right. If he'd followed the perspectival rules of *Marriage Feast*, he'd have given this railing a matching orthogonal on the right,

trained at a central vanishing point. He would also have distributed his figures relatively evenly around the picture. Instead, he lets that railing crowd most of them into the work's right half. It is as if Renoir had focused on a single corner of *Marriage Feast*—one table at the banquet. Imagine a mirror image of *Luncheon* set against the work's right edge and you arrive at the perspectival system of Veronese's painting.

This fragmentation of Renaissance perspective is reinforced by other careful carelessness. *The Luncheon's*

THE SUBJECT

➤ ent classes and of both sexes all get together and talk. It is a vision of the promise of modern urban life. Nor was this only fantasy: *The Luncheon of the Boating Party* preserves not only a specific place, the Restaurant Fournaise on the Seine, but specific people, an identifiable group of Renoir's friends.

In personal terms the most significant of these is the woman who

has set her dog hygienically on the table: Renoir's future wife, Aline Charigot. Standing behind her, Alphonse Fournaise, the restaurant's owner, looks toward his two children, Alphonsine and Alphonse Jr., both disposed along the railing at the group's edges. The man in the top hat talking to Alphonse Jr. is Charles Ephrussi, a banker and a collector of Renoir's work. For the rest, the man best known to history is the

Renoi[...] dealer[...] 1910.[...]

THE PROVENANCE

➤ Needless to say, the result wasn't one extremely lengthy lunch, but a series of sittings, with different people present at different times.

In February 1881 Renoir sold the painting to the art dealer Paul Durand-Ruel. (He was key to the commercial success of many of the Im-

THE MUSEUM

Duncan Phillips and his wife Marjorie in the main gallery, ca. 1922.

➤ the art collection. An annex was built in 1960; another was finished in 1989.

The Phillips Collection is particularly strong in works by the French

Impressionists and Post-Impressionists. (Phillips' favorite was a self-portrait by Paul Cézanne; he said it was the first thing he would rescue if the gallery

THE LUNCHEON OF THE BOATING PARTY BY PIERRE-AUGUSTE RENOIR

THE ARTIST

Pierre-Auguste Renoir, self-portrait, ca. 1899.

Cartoon mocking the third impressionist show in 1877. Man says: "But these are the colors of a corpse!" Painter says: "Indeed, but unfortunately I can't get the smell."

For almost 100 years beginning in the mid-19th century, Paris was famous for radical aesthetic change. A series of artistic innovations caused a succession of outrages—although as time went by it got harder to get a rise out of people. (Indeed, André Breton, leader of Paris' Surrealist movement of the 1920s and '30s, was reduced to arguing that the ultimate artistic act would be to fire a gun into a crowd.)

The contemporary viewer of Pierre-Auguste Renoir's radiant paintings may find it hard to see how Impressionism fits in this chain of affronts. Yet the first writings on Renoir and the other Impressionists are sprinkled with words like "madmen," and at an Impressionist sale in 1875, police had to quiet the crowd. Actually Renoir (his life is outlined in the section on *A Girl with a Watering Can*, pages 90–93) was an equivocal radical. Born in 1841 to a poor tailor and a seamstress, Renoir was himself an artisan at one time and seems to have seen art as a doorway to a more refined, more beautiful, happier existence—not just for him (in fact for years painting brought him only poverty) but for anyone looking into his visual world. ➤

THE TECHNIQUE

Today, a painting like *The Luncheon of the Boating Party* seems deceptively straightforward, perhaps because cameras make it look easy to picture a group of people, apparently unposed in the comfortable stances of the good life, their places relative to each other both clear and seemingly natural. In painting, though, this is hard to do. Few works in this book attempt what Renoir tries here. The one that comes closest is Bruegel's *Wedding Dance* (pages 50–53).

The apparently casual take on everyday life was a trademark of Impressionism, and one of its departures from French academic art. Even so, in *The Luncheon* Renoir is not so much bringing something new into the world as wrenching a tradition around to his own ends. He has art-historical precedents for the subject of the shared meal, most famously Leonardo da Vinci's *Last Supper*. A likelier inspiration, though, is the 16th-century painting by Paolo Veronese,➤

THE SUBJECT

"I'm doing a picture of boaters," Renoir wrote a friend in the summer of 1880, "which I've been itching to do for a long time. I'm getting a little old and I didn't want to postpone this little festivity....One must from time to time try things beyond one's strength." *The Luncheon of the Boating Party*, of course, was that picture. Renoir didn't finish the work until early the following year, and worried about finishing it at all. His concern was partly financial—one of his larger canvases, *The Luncheon of the Boating Party* took a lot of paint. But on other terms too it was one of his most ambitious works.

The hats tell the story: from boaters to bowlers to an aristocratic gent's conspicuous topper. *The Luncheon* proposes a civilized model of social interchange in which a good-sized group of people of differ-➤

THE PROVENANCE

Renoir worked on and off on *The Luncheon of the Boating Party* from the summer of 1880 until early in 1881. Part of the delay was the difficulty in getting his friends to the Restaurant Fournaise: whereas a photograph demands that everyone be in the same place only for the short time it takes to make the shot, the diners in *The Luncheon* had to sit still for as long as Renoir asked. ➤

THE MUSEUM THE PHILLIPS COLLECTION

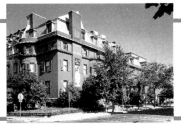

The Phillips Collection gallery is located at 1600 21st Street N.W. in Washington, D.C. Founded by art collector Duncan Phillips in 1921, the museum was first opened in two rooms of his house. The original neo-Georgian house was built in 1897 for Duncan Phillips' parents. Less than a decade after the gallery opened, Phillips and his family moved out to make room for➤

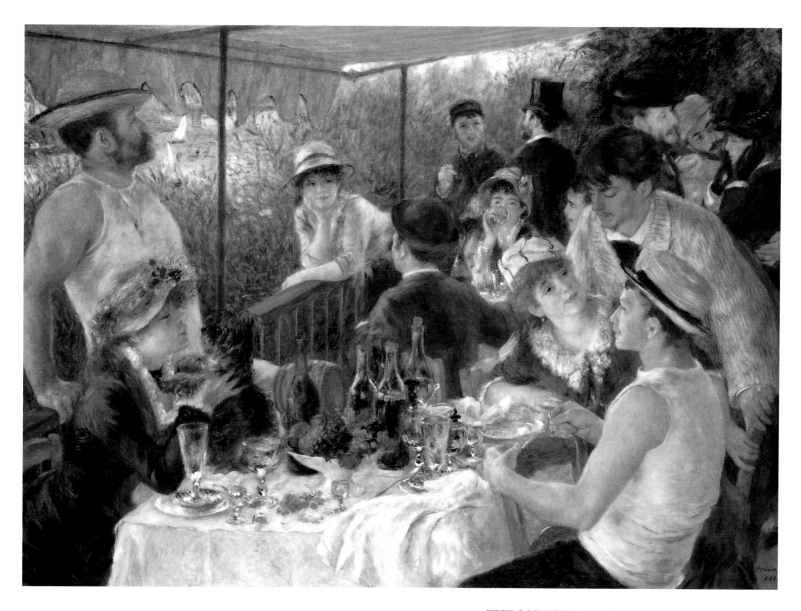

THE LUNCHEON OF THE BOATING PARTY
by Pierre-Auguste Renoir, 1881
oil on canvas
51 x 68 in. (129.5 x 172.7 cm.)
The Phillips Collection
Washington, D.C.

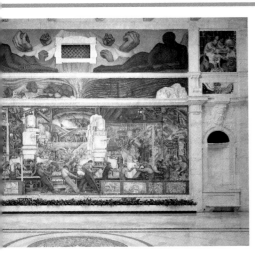

rth wall, the Detroit Institute of Arts, 1932–33. The
workers inside a Ford automobile factory is
echnology. A machine-enthusiast, he spent over a
assembly process at the Ford industrial complex.

folds, sometimes sleeping there. The murals made him famous.

Fame brought commissions, some of them in the United States. Ironically, though Rivera had been in and out of the Communist Party, the first American commission was in San Francisco's Pacific Stock Exchange in 1930. San Francisco made Rivera welcome, but in 1933 his murals in the Detroit Institute of Arts only survived conservative protest through the support of the auto magnate Edsel Ford. And this was just the rehearsal for Rivera's battle the same year in New York City's Rockefeller Center: asked to remove a portrait of Russian revolutionary Vladimir Lenin from a large project, he refused, and the murals were destroyed.

In 1929, Rivera had married Frida Kahlo, herself a remarkable painter. The couple were the radical chic of their day, their lives a round of demonstrations, committees, and art. Their marriage was a difficult but devoted one: divorced in 1939, they remarried in 1940.

In 1948, Rivera included the slogan "God Does Not Exist" in a mural in the Hotel del Prado in Mexico City. The hotel management covered up the painting. The next decade was full of diffi-culty: in 1950, the aftermath of an operation hospitalized Kahlo for almost a year, with Rivera sleeping in the room next door. She died in 1954. The following year Rivera was diagnosed with cancer; at this point back in the Communist Party, he went to Moscow for treatment, and believed himself cured. In 1956, though, something made him join the Catholic church. When that happened, the hotel mural was uncovered, the words "God Does Not Exist" were removed from it, and the painting was unveiled. Shortly after, in 1957, Rivera died, not of cancer but of a heart attack. ❑

ing the shallow space, almost touching the picture frame on all sides, they suggest size and weight. A play of linked colors reinforces this solidity: the white-to-cream of the man's clothing moves in one direction through the light-yellow-brown of his strap and hat to the brown basket, and in another movement,

through the pink flowers and the woman's blouse to her red skirt, a red balanced by green leaves. Fitted together like a jigsaw puzzle, the painting yet shows a recognizable scene. Rivera's humans may be cylinders, spheres, and cones. Or it may be the reverse. ❑

An Artist in Her Own Right

The marriage of Rivera to Frida Kahlo in 1929 was the union of two strong artistic personalities. To Kahlo's parents, "It was like a marriage between an elephant and a dove"—Rivera usually weighed nearly 300 pounds—but the featherweight Kahlo was formidable too.

Victim to physical infirmities and pain, Kahlo often found herself the most interesting subject for the canvas. In her many self-portraits, she stares hard at the viewer—and herself. Kahlo frequently included anatomical parts in her works: her unfulfilled first wish was to be a doctor.

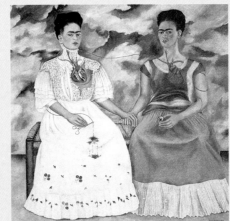

The Two Fridas, 1939—in this dramatic self-portrait, Kahlo shows one version of herself holding forceps, the other a portrait of Rivera.

politics were secondary; his ability to reach a wide audience made him interesting to industrialists and bureaucrats. (The American federal arts programs during the '30s were inspired by the Mexican mural movement.) Perhaps the translation of

idealistic ambitions into reality always involves such paradoxes. ❑

response to Bender's letter, and it arrived in the museum the same year. ❑

has a special collection of books on the history of photography.

SFMOMA's collection on architecture and design focuses on trends in the American West and the Pacific Rim. ❑

THE FLOWER CARRIER

Tehuana Women, a scene from Rivera's monumental mural on the walls of the Ministry of Education in Mexico City.

THE ARTIST

➤ 1910–11, coincidentally at the outbreak of the decade-long Mexican Revolution. Later, this serendipity allowed him to claim a part in the fighting—retrospective wishful thinking. On the revolution's first day, a show of his was opened by the wife of the dictator Porfirio Díaz. She bought six paintings, and Díaz's government bought seven more.

In Paris, however, Rivera devoured several styles of modernist art before settling into Cubism around 1913. Living in high bohemia, he had his share of scandals. In 1916, Pablo Picasso snubbed him as a copyist. In 1917, an argument with a powerful critic became a fist-fight. While living with one Russian artist, he pursued another; both women gave him children. And so on. Rivera's familiarity with Paris's Russian community must at least have turned his attention to the revolution of 1917, which led him to his greatest work. He would recall, "I stopped painting in the Cubist manner because of the war, the Russian Revolution, and my belief in the need for a popular and socialized art."

Rivera studied Renaissance frescoes in Italy in 1920–21, then returned to Mexico to paint murals of his own. With José Clemente Orozco, David Alfaro Siqueiros, and their followers, he would make the mural a 20th-century art form. In 1923–28, in Mexico City's ministry of education, he painted the *Cosmography of Modern Mexico*, a 17,000-square-foot fresco filling two three-story courtyards with scenes of Mexican life. Rivera worked 18-hour days, eating on the scaf-

Detroit Indu main panel Rivera's tri month stud

THE TECHNIQUE

➤ modernist about *The Flower Carrier*? Part of the answer lies in a famous remark of the French Impressionist painter Paul Cézanne, about his wish to "see in nature the cylinder, the sphere, and the cone." Paintings often break down into such shapes, but few artists before Cézanne would have expressed this ambition as a priority. Cézanne's analytic and formal impulse drives a good deal of later art, Cubism included. In *The Flower Carrier*, the man's tubular limbs, the woman's pyramidal dress and

Detail of Detroit Industry, north wall: workers in a Ford plant assemble a car engine.

round head, the triangle of his strap and her sash, and the dome of blossom atop the cylindrical wicker basket could virtually illustrate Cézanne's desire.

Rivera's flat masses turn to volume only at their edges, but by fill-

THE SUBJECT

➤ center of the plastic world, where forms and colors existed in absolute purity. In everything I saw a potential masterpiece—the crowds, the markets, the festivals, the marching battalions, the workingmen in the shop and in the fields—in every glowing face, in every luminous child." The joy of this return combined with his leftist politics to create works like *The Flower Carrier*.

The painting shows the most traditional kind of labor, but Rivera was also fascinated by technology—as shown in his murals of heavy industry in the Detroit Institute of Arts. Rivera's career is full of such contradictions. To devise a Mexican popular art, he studied the high art of the European Renaissance. The scale and ambition of his work, and his demonstration that painting remained an art of mass appeal in the 20th century, inspired many artists to whom his

THE PROVENANCE

➤ patron Albert Bender, whom Rivera had met during his stay in the city, decided to cement the local public's interest in Rivera by donating several of his paintings to the San Francisco Museum of Modern Art. Besides giving other works, Bender wrote to Rivera in Mexico announcing his gift to the museum of $500 for the purchase of a new Rivera work. In 1935, Rivera painted *The Flower Carrier* in

THE MUSEUM

➤ Still. The museum also has a major collection of the art of Southern California and the art of the San Francisco Bay area.

Another notable collection features 20th-century photography—including examples of 1920s German avant-garde, 1930s European surrealist, and works by Americans Alfred Stieglitz, Ansel Adams, and Edward Weston. The Ackerman library

The new museum building.

THE FLOWER CARRIER BY DIEGO RIVERA

THE ARTIST

Diego Rivera and his wife, artist Frida Kahlo, in 1932.

The controversial leader of the Mexican mural movement of the 1920s and '30s, Diego Rivera infused his work with left-wing politics but inspired artists of many persuasions. An outsize personality—big, womanizing, pistol-wearing—he spent years abroad exploring European art movements. Then, on returning to Mexico, he found himself in mural painting: "My style was born as children are born, in a moment, except that this birth had come after a torturous pregnancy of 35 years."

Rivera was born in Guanajuato, Mexico, in 1886. His father, an editor of a liberal newspaper, eventually moved the family to Mexico City. Here, in 1896, Rivera enrolled in art classes at the Academia de San Carlos. He already sketched constantly: "My earliest memory is that I was always drawing." In 1898 the academy gave him a scholarship, and he went there full-time.

San Carlos supplied the standard academic training,

and Rivera's young work is mostly conventional. In 1905 he won a stipend from Mexico's then very conservative government; in 1907 he got another one, to study in Europe. He was gone for 14 years, though he visited his home in ➤

Marine Fusilier, painted by Rivera in 1914 while he was in Europe, shows the influence of Cubism.

THE TECHNIQUE

In 1922, Rivera and other muralists issued a manifesto: "We repudiate the so-called easel painting and all the art of ultra-intellectual circles, because it is aristocratic, and we glorify the expression of Monumental Art because it is a public possession." These artists didn't like small, costly works made for rich folks' private pleasure; they painted publicly and grandly so

that everyone could see their pictures for free. When Rivera began his murals, however, the Mexican government paid him only $2 a day. He was not in a position to abandon paintings, like *The Flower Carrier*, of an easily marketable size.

Calling for an art that would "help the masses to a better social organization," Rivera

would add, "In Cubism there are many elements that do not meet this specific need." (Hence the manifesto's dig at "the art of ultra-intellectual circles.") Yet he could also claim, "I have never left Cubism." What is ➤

THE SUBJECT

For Rivera, "Mexican mural painting made the masses the hero of monumental art." He backed up his words with his many paintings of Mexican labor. *The Flower Carrier* is one of these, showing a *cargador*, a burden bearer, struggling to rise under his load. If the picture recognizes the hardships of the

Mexican laborers in a field of agave. Fermented agave roots make a potent liquor: tequila.

working life, it also dignifies them, its pink bouquet speaking of richness and beauty, its two figures of community and mutual support.

When Rivera returned to Mexico in 1921, he fell in love: "My homecoming produced an aesthetic exhilaration…. I was in the very ➤

THE PROVENANCE

In 1931, when Rivera left San Francisco after completing his Pacific Stock Exchange mural and other commissions, a journalist for the *San Francisco News* wrote, "California's native painters will all profit by the exploitation"—the word was surely a joke on the artist's politics—"of Rivera in recent months; it has meant an enormous stimulation of public interest in art." Several years later, the local bibliophile and art ➤

THE MUSEUM SAN FRANCISCO MUSEUM OF MODERN ART

The San Francisco Museum of Modern Art, located at 151 Third Street next to the Yerba Buena Gardens, moved in 1995 into a new building designed by Swiss architect Mario Botta. Founded in 1935, the museum was the first on the West Coast to exhibit 20th-century art exclusively. It was called the San Francisco Museum of Art until 1975, when the word "modern" was added.

SFMOMA has a collection of paintings by American artists Jackson Pollock, Philip Guston, Richard Diebenkorn, and Clyfford ➤

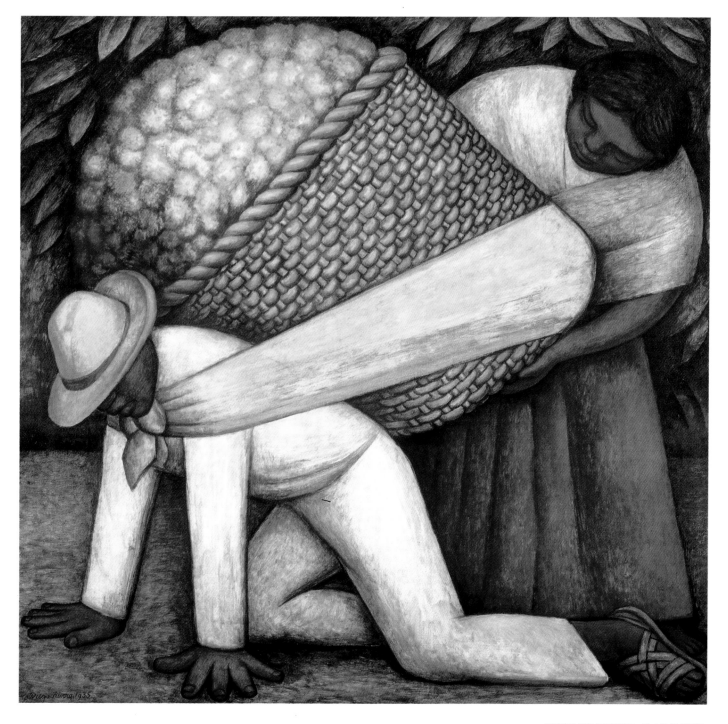

THE FLOWER CARRIER
by Diego Rivera, 1935
oil and tempera on masonite
48 x 47¾ in.
(121.9 x 121.3 cm.)
Albert M. Bender Collection
San Francisco Museum of Modern Art
San Francisco, California

had to be green. "I think the revolution could be a great thing," he said, "if it retained its respect for what is other and different."

In 1920, Chagall left Vitebsk to design sets for the Moscow Jewish Theater. Two years later he and his wife and daughter managed to get to Berlin. His dealer there had set the profits from his 1914 show aside for him, but Germany's soaring postwar inflation had erased their value. Fortunately, Chagall's European reputation had grown considerably during his absence. Returning to Paris in 1923, he settled into a period of productivity and prosperity.

ll remem-
ussia, with
11–12.

In 1933, Adolf Hitler came to power in Germany. Classing Chagall's art "degenerate," the Nazis confiscated dozens of his paintings from German collections. (The work of many other artists suffered a similar fate.) When World War II broke out, the Chagalls fled to southern France. In 1941, after Marseille police threatened to turn the artist over to the Nazis, they emigrated to New York.

A frequent character in Chagall's painting is the figure of the wandering Jew. Chagall must have felt he had lived that life—not least in 1944, when Bella died of a sudden illness. "The

A roomful of Nazi-confiscated art in Berlin. Among the works shown are a self-portrait by Vincent van Gogh and Pablo Picasso's *Head of a Woman*; the Nazis considered these paintings—and Chagall's— "degenerate."

darkness has gathered before my eyes," Chagall wrote; he was long unable to work.

Four years later, Chagall returned to France. The Paris art world had never recovered from the war, and in 1949 he moved to the Côte d'Azur. He continued to take risks, tackling large commissions: murals, mosaics, and stained-glass windows, not-ably in New York City's United Nations Building and Metropolitan Opera House. He visited Israel several times, and also Russia, after decades of absence. He died in 1985. His own words remember him well: "I know that Rembrandt loves me." ❑

drifting haphazardly into soft clouds of red, white, and blue (an aerial tricolor, the French national flag); and the painting's peculiar directionality (whichever side you look at it from, at least one item is right way up)—the dream quality is inescapable. But if the painting isn't rational, neither is it random. Free-floating blues, reds, and yellows, for example, might tint surprising places, but they are deftly balanced, strong highlights that move the eye around the canvas. The central white beam, with its zigzagging

cohorts, is a powerful dynamic core.

Chagall's main concern was a painting's appearance. Once he tried to explain a famous weirdness, the woman in *To Russia, with Asses and Others* of 1911-12: why had he lifted her head a wide step off from her body? "Merely because," he said, "I happened to need an empty space there." ❑

flowers in a pot and heart in hand, into a kind of heaven. That parachutist is also classic: suspension of gravity is Chagall's fondest ecstatic sign. In *Birthday*, of 1923, for example, he gives Bella an airborne kiss. Even as a boy in Vitebsk, he would climb onto the roof to look at the town; and his mother once

told him that her father, the better to enjoy a fine day, had sat on the chimney top to eat carrots. Chagall loved Vitebsk, and loved Paris—indeed he wrote once of "Paris! My second Vitebsk!," which must have amused Parisians no end. ❑

The Eiffel Tower, symbol of Paris, is here the backdrop to the 1900 World's Fair exhibition.

Chagall and Bella kiss in *Birthday*, 1923.

Chagall, Paul Klee, Pablo Picasso, and others in the late 1920s. In

1937 he set up a foundation to establish an art museum; he donated *Paris through the Window* to the museum the same year. ❑

gallery space in lower Manhattan. ❑

MUSEUM HOURS
Sunday–Wednesday:
10 a.m. to 5 p.m.
Friday and Saturday:
10 a.m. to 8 p.m.

ADMISSION
Admission charged.
Free to members and children
under 12 with an adult.

PARIS THROUGH THE WINDOW

THE ARTIST

➤ seeing French masterpieces, and meeting the extraordinary Paris art world of the day.

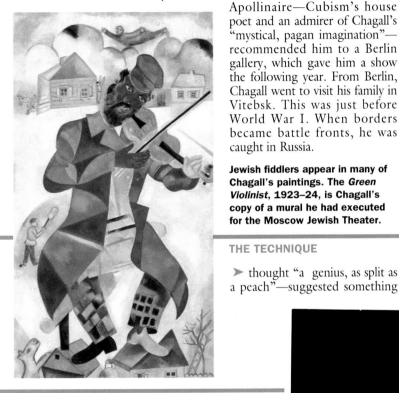

Jewish fiddlers appear in many of Chagall's paintings. The *Green Violinist*, 1923–24, is Chagall's copy of a mural he had executed for the Moscow Jewish Theater.

Chagall quickly absorbed the principles of advanced French art. In 1913, his friend Guillaume Apollinaire—Cubism's house poet and an admirer of Chagall's "mystical, pagan imagination"—recommended him to a Berlin gallery, which gave him a show the following year. From Berlin, Chagall went to visit his family in Vitebsk. This was just before World War I. When borders became battle fronts, he was caught in Russia.

The silver lining was his reunion with Bella Rosenfeld, a Vitebsk woman he had met in 1909 and loved even then. They were married in 1915; he would call her "the great central image of my art." To avoid conscription, Chagall took a clerical job in St. Petersburg in the war bureaucracy. In the city for the October Revolution of 1917, he welcomed the Bolsheviks: not only did they quit the war, they granted citizens' rights to Jews.

The new government's minister of culture, Anatoly Lunacharsky, had known Chagall when both were Russian expatriates in Paris. Lunacharsky named

Chagall commissar of fine arts in Vitebsk, charged with organizing exhibitions and theater productions and with opening and directing an art school. Chagall became an enthusiastic communist. But the new freedoms arrived with strings: on one side the abstract painter Kasimir Malevich, a faculty member at the Vitebsk art school, declared his aesthetics "bourgeois," on the other the revolutionary authorities kept wondering why the cows in his pictures

Living in Paris bered Vitebsk Asses and O

THE TECHNIQUE

➤ thought "a genius, as split as a peach"—suggested something

similar in a poem on the artist: "He is asleep/Now he is awake/And suddenly he is painting." Dream, vision, memory—a decade before Surrealist art, these were Chagall's turf. Cubism may have liberated his work from the chores of conventional resemblance, but Cubism, as an analysis of the world's surfaces, is far from the delirium of *Paris through the Window*.

That floating row of baseless buildings; that two-faced well-dressed chap with his human-headed cat; that tawny firmament,

THE SUBJECT

➤ Jewish world: the sphinxlike creature in *Paris through the Window*, for example, perhaps reflects the Hasid belief that animals may carry the human souls of late sinners, condemned to wander the earth. Chagall's magical otherworldliness has been checked against the Cabala, a body of mystical Jewish doctrine. And even in this Paris scene he

includes a tiny traditional couple, strolling horizontally and head to head beneath the Eiffel Tower.

If Chagall didn't love modernity, he certainly loved Paris. He had a wonderful phrase for the atmosphere he found in the city: "*lumière-liberté*," "light-liberty," as if the City of Light fused the two nouns into one quality. The absolute buoyancy of *Paris through the Window* is classic Chagall—a crazy romantic, he makes a man at a window with a literally fabulous view, with

THE PROVENANCE

➤ lector named E. Kluxen purchased the painting. An American collector, Solomon R. Guggenheim, acquired the painting in 1936. Guggenheim had begun collecting the works of modern artists such as

"Style is not important. To express oneself is. Painting must have psychic content."

THE MUSEUM

➤ The gallery space inside the building matches the contours of the exterior. Art is shown along a sloping ramp that encircles a

central court.

The museum collection contains examples of American and European art from the late 19th

century to the present.

An annex to the Wright building opened in 1992, as did another

Expanded gallery space opened in 1992 in a building in lower Manhattan.

PARIS THROUGH THE WINDOW BY MARC CHAGALL

THE ARTIST

Marc Chagall with his wife Bella and daughter Ida in his Paris studio, ca. 1923.

"My name is Marc, my emotional life is sensitive, and my purse is empty, but they say I have talent." Splendidly Russian, Marc Chagall traveled far with lines like these—from the folk culture of Jewish Vitebsk to the precincts of modernist art. Yet in some way he never left home. As he once said of his paintings, "There is not one centimeter free from nostalgia for my native land."

He was born in 1887 into a poor family. His father hauled barrels in a herring depot; his mother, wanting more for her son, bribed his way into a school that usually barred Jews. Graduating in 1906, Chagall hoped to study art in St. Petersburg, where Jewish residence was banned. Outsmarting the bureaucracy of segregation, he was in a St. Petersburg academy by early 1907.

Here Chagall saw reproductions of Western art—especially French. "Paris!" he would recall, "For me, there was no more beautiful word than that." In 1910 he took the train ride west. He had little money: if he bought a herring, he ate the head and saved the tail for tomorrow. But he was living in Montmartre, ➤

THE TECHNIQUE

Chagall came to France in 1910 to learn from modern art, and *Paris through the Window*, painted in 1913, depends on Cubism, particularly for the intersecting panels that triangulate the sky, like literal sheets of light. Yet Chagall didn't declare himself a Cubist. Not only were that movement's bottles and guitars just "reality in different styles," he said, but Cubism explored only "a single aspect" of reality: "its relations of light and shade, or its geometrical relationships." For Chagall, "The entire world within us is reality, perhaps more real than the visible world." What he wanted was "a realism, if you like, but a psychical one"—a "psychic fourth dimension."

Many admirers of Chagall see his paintings as dreams. Pablo Picasso thought that "when Chagall paints you do not know if he is asleep or awake." The French poet Blaise Cendrars—a friend of Chagall's, whom he ➤

THE SUBJECT

When the Eiffel Tower was built, in 1887–89, one writer called it "a junkyard Nôtre Dame"; another saw it as "ironmongery painted in veal juice." But artists recognized an exhilarating symbol of the modern age. Georges Seurat made a study; later, so did Picasso. Chagall's friend Robert Delaunay painted it many times. Like the train or *métro* (a novel urban transport, surely, for the man from Vitebsk, who rendered it upside-down), the tower in *Paris through the Window* is something more than a friendly landmark: it is a sign of modernity's promise.

Actually, Chagall wasn't so keen on modernity. He distrusted "an era that sings hymns to technology and deifies Progress." Far more common than modern cityscapes in his work are remembered scenes of Jewish Russia. His painting is deeply rooted in the ➤

THE PROVENANCE

Painted in 1913, *Paris through the Window* was shown the following year in Chagall's first solo exhibition in Berlin in the gallery of Herwarth Walden, a famous art dealer whom Chagall had met through the French poet Guillaume Apollinaire. At some point a col- ➤

THE MUSEUM SOLOMON R. GUGGENHEIM MUSEUM

The Solomon R. Guggenheim Museum is located at 1071 Fifth Avenue in New York City. The spiral-shaped concrete building, which opened its doors to the public in 1959, was designed by the celebrated American architect Frank Lloyd Wright. ➤

The original museum building by Frank Lloyd Wright in the foreground, the new annex behind it.

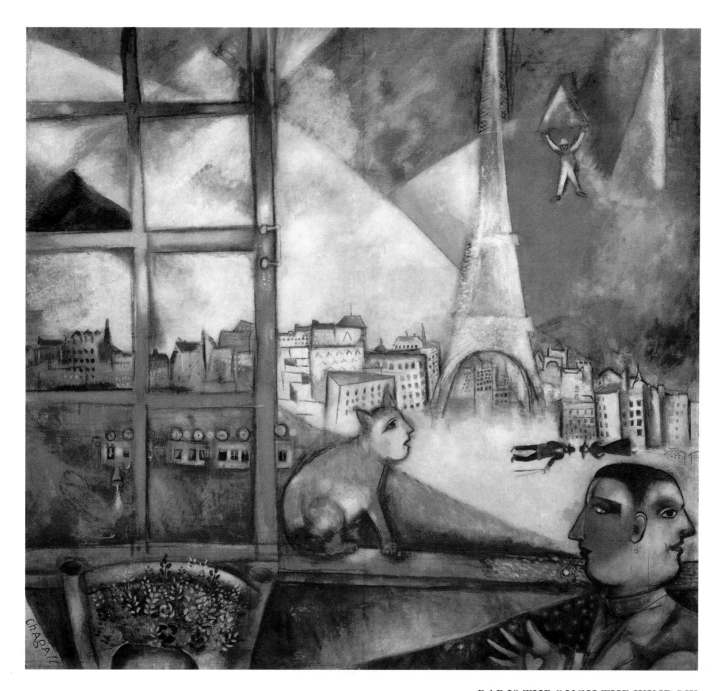

PARIS THROUGH THE WINDOW
by Marc Chagall, 1913
oil on canvas
53½ x 55¾ in.
(135.8 x 141.4 cm.)
Gift of Solomon R. Guggenheim
Solomon R. Guggenheim Museum
New York, New York

ing him in Florence in 1439. That year, members of the court and the clergy of Constantinople had visited the town. Piero surely saw them, for some of the figures in the Arezzo frescoes wear Byzantine clothes.

In 1454, the church fathers of Sant'Agostino in Sansepolcro asked Piero for an altarpiece.

Learning, perhaps, from the slow progress of the Misericordia painting, they gave him eight years to finish; he took 15. Piero's travels remain partly obscure, but Vatican archives for 1459 record a payment to him "for his share of the work on paintings he carried out in His Holiness's bedroom." These too have been lost.

A treatise on architecture from the 1460s imagines an ideal city, and names Piero as an artist capable of decorating it. Piero may have been an architect himself: he is reputed to have built a certain house in San-

sepolcro. He and his brothers certainly lived in the house, and he painted a fresco of Hercules in it. In 1467 he finally served as a town councilor. The following year, still in Sansepolcro, he painted a banner that was carried ceremonially through the countryside to its commissioners in Arezzo.

In 1469 Piero was in Urbino, where the duke, Federico di Montefeltro, was a patron of his. But as he grew older he spent more time in Sansepolcro, where his activities are

traced by a series of commissions, public responsibilities, and documents (one of them recording late payment of taxes) in the 1470s and '80s.

Some 60 years after Piero's death, a Sansepolcro lantern-maker recalled that as a child he "used to lead master Piero di la Francesca about, an excellent painter who had become blind." Piero wasn't blind in July of 1487, when he drew up his will: his notes for it survive, in his own hand. He wanted to be buried in the Badia, Sansepolcro's most important church. And that is where his body was laid, on October 12, 1492. ❑

fer monumentality to action.

Piero scorned artists who "do not understand the power of the lines and the angles," but his rather dry definition of painting—"nothing else but a demonstration of planes and solids made smaller or greater according to their term"—sells his own work short.

He may have used algebra to summon the immense and silent dignity of his paintings, but no sums contain their effect. ❑

The central panel from the Misericordia altarpiece shows the Madonna towering over her kneeling devotees.

to touch the ceiling in fact, when seen from below: did this work's commissioner want a painting to kneel to in prayer? If so, he may have intended to hang it in a room where its assigned place was to one side, so that as he looked at it he had a wall to his right and open space to his left—just as if he were really standing before this throne in this court, with its

colonnade coming in from the right and the space running out of the picture to the left. By setting the Virgin's throne in a corner, perhaps Piero was encouraging the illusion that his patron's room extended into the kingdom of heaven—a room with a view indeed. ❑

Seymour of the same city and later passed on to his daughter in Wiltshire. American collector Robert Sterling Clark acquired the paint-

ing in 1913; it was installed in the Sterling and Francine Clark Art Institute in 1955. ❑

The museum library contains about 130,000 books, periodicals, and auction sales catalogs, and over 100,000 slides, as well as a collection of photographs. The library also houses the Williams College Graduate Program in the History of Art. ❑

MUSEUM HOURS
Tuesday–Sunday: 10 a.m. to 5 p.m.

ADMISSION
Free.

VIRGIN AND CHILD ENTHRONED WITH FOUR ANGELS

THE ARTIST

➤ Antonio d'Anghiari in Sansepolcro. We know this because Piero's salary is mentioned in an i.o.u. signed by d'Anghiari. By 1439, Piero was collaborating with Domenico Veneziano on frescoes in Florence. The year before, Domenico had worked in a palace, later demolished, in Perugia; an early account has Piero painting "many things" in Perugia, but only one altarpiece of his survives there. Perhaps Piero had also painted in the palace.

Scenes from *The Legend of the True Cross* embellish the main chapel in the church of San Francesco in Arezzo.

In 1442, Piero was listed as eligible for service on Sansepolcro's town council. He was there again in 1445, when the Confraternity of the Misericordia commissioned an altarpiece from him, to be delivered in three years. But Piero soon left town, and the contract wasn't paid off until 1462. In 1447 he was in Loreto, working on a fresco that he had to abandon after an outbreak of plague. At some point he created more now-lost murals in Ferrara. His first clearly datable surviving masterpiece wasn't painted until 1451: the painting in Rimini showing the lord of that town, Sigismondo Malatesta,

praying to his patron saint.

The fresco cycle *The Legend of the True Cross*, in the church of San Francesco in Arezzo, is Piero's next great work. It was begun in the mid 1440s by Bicci di Lorenzo, but Bicci soon fell ill—he died in 1452—and at some point Piero took over. Besides being beautiful, his frescoes reinforce the evidence plac-

Piero's portrait of a patron, the duke of Urbino (*right*); inside the duke's palace (*above*).

THE TECHNIQUE

➤ emphasizes by falling, nearly touching his head, then rising again. The surprise of the column immediately left of Mary's head may be explained by Piero's desire to center Christ in an internal frame within the painting.

Piero asserts Mary's presence through color: along with her remarkable face, her dark blue robe is the painting's place of force (given the gentler off-whites, grays, and muted reds around it), and its distinction from Christ's bright body makes for the picture's sharpest contrasts. Her low dais, a firm bar softened by its subtle rosettes, mirrors the entablature over her head, so that she is framed at top and bottom by the regularities of architecture and on either side by the discreetly winged angels. These evenly disposed figures have a columnar stillness typical of Piero, who tended to pre-

THE SUBJECT

➤ space beyond the colonnade, and how the frieze over the two dark panels seems brighter than the cornice above it, as if the entablature in the colonnade had cast its shade onto the rear wall's top.) This is the court of heaven. The moment, then, is eternal in a literal sense—we are looking not at an event in Christ's earthly life but at a celestial condition.

This would support a scholarly theory about an odd element of the picture—the figures' height in relation to the

room. Oddly, the Virgin's head nearly touches the entablature. The people look tall, seem

A page from trated tre *Perspect* describin matics scienc conne time.

THE PROVENANCE

➤ came from a wealthy merchant family that was based in Sansepolcro but had spent little time there, preferring its country estates; Cristoforo, though, had settled in the town. If it was he who commissioned the work, perhaps he wanted to decorate his new home.

The painting was sold at auction in London in 1869 to Arthur

THE MUSEUM

➤ house their art collection, the institute is best known for its many French Impressionist paintings, particularly over 30 by Pierre-Auguste Renoir. Clark, who died in 1956, oversaw the building of the museum; his wife served as president until her death in 1960.

Reflecting the taste of the Clarks, paintings from 14th- through 19th-century Europe are at the museum, as well as from 19th-century America. The museum also displays collections of glass, porcelain, sculpture, and silver.

VIRGIN AND CHILD ENTHRONED WITH FOUR ANGELS BY PIERO DELLA FRANCESCA

THE ARTIST

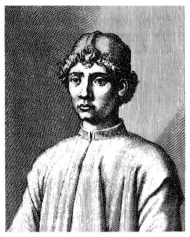

Engraved portrait of Piero della Francesca as a young man.

A sovereign master of the Italian Renaissance, Piero della Francesca must have understood the Renaissance ideal of the artist as a man at home with knowledge: history, science, the classics. He himself was a serious student of mathematics. But though his science may have made possible his work's clarion light and extraordinary grave stillness, it surely does not explain them.

Piero was born, perhaps in 1406 but more likely somewhat later, in Borgo San Sepolcro (today Sansepolcro), a Tuscan town more prominent then than now. His family was well off, mainly from dealings in the textile

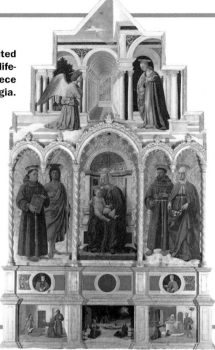

Piero della Francesca painted several altarpieces in his lifetime; this multipaneled piece was for a convent in Perugia.

dye called rocket. The adult Piero would buy land in Sansepolcro and probably had a share in the family business. But the town was never an artistic center, and he traveled widely to paint. The documents of his life are scattered and his biography is hard to construct.

In 1432, Piero was assisting the painter ➤

THE TECHNIQUE

To Giorgio Vasari, the 16th-century biographer of the Renaissance painters, it was obvious that Piero was a mathematician—an artist possessing "a thorough acquaintance with Euclid, so that he understood better than anyone else all the curves in regular bodies." Today, Piero's math would make uphill conversation for all but the serious scholar. Yet Piero cared enough about mathematics to write treatises on its relation to painting. The most obvious application was in the geometries of perspective, but there were also questions of form and volume, and of

light: according to one analysis of the Montefeltro Altarpiece, for example, a little highlight on the Duke of Urbino's armor demonstrates the first-century Greek scientist Hero of Alexandria's theorem on reflection—a theorem Piero is likely to have known.

Piero's rigor can be sensed in his careful balancing of the necessary asymmetries in *Virgin and Child Enthroned with Four Angels*. The baby Christ, for example, is off center on Mary's knee, but is neatly framed by the colonnaded architecture, as a background festoon ➤

THE SUBJECT

Piero gave many of the people in his paintings a similar, striking expression—serious but not exactly thoughtful, not so much reaching for knowledge as containing it. And in this *Virgin and Child* we can tell what it is that they know: the Virgin is offering her son a rose, in the Renaissance a symbol of martyrdom. (The rose's thorns prefigure Christ's

crown on the cross.) He takes it—takes his fate—without hesitation. The rightmost angel indicates his gesture and looks straight at us, enjoining us to mark his sacrifice. The moment seems calm, destined, eternal.

The place is sumptuous: classical piers and columns define a room within a room, a peristyle or colonnaded court inside a larger space that gives the painting its back wall. (Note how a color shift implies shadow in this ➤

THE PROVENANCE

In 1834, when an English aristocrat, Sir Walter Trevelyan, bought *Virgin and Child Enthroned with Four Angels* from a dealer in Florence, he was told it

had once belonged to a Cristoforo Gherardi and that the Gherardis had been family friends of Piero's. There was indeed a Cristoforo Gherardi in Sansepolcro in Piero's time. He ➤

THE MUSEUM STERLING AND FRANCINE CLARK ART INSTITUTE

The Sterling and Francine Clark Art Institute is located at 225 South Street in Williamstown, Massachusetts. The art galleries of

the institute are housed in two buildings connected by a bridge; the original white marble building opened in 1955, the red granite

building in 1973.

Built by Singer sewing machine heir Robert Sterling Clark and his wife Francine to ➤

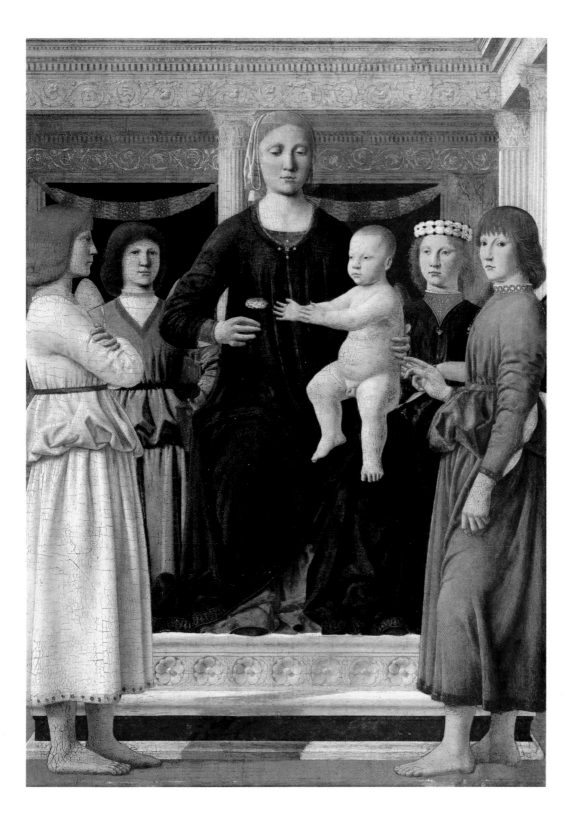

VIRGIN AND CHILD
ENTHRONED WITH FOUR
ANGELS
by Piero della Francesca,
ca. 1460–70
oil possibly with some tempera on
panel, now transferred to fabric
on panel
42⁷⁄₁₆ x 30⁷⁄₈ in.
(107.8 x 78.4 cm.)
Sterling and Francine Clark Art
Institute
Williamstown, Massachusetts

complained of the place, "The people are ugly here," Miller made their unattractiveness their virtue: "They are ugly," he replied, "they are people." From 1929 on Marsh kept a studio on 14th Street, from which he would watch Union Square through binoculars, looking for scenes to paint. At parties he would draw as he talked. At Coney Island he drew standing in surf with his trousers rolled up over his knees. On his death he left over 100 notebooks of sketches—the seeds of his paintings.

Marsh's murals in the rotunda of the old U.S. Customs House in New York City.

The New York scenes Marsh began in the late '20s were critically successful and soon began to appear in large exhibitions. But they didn't sell well. When the Depression came, Marsh recorded hobo jungles and bread lines, soup kitchens and Bowery missions—not the art collector's dream. An inheritance tided him over; after the mid-30s he also taught art. In 1936–37, when the federal government was commissioning artists' projects, Marsh executed murals. (These hardly supported him, though: for one of them he got a Treasury Department assistant clerk's pay, 90 cents an hour.) Marsh's scenes of New York Harbor and his figures of the early European explorers of the Americas still fill the dome of the U.S. Customs House in Manhattan. Here too he combined New York and the old masters: unable to find a portrait of the Florentine navigator Giovanni da Verrazano, discoverer of New York Bay, he copied Titian's portrait of the Duke of Urbino and gave it Verrazano's name.

Marsh worked steadily, his reputation solid, until his death, in 1954, of a heart attack. He was only 56. Sadly, he had lived to see the destruction of much of the New York he loved, the "wonderful old world that's passing…. All the things of the old days were so much better to draw." ❑

wall. But Marsh didn't care about friezes; he cared about the old masters' illusion of deep space. It was just that he often didn't paint it. Ironically, his tendency to flatten space and perspective, and his sense of the arbitrariness of the point where the painting stops, recall many modern artists whose radicalism he scorned.

Those artists, though, were working, often abstractly, with ambitious conceptual ideas. Marsh's sources were more immediate: above all, probably, he was inspired by the crowded Manhattan street—a band of people in a raggedy line, none of them visually mattering more than any other. ❑

Marsh had links with the Social Realist school of art, but he wasn't an activist artist. With the newspaperman's sense of currency, he mainly wanted to address "the characteristic life" of the day. Perhaps Marsh's opera house is just a more enervated form of his burlesques and his beaches—a sliver of the urban spectacle. ❑

Kitchens for dispensing free food (left) were common urban sights during the Depression. In 1932, when Marsh drew *Bread Line—No One Has Starved* (right), over 10 million Americans had become unemployed.

tor Edward J. Gallagher, Jr. in 1954, includes modern sculpture by Pablo Picasso, Auguste Rodin, and others. The widow of sculptor Jacques Lipchitz donated over 60 of his clay and plaster models and sketches to the museum in 1980. ❑

MUSEUM HOURS
Monday–Friday:
9 a.m. to 5 p.m.
Sunday: 12 p.m. to 4 p.m.

ADMISSION
Free.

MONDAY NIGHT AT THE METROPOLITAN

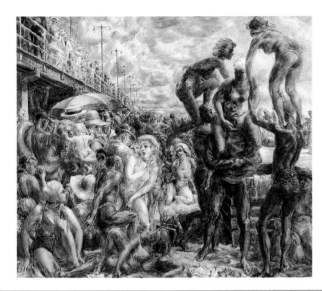

Coney Island Beach, 1934. Marsh loved a beach scene; for him there was beauty in the "bunions and varicose veins and the flat chests."

➤ disingenuous.) After graduating, Marsh became an illustrator for New York newspapers and magazines. *The Daily News*, he said, "took the place of an art school" for him; he also worked at *The New Yorker*.

It wasn't until 1923 that Marsh began to paint, partly under the influence of Betty Burroughs, a sculptor whom he married that year. (Until then, painting had seemed to him "a laborious way to make a bad drawing.") In 1925–26, revisiting Paris, he was entranced by the art in the Louvre. But the trip also made him realize how fortunate he felt "to be a citizen of New York, the greatest and most magnificent of all cities in a new and vital country whose history had scarcely been recorded in art." Marsh

would try to reconcile these two loyalties. One of his favorite subjects, the beach at Coney Island, he compared to the old masters: "the sea, the open air, and the crowds—crowds of people in all directions, in all positions, without clothing, moving—like the great compositions of Michelangelo and Rubens."

Off and on through the '20s Marsh took classes at the Art Students League. Here he met the painter Kenneth Hayes Miller, who helped him see the possibilities of picturing the city. Miller thought Manhattan's rowdy 14th Street the "world's greatest landscape." When Marsh

THE TECHNIQUE

➤ 'fat,' oily effect." He could achieve the dignity of oil paint, then, and the licked surfaces he liked—there is no flat color in a Marsh—without sacrificing speed and spontaneity.

Modernity was in Marsh's eye, though. That speed, for example, was the habit of a city newspaperman. And *Monday Night at the Metropolitan* abandons compositional convention in place since the Renaissance: there are no converging perspectival lines to point to the painting's heart—visually, no figure

matters more than any other. The result is that the picture doesn't explain why Marsh picked this particular patch of audience over another, or why he stopped painting where he did. He could have continued at left and right as far as the balconies ran.

An art-historical precedent for this might be the frieze or bas-relief, and Marsh's figures here are indeed sandwiched friezelike in rows and tiers between the viewer and that glowing red

THE SUBJECT

➤ peaked and cold. Yet the worst Marsh said of such folk was that they were visually boring. "I'd rather paint an old suit of clothes than a new one, because an old one has character," he once remarked.

While these Depression-era opera-goers were coolly watching each other, men not far away were sleeping in the street. Marsh often pictured them, too, but not very differently from the way he handled the rich. Usually he painted

groups, and he tended to frame his crowds to show that they continued outside the picture—that no exceptional person or event was shown, only a fragment of a larger scene.

THE PROVENANCE

➤ who collected American art with populist overtones, was an alumnus of the University of Arizona. In 1945, he donated Marsh's painting to the fledgling University of

Arizona Museum of Art, which he had helped to create. ❏

THE MUSEUM

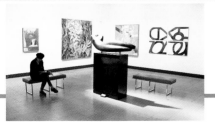

➤ Hopper, and others. In the early '50s collector Samuel H. Kress donated over 50 European paintings

dating from the Renaissance through the 17th century. This donation forced the museum to move out of the library to the

building at its present location in 1955.

The Gallagher Memorial Collection, established by collec-

MONDAY NIGHT AT THE METROPOLITAN BY REGINALD MARSH

THE ARTIST

Etched self-portrait of Reginald Marsh in 1928. Marsh was a prolific printmaker as well as a painter.

"Go out into the street, stare at the people. Go into the subway, stare at the people." So Reginald Marsh used to tell his students when they wondered what to paint. Marsh loved Manhattan crowds—crowds in the street, in nightclubs and dance halls and burlesques and opera houses, crowds shopping and going to work. Documenting the cityscape of his time, he fixed on its people.

Born in 1898, when his parents were living in Paris, Marsh grew up in New Jersey and New York suburbs and was drawing before he was three. His father, Fred Dana Marsh, was an artist who kept a home studio. His mother, Alice Randall, was a painter too; she would assign Reginald the exercise of making portraits and drawing copies of sculpture.

Perhaps in reaction, the young Marsh avoided fine art. At Yale, he essentially flunked art school—"Use dirty palette and unwashed brushes all season," he would

After leaving Yale, Marsh illustrated magazines, including *Vanity Fair,* which published *Irving Place Burlesque* in December 1928.

remember; "Denied access to life class." He preferred illustrating the university paper and enjoying himself in other ways. (When he later claimed to have discovered burlesque theaters only after a magazine editor assigned him the subject, he may have been ➤

THE TECHNIQUE

In the early 1920s, Marsh went through a modernist phase he would recall in an autobiographical sketch: "Become sophisticated. Scorn old masters. Enthusiastic over Matisse, Picasso, Cézanne…. Feel altogether aesthetic. Move to Greenwich Village." Marsh soon wrote off this "dandy-ism in taste," however, and returned to the inspiration of the old masters. He was a painter of the modern world who shunned modern visual means.

In many paintings, including *Monday*

Night at the Metropolitan, Marsh even used an antique medium—tempera, an egg-yolk-based solution little used since the 15th century. Marsh thought his work in oils "an incoherent pasty mess." He found the fast-drying tempera easier to handle, at the same time that "a certain greasy quality of the yolk gives a ➤

THE SUBJECT

"Well bred people are no fun to paint," said Marsh, who liked his humanity more random. But probably his single favorite theme was pleasure—beaches, amusement parks, dance halls, theaters. The Metropolitan Opera House (which in the 1930s stood at 39th Street and Broadway) was an obvious subject for him, and he painted it several times.

There was money in Marsh's family; he knew the *Monday Night at the Metropolitan* crowd well. In the painting they look rather dour. Their elegant fatigue masks some expensive display, and though the opera hasn't begun yet—people are still finding their seats—at least five of them are using binoculars. This audience is its own show.

Perhaps Marsh was mocking them: the faces in the Met's Grand Tier or Golden Horseshoe are a little ➤

THE PROVENANCE

Beginning in 1930, Marsh showed regularly at the Frank K. M. Rehn Gallery in Manhattan. Marsh painted *Monday Night at*

the Metropolitan around 1936 and it went into the Rehn Gallery. In 1942, the painting was bought from Rehn by New York businessman C. Leonard Pfeiffer. Pfeiffer, ➤

THE MUSEUM THE UNIVERSITY OF ARIZONA MUSEUM OF ART

The University of Arizona Museum of Art is located at Park Avenue and Speedway Boulevard in Tucson. Four donated collections form the foundation for the museum's holdings.

The museum opened in 1942 in a room of the campus library with the collection of C. Leonard Pfeiffer, who donated works by contemporary American artists such as Marsh, Edward ➤

MONDAY NIGHT AT THE
METROPOLITAN
by Reginald Marsh, ca. 1936
tempera and oil on board
39½ x 29½ in.
(100.5 x 70.5 cm.)
Gift of C. Leonard Pfeiffer
The University of Arizona
Museum of Art
Tucson, Arizona

Order No. 11, ca. 1865–70, depicts Union officers evicting Missouri residents from their homes during the Civil War. Until the 1930s, Bingham would be best known for this work.

business in 1852. Now Bingham again had to market his own work, touting editions of prints at county fairs. He continued to prosper but lost some of his leisure and freedom. Perhaps in consequence, his art began to deteriorate in the late 1850s. From 1856 to 1858 he traveled in Europe with his wife and children, eventually settling in Düsseldorf, Germany, home of a finickily polished painting style, which also influenced him for the worse.

When the Civil War began, Bingham announced himself "for man conditionally, though for the Union unconditionally." He joined a reserve regiment and probably saw combat, though he was already 50. In 1862 one of his politician cronies found him a more fitting post, as the state treasurer of Missouri. Bingham's most important late painting arose from the war. In 1863, the Union general Thomas Ewing ordered western Missouri depopulated on the grounds that it had supported Confederate raids. The order created great suffering; Bingham personally asked Ewing to rescind it. When Ewing refused, Bingham promised to make him "infamous with pen and brush as far as I am able," and began work on *Order No. 11*, depicting the evictions. In 1870, Bingham circulated photographs of the painting to help defeat Ewing's nomination for the Ohio governor's race.

Bingham painted less in the 1870s during which he returned to politics: Kansas City police commissioner in 1874, Missouri adjutant general in 1875. He occasionally painted portraits. When he died, in 1879, he was serving both his vocation and his state, as a professor of art at the University of Missouri. ❑

space; the framing of the picture's brightly lit heart amid dark mountains and sky. Finally, there are traces of Virgin Mary iconography in the foremost of the two women, mounted and wearing a shawl.

On that first trip to Philadelphia, Bingham wrote Elizabeth that he had bought "a

lot of casts from antique sculpture." Like European artists since the Renaissance, he used these as models in his painting. The figures in *Daniel Boone Escorting Settlers* are so literally statuesque as to have a frozen look. The history of such poses in Western art

makes them reflexive indicators of noble seriousness, but one wonders if they will ever get to where they're going. ❑

Daniel Boone

Wilderness trailblazer, Indian fighter, frontiersman *extraordinaire*—these are the popular images of Daniel Boone, whose feats in the backwoods were already legend by the time George Caleb Bingham was born, thanks largely to a fanciful biography by a Pennsylvania schoolteacher, John Filson, in 1784.

Born in Pennsylvania in 1734, Boone moved to the North Carolina frontier with his family as a boy. Later, in search of wealth, he went on wilderness expeditions, including the crossing of the Cumberland Gap. Boone got what he was looking for in Kentucky. Here he founded settlements named after himself, made land claims, and basked in the fame that Filson's book brought him. But by the 1790s his land dealings had led to numerous lawsuits and charges of fraud. In old age, he moved to Missouri, where he died in 1820.

Engraving of Daniel Boone by James Otto Lewis, 1820, based on a Chester Harding portrait.

matic, and the sky brighter.

The intention, probably, was to evoke biblical language and stories—the Psalmist walking through the valley of the shadow of death; Moses parting the Red Sea, heading for the Promised Land; the journeys of Joseph and Mary toward their sacred purpose. That

these divinely justified pilgrims are not adventurers but a family defines their journey as a mission to civilize the wilderness, with its blasted, uncultivated trees. For a sensitized 19th-century audience, Bingham even included clear symbols in the roots and sticks in the foreground, at the travelers' feet: the Christian cross. ❑

...uction by the ...ork City in ...e in the ornate ...Tabernacle.

One Nathaniel Phillips of St. Louis bought the painting from Bingham in the same year it was finished. In 1890, by then a resident of Boston, Phillips donated the painting to the Washington University Gallery of Art in St. Louis. ❑

MUSEUM HOURS
Monday–Friday: 10 a.m. to 5 p.m.
Saturday–Sunday: 1 p.m. to 5 p.m.
Closed Mondays from May to August.

ADMISSION
Free.

DANIEL BOONE ESCORTING SETTLERS THROUGH THE CUMBERLAND GAP

THE ARTIST

➤ Elizabeth Hutchison, a young Missouri schoolgirl whom he would marry the following year, that he was seldom satisfied with his work. Still, he added, "I shall continue to paint, and if men refuse to have their faces transferred to canvas, I shall look for subjects among the dogs and cats."

In 1838, Bingham went East. He probably studied briefly at Philadelphia's Pennsylvania Academy of Fine Arts; he certainly saw art there—contemporary American painting and some old

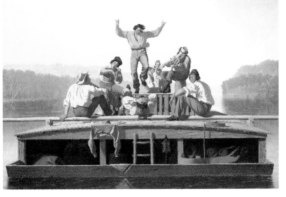

The Jolly Flatboatmen, 1846, is one of the river paintings that made Bingham famous. The scene recalls an already vanishing era; by the 1840s, steamboats, not flatboats, dominated America's rivers.

master work. Soon, though, he returned to the itinerant-portraitist life in Missouri. He traveled so much that when Elizabeth wrote asking him to visit, she added acidly, "We will be so delighted to see you."

Fascinated by politics, Bingham spent most of 1840–44 in Washington, D.C.—Elizabeth with him—producing portraits of politicians in a basement of the still unfinished Capitol. During this Eastern stay

he discovered the American Art-Union, an association chartered "to foster American art" by buying paintings and distributing prints of them among its members. The Art-Union began buying Bingham's pictures. His best work followed, and his greatest popular success: freed from having to attract portrait sitters, he began painting genre subjects—rafters and trappers on the Missouri and Mississippi rivers, small-town elections, scenes of life on the frontier homestead. He also found time to enter politics himself, winning a term in the Missouri legislature in 1848.

The Art-Union went out of

THE TECHNIQUE

➤ Louis, where by the 1830s the university there offered drawing courses and had a chapel containing two paintings said to be by the 17th-century Flemish master Peter Paul Rubens. Though he was already in his late 20s when he first went to Philadelphia and New York City, the art he saw there certainly influ-

enced him. Most important to his style, though, was his childhood habit of copying whatever pictures came his way, unconsciously training hand and eye.

A surprising variety of printed pictures circulated in 19th-century America: *Daniel Boone Escorting Settlers through the*

Cumberland Gap, like most of Bingham's paintings, is full of familiar devices. From engravings, Bingham must have learned Renaissance and Baroque pictorial formulae: the pyramidal grouping of figures; their placement parallel to the picture plane, and separated from the viewer by a meaningful empty

THE SUBJECT

➤ Bingham's first recorded painting—the tavern sign he did in his teens, long vanished but described by a friend—showed "old Dan'l Boone in Buck skin dress with a gun at his side for Judge Dade's Hottel" in Boonville, Missouri.

Bingham based *Daniel Boone Escorting Settlers* on popular accounts

of Boone's journey. Boone, in surprisingly immaculate buckskin, leads the party. His wife, Rebecca, rides beside him, his daughter Jemima is behind her, and Jemima's coonskin-capped husband, Flanders Callaway, is at his left. The place is the crest of a pass in eastern Tennessee, on Boone's route from North Carolina to

Kentucky. Here, in words ascribed to Boone, are cliffs "so wild and horrid, that it is impossible to behold them without terror." Bingham actually reworked the painting to make the cliffs wilder: in an earlier version, preserved as a print, the landscape is less dra-

Lithograph depicting American Art-Union 1847. The auction t hall of a building ca

THE PROVENANCE

➤ another artist, William Ranney; and the Art-Union, having bought Ranney's picture, had no interest in another. Bingham himself had to arrange for the painting to be engraved—much of his income came from the sale of

printed copies of his work—but he ended up turning this to his advantage, for it gave him the opportunity to rework the painting extensively after the engraving had been made.

THE MUSEUM

➤ 3,000 objects, including Egyptian mummies, Greek vases, and European paintings from the

Barbizon, Realist, and Academic schools. The museum also has a collection of paintings by 19th-

century American artists including Frederic Church, George Inness, and Thomas Eakins. Among the

20th-century artists represented at the museum are Pablo Picasso, Joan Miró, and Max Ernst. ❏

DANIEL BOONE ESCORTING SETTLERS THROUGH THE CUMBERLAND GAP
BY GEORGE CALEB BINGHAM

THE ARTIST

George Caleb Bingham, ca. 1860.

George Caleb Bingham, known in his time as "the Missouri artist," is best recognized for images of frontier life in 19th-century America. A sometime politician, Bingham also recorded the processes of American democracy in rural election campaigns. The politician's immodesty may have been contagious: among painters of the American scene, Bingham believed himself "the greatest among the disciples of the brush, which my native land has yet produced."

Bingham was born in Virginia's Shenandoah Valley in 1811, the son of a prosperous miller and landowner. In 1818 Bingham's father Henry lost the property after pledging it as security for a friend's debt. The Binghams moved to Franklin, Missouri, on the Missouri River, to start afresh in the raw West.

As a child, Bingham drew constantly, even marking up the walls of the Shenandoah mill. In Franklin the family opened an inn, where one guest was a portraitist whom George, then 9, watched paint: "The wonder and delight with which his works filled my mind impressed them indelibly upon my then unburthened memory."

The Binghams initially prospered in Franklin, but Henry shortly died, and George, then 12, had to go to work rolling cigars. In 1827 the family moved to a farm near Arrow Rock, a busy Missouri River town of trappers, traders, boatmen, and politics—it was the home of three of the young state's first governors. The teenaged Bingham considered becoming a preacher or a lawyer, but after making his first painting, a tavern sign, he chose art.

Bingham spent the early 1830s painting portraits around the state. In 1835 he wrote to ➤

THE TECHNIQUE

Bingham's experience of art in frontier Missouri must have been limited and haphazard. When he visited Paris in 1856, and went to the Louvre, the paintings in that great museum left him "staggering in doubt"; he felt like "a juror bewildered by a mass of conflicting testimony" as to what art should be. As a child and young man, Bingham had seen itinerant portrait painters, such as he himself would be for a while; and he had spent time in St. ➤

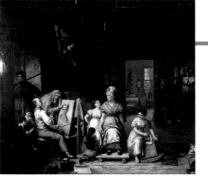

In the days before photography, many artists, like the one in Charles Bird King's *The Itinerant Artist (left),* made their livelihoods painting portraits from town to town. As a young man, Bingham spent years traveling across Missouri seeking portrait commissions.

THE SUBJECT

Daniel Boone Escorting Settlers through the Cumberland Gap describes an event of mythic importance for 19th-century America: the frontiersman's crossing of the Appalachians in 1775, when he and his family pioneered the homesteading of Kentucky. Nicknamed "the Columbus of the woods," Boone came to symbolize the opening up of the North American interior (west of the Appalachians) for white settlement.

Bingham knew the Boone legend all his life. His family's journey west from Virginia, when he was 6, had followed the Wilderness Trail, which Boone had blazed through the Cumberland Gap 40-odd years earlier. In Missouri the Binghams lived in the Boon's Lick area, named for the Boone family, which had moved there from Kentucky. The artist who visited Bingham's parents' inn had painted Boone's portrait and was making copies of it during his stay in Franklin. Finally, ➤

THE PROVENANCE

When Bingham began *Daniel Boone Escorting Settlers through the Cumberland Gap,* in 1851, he planned to sell the painting to the American Art-Union, telling a friend, "The subject is a popular one in the West, and one which has never been painted." By the time he finished, though, a year later, the theme *had* been painted, by ➤

THE MUSEUM WASHINGTON UNIVERSITY GALLERY OF ART

Washington University Gallery of Art, at Forsyth and Skinker Boulevards in St. Louis, Missouri, was founded in 1881. Its collection resided in the St. Louis Art Museum until 1960, when it came to its present location in Steinberg Hall.

The museum's collections contain over ➤

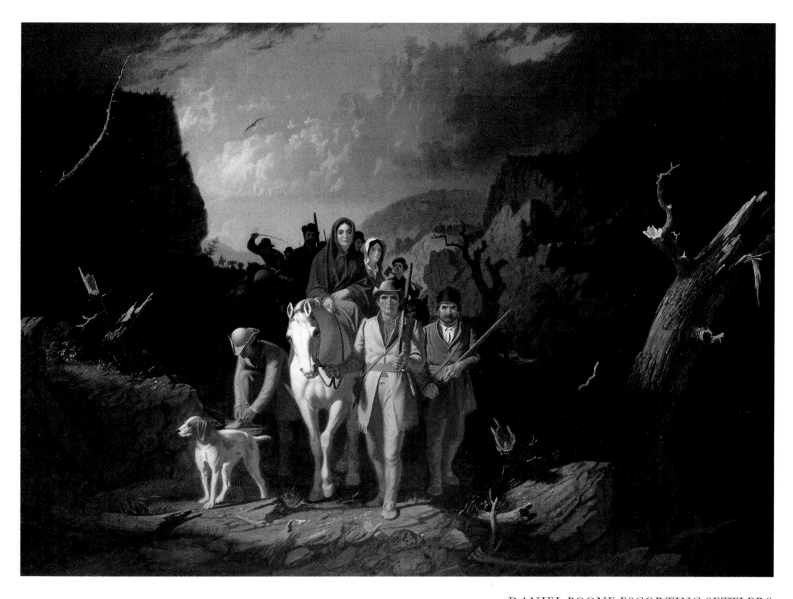

DANIEL BOONE ESCORTING SETTLERS
THROUGH THE CUMBERLAND GAP
by George Caleb Bingham, 1851–52
oil on canvas
36½ x 50¼ in. (92.7 x 127.6 cm.)
Gift of Nathaniel Phillips
Washington University Gallery of Art
St. Louis, Missouri

artist—exhibiting sporadically in group shows and supporting himself on commercial illustration. By late 1913 he was living on Washington Square in Manhattan's Greenwich Village, in the apartment that would be his home and studio until he died. Hopper's first one-man show came only in 1920, when he was 37. Two years later, a friend, Josephine Nivison, was invited to show her watercolors in a group show at the Brooklyn Museum; she suggested that Hopper be included, too, and the show resulted in the first sale of one of his paintings in a decade, and only his second sale

ever. He was 41. The following year he married Jo Nivison. He was also taken on for the first time by a private dealer, and that show sold out.

Jo was an artist who, like Hopper, had studied with Henri. She was also a former actress and, again like Hopper, a theater fan. Jo posed for Hopper often during their marriage; she usually insisted on being the model whenever he represented a female figure.

Hopper's gallery show in 1923 marked the beginning of his reputation's steady ascent. By the time he died, in 1967, he was widely recognized as America's

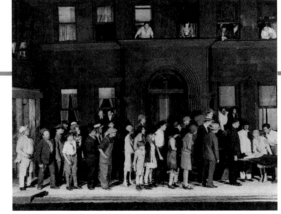

Morning Sun, 1952, shows one of Hopper's recurring themes: a bare room in the city with a lone occupant looking out.

great modern realist. His art never lost its hermetic mysteriousness, and its poignance. Late in life, asked what he was after in one of his last paintings, *Sun in an Empty Room* of 1963, he replied, "I'm after me." The room is unpeopled, unfurnished, its only presence the sunlight on a bare wall. ❏

Matisse, André Derain, and the rest. Hopper thought them "for the most part very bad." He emerged at a time when many American painters felt the need to turn away from Europe and to develop an authentically American imagery and style. Although he would later deny that his Parisian experiences had influenced his work, letters home from France convey his pleasure in European art,

especially in French Impressionism. Robert Henri, his teacher, had argued for dark, somber colors; Paris lightened Hopper's palette, introducing pastels reminiscent of, say, Claude Monet. In 1962, five years before he died, Hopper admitted in an interview, "I think I'm still an Impressionist." ❏

utterly depopulated. In an earlier phase of the work, Hopper put a figure in one of the windows; then he painted it out. The human emptiness of so many of his images is entirely his own poetic effect.

Is it appropriate, then, to call Hopper a realist? True objectivity

Set from *Street Scene* by Elmer Rice at New York's Playhouse Theatre, January 19, 1929.

in painting is impossible. Hopper wrote of aiming to transcribe not nature itself but rather his own impressions of it. He was once asked why there were no figures in one of his city scenes. "I don't know why," he replied, "except that they say I am lonely." ❏

Hopper's first one-man show, in 1920, had been at the Whitney Studio Club, a New York artists' society founded by Gertrude

Whitney in 1918. The club and the museum offered Hopper enduring support. When his wife, Jo, died, less than a year after Hopper

did, she bequeathed to the Whitney his entire artistic estate—more than 2,500 oils, watercolors, drawings, and prints. ❏

tional shows at the branch museums. It also offers a well-regarded course in curating for students considering professional careers in the art world. Every two years, the Whitney Biennial exhibitions

aim for a comprehensive statement on the direction of the American art of the day. ❏

EARLY SUNDAY MORNING

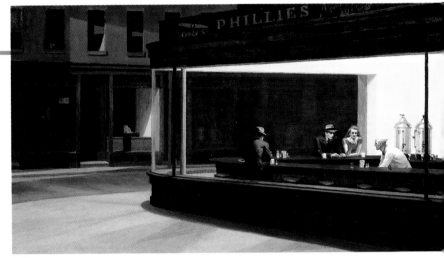

THE ARTIST

➤ in Manhattan. He stayed there until 1906, winning prizes and scholarships and studying with important New York painters of the time—William Merritt Chase and, particularly, Robert Henri, whom he recalled as an inspiring teacher.

On graduating, Hopper traveled to Europe—to England, Holland, Germany, Belgium, Spain, and most significantly Paris, where he lived from October of 1906 to late June of 1907, and which he revisited in 1909 and in 1910. French art was to have an enormous influence on this archetypal American painter,

A restaurant on Greenwich Avenue in New York City inspired the setting for *Nighthawks*, 1942. Hopper said of this painting, "Unconsciously, probably, I was painting the loneliness of a large city."

but he needed time to absorb it. What he immediately loved was the life of Paris, and what this famously isolate mentality saw as the city's appeal is striking: "Every street here is alive with all sorts and condition of people...The people here in fact seem to live in the streets, which are alive from morning until night...

with a pleasure-loving crowd that doesn't care what it does or where it goes, so that it has a good time." Hopper would also say, "I do not believe there is

another city on earth so beautiful as Paris." Yet he never returned to the city after 1910.

Back in New York, Hopper took up the life of the struggling

THE TECHNIQUE

➤ support it extraordinarily solidly, given that they simultaneously read as hollow, empty voids. The regularly spaced windows on the buildings' second floor, their rhythm syncopated by the roof beams and by the varying heights and colors of the window shades, lend geometry to realism. Finally,

the sky becomes a flat blue bar, prevented by the dark, boxlike vertical at right from sandwiching the buildings too heavily.

For all its importance in American art, Hopper's work developed in opposition to the artistic innovations of his day. While in Paris in 1906, for example, Hopper saw what was then the most controversially avant-garde art, the brightly colored paintings of the Fauves—Henri

THE SUBJECT

➤ referred to it as "that Street Scene set we loved so much."

In painting *Early Sunday Morning*, Hopper seems to have adapted Mielziner's idea by transforming the four ground-floor windows into doors, and changing the facade into a row of small storefronts. The glow of Hopper's red brick wall and yellow window-blinds, as well as the long horizontal shadows in the street, may also imitate the effects of stage lighting. (If the street were indeed Seventh Avenue, these

shadows would be running more or less north-south; the sun, in other words, would no longer be rising in the east.)

Hopper altered the theater spectacle in another way as well. Mielziner's set had let actors appear in the second-floor windows of the apartment house, and a production photograph of *Street Scene* (far right) shows a stage crowded with actors. But *Early Sunday Morning* is

Portrait of museum founder Vanderbilt Whitney by Hopper Robert Henri, 1916.

THE PROVENANCE

➤ the establishment of the Whitney Museum of American Art, which opened the following year in four remodeled brownstone buildings in Greenwich Village. The foundation of

the museum's collection was the group of nearly 700 artworks, Whitney's own purchases, that she donated to the new institution. That nucleus included *Early Sunday Morning*.

THE MUSEUM

➤ Plaza, Stamford, Connecticut; and the Whitney Museum of American Art at Philip Morris, 120 Park Avenue, New York City.

The museum's permanent collection contains about 10,000

artworks. The focus is strictly on American art, though there is some latitude for artists who were born elsewhere but made their careers in America. In addition to Hopper, other figures in the col-

lection include Georgia O'Keeffe, Stuart Davis, John Sloan, Andrew Wyeth, and many more contemporary artists.

The museum stages about 15 exhibitions a year, with addi-

EARLY SUNDAY MORNING BY EDWARD HOPPER

THE ARTIST

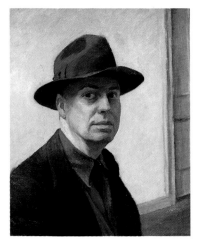

Edward Hopper, self-portrait, 1925–30.

The paintings of Edward Hopper say something crucial about the American soul. It's not only their subjects, which dignify a stretch of Americana running from the Victorian architecture of tree-shadowed East Coast towns to the streets of an empty-looking, seedy New York City, with intermediary bursts of light in the seascapes and landscapes of New England. It's something about the mood they insist on finding in these scenes, the loneliness and melancholy, and the quiet. These were also the qualities of the artist: Hopper was notorious for the long silences in his conversa-tion. His wife once said of him, "Sometimes talking with Eddie is just like dropping a stone in a well, except that it doesn't thump when it hits bottom."

Hopper was born in 1882 in Nyack, a Hudson River town about 40 miles north of New York City. In 1899, after graduat-ing from high school, Hopper be-gan a daily train-and-ferry commute to study commercial illustration at a school in New York City. His parents

Sketch of a Parisian woman, 1906–07 or 1909. Hopper visited Paris after leaving the New York School of Art.

had wanted him to learn a money-making skill. In fact, com-mercial art was to sustain him until his paintings began to sell (which wasn't until 25 years later), but Hopper never enjoyed this kind of work, and in 1900 he transferred to the fine-arts-oriented New York School of Art, on 57th St. ➤

THE TECHNIQUE

Hopper was admired not only by the early 20th-century realist painters who were his peers but also by some among the experimental van-guards with which he had nothing obvious in common. However traditional he may have seemed, the formal rigor of his work and the precision of his color consti-tuted an adventurousness of their own.

His 1930 painting, *Early Sunday Morning*, is

blocked out in a typical Hopper format: the whole picture rests on a strong horizontal—the street and its shadows. The four dark doorways, echoed by the stubbier verticals of barber pole and fire hydrant, resemble pillars standing on this horizontal.The doorways support the upper half of the picture—➤

THE SUBJECT

Early Sunday Morning is a New York City view that Hopper said was inspired by a row of shops on Seventh Avenue. His choice of this stretch of undistinguished vernacular archi-tecture as a subject is exactly the kind of decision that framed him as the great American realist; as a description of a specific place, however, the painting is quite misleading. For one thing, no one has been able to identify exactly the site that it shows. For another, there seems to be lit-tle doubt that at least one image Hopper had in mind in *Early Sunday* *Morning* had nothing to do with reality whatsoever, but arose rather from that epitome of artifice, the theater.

In 1929, Hopper and and his wife, Jo, had seen a production of Elmer Rice's play *Street Scene*. The set, designed by Jo Mielziner, showed the outside of a two-story apartment building, with four win-dows on the ground floor and a regular line of windows above. This design must have impressed the Hoppers; some years later Jo ➤

THE PROVENANCE

By the time Hopper painted *Early Sunday Morning*, in 1930, he was an established and well-respected artist. *Early Sunday Morning* was bought within a few months of his finishing it by Gertrude Vanderbilt Whitney, a Vanderbilt heiress and financier's wife. She was also a sculp-tor and supporter of the arts who at the time was laying plans for ➤

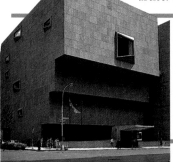

THE MUSEUM WHITNEY MUSEUM OF AMERICAN ART

The Whitney Museum of American Art is located at 945 Madison Avenue, New York City. The site is the museum's third—it opened on West Eighth Street in 1931 and continued on West 54th Street from 1954 to 1966. The present building, designed by architects Marcel Breuer and Hamilton Smith, is considered a triumph of modernist architec-ture, and its trapezoidal project-ing window on Madison Avenue is a popular New York landmark.

The Whitney runs two branch museums: The Whitney Museum of American Art at Champion, One Champion ➤

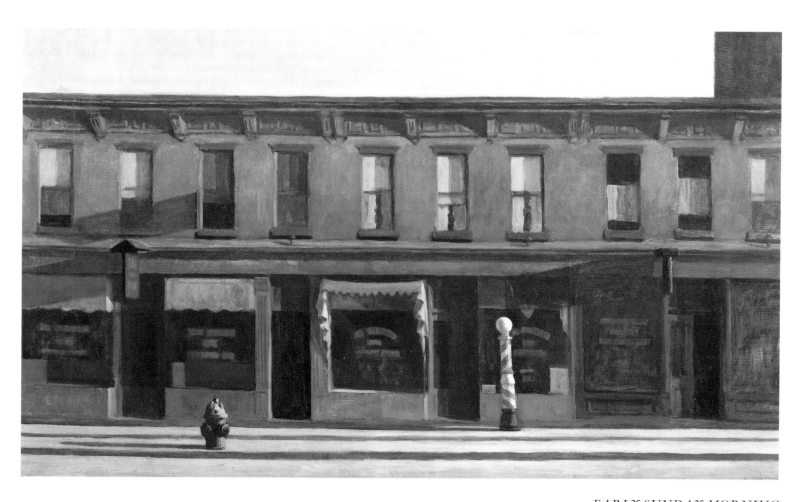

EARLY SUNDAY MORNING
by Edward Hopper, 1930
oil on canvas
35 x 60 in. (89 x 152.4 cm.)
Bequest of Josephine N. Hopper
Whitney Museum of American Art
New York, New York

Vertue described Canaletto as "a sober man," "remarkable for reservedness & shyness in being seen at work, at any time, or anywhere." In 1749, Vertue (who was no speller) added, "On the whole of him something is obscure or strange. he dos not produce works so well done as those of Venice." Yet he did well enough in London to spend 10 years there before returning home.

In 1760 a young Englishman, John Crewe, and his tutor, John Hinchliffe, saw "a little man" sketching in St. Mark's Square. On a hunch, Hinchliffe called out, "Canaletti!" The man replied, "Do you know me?," then invited the pair to his studio. Making Crewe a present of a drawing, Canaletto also showed him a London view that he said he could not bear to sell. Then he let Crewe buy it.

S. Marco: the Crossing and North Transept, with Musicians Singing, 1766. Canaletto's handwriting at the bottom proclaims that he made this pen-and-ink drawing at age 68 "without glasses."

In 1763, Canaletto was elected to the Venice art academy as a "skilled and celebrated Professor, Painter of the highest honesty and virtue." A drawing of 1766 bears a proud note: "I, Zuane Antonio da Canal, did the present drawing of singers in the Ducal Church of St. Mark's in Venice at the age of sixty-eight, without glasses." The next trace of him appears in the Venetian health office's records for April 20, 1768: "Antonio...Canal, 71, of fever and inflammation of the bladder, 5 days. Doctor Musolo, death at 7 o'clock."

Canaletto left behind "pictures, medium and small, 28," some clothes, a house, and some household goods. He had never married, and the site of his tomb went unrecorded. ❑

The Bucintoro Returning to the Molo on Ascension Day. The golden gondola of the doge (on the right) comes back to port after festivities commemorating the anniversary of a Venetian victory over Slav pirates on Ascension Day in 1000 A.D.

tain the arching bridge that pushes up tensely against it. The craft on the river move generally downstream, but not at uniform angles; make a dynamic clutter. Yet the expanse of blue air gives the painting a serene spaciousness.

This light is the painting's strength and its failing: that is not a gray northern sky. For

Vertue, Canaletto's English work was odd, "his water & his skys at no time excellent...& what he has done here...not various nor so skillfull as might be expected." Perhaps Vertue sensed that Canaletto's loyalties were elsewhere. English viewers probably should have been grateful, though: spreading a warm canopy of Venetian glamour above their town, Canaletto was giving them an umbrella. ❑

Stephen's Chapel, and St. John's Church.

Canaletto had a reputation for accuracy: one contemporary found that before his paintings "the eye is deceived and truly believes that it is the real thing it sees, not a painting." Actually, Canaletto often played tricks with topography for dramatic effect, and in his treatment of *Westminster Bridge* he is positively dishonest: in 1746, the bridge was unfinished. It was the greatest public engineering project of the day, and Canaletto painted it several times. Elsewhere he acknowledged that the temporary timbering in some of the arches had yet to be filled in with stone. On this ceremonial occasion, though, he painted them as gloriously achieved. The bridge wasn't finally opened until 1750.

At the bridge's center Canaletto set statues of the river gods Thames and Isis. Here history fooled him: though planned, the statues were never installed. ❑

sold the painting to art collector Paul Mellon, whose father Andrew had created the National Gallery of Art in Washington, D.C. Mellon's mother was English, and he was an Anglophile who specialized in collecting British books and paintings. In 1976, Mellon donated *Westminster Bridge, London* and other paintings to Yale University to establish the Yale Center for British Art in Connecticut. ❑

English paintings by Canaletto.

The Yale Center often exhibits the work of contemporary British artists. A research library containing over 13,000 volumes is open for public use. There is also an archive of over 60,000 photographs of British art. ❑

WESTMINSTER BRIDGE, LONDON, WITH THE LORD MAYOR'S PROCESSION ON THE THAMES

THE ARTIST

➤ During this trip, however, Canaletto decided to "excommunicate the theater." According to an early biographer, he was "exasperated by the capriciousness of the playwrights." Presumably he was also inspired by Roman art.

By 1720 Canaletto had joined the *fraglia*, the Venice painter's guild. An exhibition of his in 1725 was said to "astound all." After Owen McSwiney, an Irish art dealer in Venice, began marketing Canaletto's paintings, the English proved eager customers. By 1727 McSwiney had to tell a British duke that Canaletto had "more work than he can do well in any reasonable time."

Detail of *London: Westminster Abbey, with a Procession of the Knights of the Order of the Bath.* As shown here, Caneletto created deceptively detailed paintings using simple strokes of color.

Another Venice-based Englishman, Joseph Smith, also sold Canaletto's work. Both dealers claimed to dislike him. In 1730 McSwiney told a client, "He's a covetous, greedy fellow and because he's in reputation people are glad to get anything at his price." The same year, Smith complained of his "impertinence," then, like McSwiney, reported that he was exploiting his popularity by overcharging. But the English writer Horace Walpole said that Smith employed Canaletto "to work for him for many years at a very low price, & sold his works to the English at much higher rates."

Perhaps Canaletto's work was simultaneously overpriced and underprofitable, at least for him. In the mid 1730s he was refused responsibility in the *fraglia* because he still lived with his parents—a sign of modest means.

In May 1746 George Vertue, a Londoner who kept notes on art-world doings, recorded the arrival in that city of the "famous view painter" "Cannalletti." Canaletto must have hoped to deal directly with his English patrons. He arrived with a "great reputation," according to Vertue, and was expected to prosper— "tho' many persons already have so many of his paintings."

THE TECHNIQUE

➤ was becoming increasingly important there. Most of Canaletto's paintings were sold to Englishmen, some traveling in Italy, others at home, maybe having made the Grand Tour of Europe and wanting some permanent souvenir.

Westminster Bridge, London, with the Lord Mayor's Procession on the Thames was painted in 1747, early in Canaletto's London years, and looks similar to his scenes of Venetian regattas, or of the sailing of the *bucintoro*, the doge's great gondola—surely recalled for him by the mayor of London's barge, which he sets conspicuously near-broadside to the picture's surface. The canvas is divided horizontally into two: a sweep of water and a sweep of sky, divided by a mostly flat horizon line just managing to con-

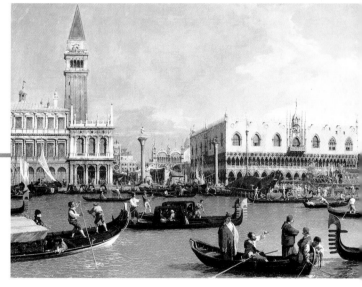

THE SUBJECT

➤ each year, he would be sworn in. Accompanying barges have come from the London merchant guilds. Also on the river float smaller boats, as well as larger sailing ships, two of which, at far left and far right, have just fired a salute.

The buildings are as identifiable as the barges. On the skyline at center left is Lambeth Palace, residence of the Archbishop of Canterbury. At right, from right to left, are St. Margaret's Church, Westminster Abbey, Westminster Hall (now incorporated in the Houses of Parliament), St.

THE PROVENANCE

Paul Mellon at the Yale Center.

➤ 13, 1895, at Christie's in London. The seller was listed as J. Carpenter Garnier; the purchaser was Colnaghi, a London art dealer. At some point, the painting was bought by the Duke of Buccleuch and remained in the Duke's collection until 1962, when art dealer Edward Speelman bought the painting. That same year, Speelman

THE MUSEUM

➤ Kahn, opened in 1977. It is a four-story concrete, steel, and glass structure with skylights.

The Yale Center contains paintings, watercolors, prints, illustrated books, and sculpture that trace the development of British art from the 15th to the mid-19th century. Included are works by William Hogarth, John Constable, J. M. W. Turner, Thomas Gainsborough, and

WESTMINSTER BRIDGE, LONDON, WITH THE LORD MAYOR'S PROCESSION ON THE THAMES BY CANALETTO

THE ARTIST

Portrait of Canaletto, 1742.

London in Charles Dickens' novels, Paris in Eugène Atget's photographs, Venice in Canaletto's paintings: Canaletto is one of those artists who have fixed the image of a great city. Once you've seen their pictures or read their books you can't imagine how you'd experience the place without them. Over 200 years after Canaletto's death, his paintings still recognizably document Venice. A resident of London for some years, he also left many paintings of the English capital.

Canaletto the man, though, remains obscure. He was born Giovanni Antonio Canal, in 1697. The name "Canaletto,"

One of Canaletto's Venetian views—*Entrance to the Grand Canal: Looking West*, ca. 1730. Like many of his works, it entered the collection of a British family.

meaning "little Canal," Canal's son, though first recorded in the 1720s, probably dates from his childhood. The senior Canal, Bernardo, painted theater sets, and at first Canaletto did too. From 1716 to 1718, he, his brother Cristoforo, and Bernardo produced stage designs together in Venice; in 1719 Canaletto and Bernardo went on shared business to Rome. ➤

THE TECHNIQUE

Canaletto was the master of what was in his time a relatively new class of art: the *vedutà*, or view. Earlier painting had rendered place beautifully but usually incidentally—the landscape had been the setting for some historical or biblical event, or had framed someone's portrait. In the 17th century, however, European artists began to realize that their customers were interested in certain places for their own sake.

Though far less cheap and disposable than the postcards of today, Canaletto's paintings served something of the same function. In the 18th century, Venice's mercantile power was fading, and tourism ➤

Title-page of *Vedute da Antonio Canal* with a dedication to Canaletto's patron and then British Consul, Joseph Smith. The book, published in 1744, featured etchings of Venice, real and imaginary.

THE SUBJECT

Venetian art and ritual attest to a love of festival. Every Ascension Day (40 days after Easter), for example, the doge would set sail in his gondola and throw a ring into the water to marry Venice to the sea. London's ceremonies were less pretty—processions

and civic oaths. For a Venetian expatriate, these would have had to do.

The event commemorated in *Westminster Bridge, London* is the annual waterborne progress of the lord mayor of the City of London to Westminster, where, on October 29 ➤

THE PROVENANCE

Canaletto arrived in London in 1746; an engraved version of *Westminster Bridge, London, with the Lord Mayor's Procession on the Thames* was published early in 1747. The procession he painted, then,

must be the one of October 1746.

Little is known about the early history of the painting. It was first recorded at auction on July ➤

THE MUSEUM YALE CENTER FOR BRITISH ART

The Yale Center for British Art is located at 1080 Chapel Street in New Haven, Connecticut, on the campus of Yale University. The

museum is literally the gift of one of the university's alumni, art collector Paul Mellon, class of 1929; he provided the art collection and

funds for construction of the museum building.

The building, designed by American architect Louis I. ➤

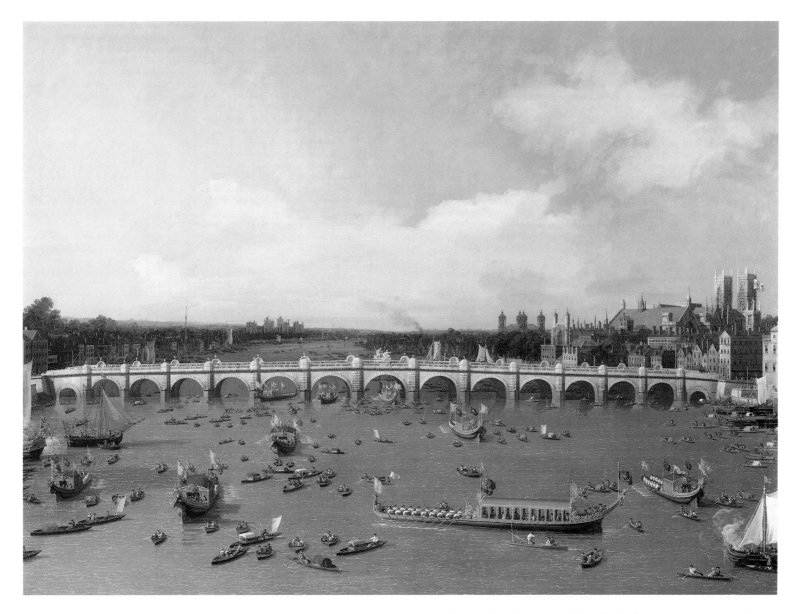

WESTMINSTER BRIDGE, LONDON, WITH THE LORD
MAYOR'S PROCESSION ON THE THAMES
by Canaletto (Giovanni Antonio Canal), 1747
oil on canvas
37¾ x 50¼ in. (95.75 x 127.5 cm.)
Paul Mellon Collection
Yale Center for British Art
New Haven, Connecticut

INDEX

SOURCES, CREDITS, AND PICTURE INFORMATION

Picture sources, credits, and information about the illustrations that appear in this book, appear below. Dimensions are given in inches and centimeters, or in feet and meters; height precedes width. Every effort has been made to correctly identify and contact the copyright holders of all paintings and illustrations used. We invite any copyright holder that we have overlooked to contact us so that corrections can be made in future editions.

page 10 (top left)
Self Portrait with a Hat, 1893-94
By Paul Gauguin
Oil on canvas
18 x 15 in. (46 x 38 cm.)
Musée d'Orsay, Paris, France
Photograph from Réunion des Musées Nationaux, Paris, France

page 10 (top right)
The Seine at the Pont d'Iéna, 1875
By Paul Gauguin
Oil on canvas
$25^{1}/_{2}$ x 36 in. (64.8 x 91.4 cm.)
Musée d'Orsay, Paris, France
Photograph from Art Resource, New York

page 10 (bottom)
View of the west facade of the Albright-Knox Art Gallery
Photograph by
Patricia Layman Bazelon
Albright-Knox Art Gallery, Buffalo, New York

page 11 (top)
Breton Girls Dancing, Pont-Aven, 1888
By Paul Gauguin
Oil on canvas
$28^{3}/_{4}$ x $36^{1}/_{2}$ in. (73 x 92.7 cm.)
Collection of Mr. and Mrs. Paul Mellon
National Gallery of Art, Washington, D.C.

page 12 (top right)
View of Tahiti
Photograph
Library of Congress, Washington, D.C.

page 12 (middle)
Shell Idol, ca. 1893
By Paul Gauguin
Ironwood and mother-of-pearl
Musée d'Orsay, Paris, France
Photograph from Réunion des Musées Nationaux, Paris, France

page 12 (bottom right)
Olympia, 1863
By Edouard Manet (1832-1883)
Oil on canvas
$51^{1}/_{2}$ x $74^{3}/_{4}$ in. (130.8 x 189.8 cm.)
Musée d'Orsay, Paris, France
Photograph from Photographie Giraudon, Paris, France and Art Resource, New York

page 13
SPIRIT OF THE DEAD WATCHING
By Paul Gauguin (1848-1903)

page 14 (top left)
Georges Seurat
Photograph
Collection John Rewald, New York, New York

page 14 (top right)
Seurat with fellow students at the École des Beaux-Arts in Paris, 1878-1880
Photograph
Bibliothèque Nationale de France, Paris, France

page 14 (bottom)
Aerial view of the Art Institute of Chicago
Photograph
From The Bennett Papers
The Art Institute of Chicago, Illinois

page 15 (top)
The Artist's Mother (Woman Sewing), 1882-1883
By Georges Seurat

Conté crayon on paper
$12^{1}/_{4}$ x $9^{1}/_{2}$ in.
(31.1 x 24.1 cm.)
Purchase, Joseph Pulitzer Bequest, 1955
The Metropolitan Museum of Art, New York, New York

page 15 (bottom)
View of the Michigan Avenue entrance of The Art Institute of Chicago, 1920
Photograph
The Art Institute of Chicago, Illinois

pages 15-16 (middle)
Monkey, 1884
By Georges Seurat
Conté crayon
$12^{15}/_{16}$ x $9^{5}/_{16}$ in.
(32.8 x 23.6 cm.)
Bequest of Miss Adelaide Milton de Groot (1876-1967), 1967
The Metropolitan Museum of Art, New York, New York

page 16 (top)
Lucie Brû in front of "La Grande Jatte," ca. 1900
Photograph
Private collection, Paris, France

page 16 (left middle)
Cover of "Journal Amusant," October 23, 1886
Magazine
Bibliothèque Nationale de France, Paris, France

page 16 (right middle)
Une Baignade, Asnières, 1883-1884
By Georges Seurat
Oil on canvas.
79 x $118^{1}/_{2}$ in. (200.6 x 301 cm.)
National Gallery, London, England
Photograph by Erich Lessing from Art Resource, New York

page 17
A SUNDAY ON LA GRANDE JATTE
By Georges Seurat (1859-1891)

page 18 (top left)
Henri Matisse in Etta Cone's dining room at the Marlborough Apartments, Baltimore, December 17-18, 1930
Photograph
The Cone Archives
The Baltimore Museum of Art, Baltimore, Maryland

page 18 (bottom left)
Etta Cone, ca. 1890
Photograph
The Cone Archives
The Baltimore Museum of Art, Baltimore, Maryland

page 18 (bottom right)
View of The Baltimore Museum of Art, 1926
Design by John Russell Pope (1874-1937)
Rendering by I.R. Egger
Graphite on paper
13 x $28^{1}/_{4}$ in. (33.2 x 71.7 cm.)
The Baltimore Museum of Art, Baltimore, Maryland

page 19 (top)
Blue Nude, 1907
By Henri Matisse
Oil on canvas
$36^{1}/_{4}$ x $55^{1}/_{4}$ in.
(92 x 140.3 cm.)
The Cone Collection, formed by Dr. Claribel Cone and Miss Etta Cone of Baltimore, Maryland
The Baltimore Museum of Art, Baltimore, Maryland

page 19 (bottom left)
Claribel Cone in Munich, 1915-1916
Photograph
The Cone Archives
The Baltimore Museum of Art, Baltimore, Maryland

page 19 (bottom right)
View of The Baltimore Museum of Art
Photograph
The Baltimore Museum of Art, Baltimore, Maryland

pages 19-20 (middle)
Odalisque with Red Pantaloons, 1922
By Henri Matisse
Oil on canvas
$27^7/_8$ x $33^1/_{16}$ in.
(67.1 x 84 cm.)
Musée Nationale d'Art Moderne,
Paris, France
Photograph from Scala Fotocolor,
Florence, Italy and Art Resource,
New York

page 20 (top)
La Négresse, 1952
Collage, paper on canvas
$178^3/_4$ x $245^1/_2$ in.
(454 x 623.6 cm.)
Ailsa Mellon Bruce Fund
National Gallery of Art,
Washington, D.C.

page 20 (middle)
*North African costumes and textiles
collected by Matisse*
Photograph reproduced from *Matisse
in Morocco*, National Gallery of Art,
Washington, D.C., 1990

page 20 (bottom)
*View of new wing for modern art at
The Baltimore Museum of Art*
Photograph
The Baltimore Museum of Art,
Baltimore, Maryland

page 21
*PURPLE ROBE AND
ANEMONES*
By Henri Matisse (1869-1954)

page 22 (top left)
*Georgia O'Keeffe at the University of
Virginia*, July 19, 1915
Photograph
Holsinger Studio Collection
(#9862), Special Collections
Department, Manuscripts Division
University of Virginia Library,
Charlottesville, Virginia

22 (middle right)
Light Coming on the Plains III, 1917
By Georgia O'Keeffe

Watercolor on paper
$11^7/_8$ x $8^7/_8$ in.
(30.2 x 22.5 cm.)
Amon Carter Museum, Fort Worth,
Texas

page 22 (bottom left)
View of The Brooklyn Museum
Photograph
The Brooklyn Museum, Brooklyn,
New York

pages 23-24
Ghost Ranch, New Mexico, 1978
By William Clift
Photograph

page 23 (middle)
Pink Tulip, 1926
By Georgia O'Keeffe
Oil on canvas
36 x 30 in. (91.4 x 76.2 cm.)
Bequest of Mabel Garrison Siemonn
in Memory of her Husband, George
Siemonn
The Baltimore Museum of Art,
Baltimore, Maryland

page 23 (bottom)
*Interior view of The Brooklyn Museum
showing Egyptian collection*
Photograph
The Brooklyn Museum, Brooklyn,
New York

page 24 (bottom)
Black Cross, New Mexico, 1929
By Georgia O'Keeffe
Oil on canvas
39 x $30^3/_8$ in. (99 x 77.2 cm.)
Art Institute Purchase Fund
The Art Institute of Chicago,
Chicago, Illinois

page 25
*RAM'S HEAD, WHITE HOLLY-
HOCK—HILLS*
By Georgia O'Keeffe (1887-1986)

page 26 (top left)
Charles M. Russell, 1883
Photograph

Montana Historical Society,
Helena, Montana

page 26 (middle)
Child's moccasins
Sioux
Leather and beads
$3^1/_2$ x $8^1/_2$ in. (8.9 x 21.6 cm.)
C. M. Russell Museum, Great Falls,
Montana

page 26 (bottom)
View of C.M. Russell Museum
Photograph
Great Falls, Montana

page 27 (top)
Waiting for a Chinook, 1886
By C. M. Russell
Watercolor
Montana Stockgrowers' Association,
Montana Historical Society, Helena,
Montana
Photograph by D. O'Looney.

page 27 (middle)
Cowboy Camp During the Roundup,
1885-1887
By C. M. Russell
Oil on canvas
$23^1/_2$ x $47^1/_4$ in.
(59.7 x 120 cm.)
Amon Carter Museum, Fort Worth,
Texas

pages 27-28 (bottom)
The Jerkline, 1912
By C. M. Russell
Oil on canvas
24 x 36 in. (70 x 91.4 cm.)
C. M. Russell Museum, Great Falls,
Montana

28 (middle)
Ho Ho Hayee, Friend Goodwin, 1907
By C. M. Russell
Pen, ink and watercolor on paper
$10^3/_4$ x $8^1/_4$ in. (27.3 x 21 cm.)
Stark Museum of Art, Orange, Texas

page 28 (bottom)
C. M. Russell in his log cabin studio
Photograph

C. M. Russell Museum, Great Falls,
Montana

page 29
BUFFALO HUNT
By Charles Marion Russell (1864-
1926)

page 30 (top left)
*Grant Wood in his Cedar Rapids
studio*, 1932
By John W. Barry (1905-1988)
Photograph
Gift of Mrs. John W. Barry
Cedar Rapids Museum of Art, Cedar
Rapids, Iowa

page 30 (middle)
Memorial Window, 1927-1929
By Grant Wood
Leaded stained glass
24 x 20 ft. (7.3 x 6.1 m.)
Veterans Memorial Building, Cedar
Rapids, Iowa
Photograph by George T. Henry
Courtesy
Tucker/Thomson/Graphics,
Cedar Rapids, Iowa

page 30 (bottom)
Cincinnati Art Museum
Photograph
Cincinnati Art Museum,
Cincinnati, Ohio

page 31 (top left)
Grant Wood in France, 1920
Photograph
Courtesy James Dennis

page 31 (top right)
Members of 4-H Club and their calves,
1930s
Photograph
Library of Congress, Washington,
D.C.

page 31 (bottom)
*Grand staircase, Cincinnati Art
Museum*
Photograph
Cincinnati Art Museum, Cincinnati,
Ohio

page 32 (middle left)
Stone City, 1930
By Grant Wood
Oil on composition board
30¼ x 40 in. (76.8 x 101.6 cm.)
Joslyn Art Museum, Omaha,
Nebraska

32 (middle right)
American Gothic, 1930
By Grant Wood
Oil on beaver board
29¹⁵/₁₆ x 24¹⁵/₁₆ in.
(76 x 63.3 cm.)
Friends of American Art Collection
The Art Institute of Chicago, Illinois

page 32 (bottom)
The Donor, 1485
By Hans Memling (1433-1494)
Oil and tempera on panel
13½ x 10½ in.
(34.3 x 26.7 cm.)
Gift of Arthur Sachs, Mr. and Mrs.
Martin A. Ryerson Collection
The Art Institute of Chicago, Illinois

page 33
DAUGHTERS OF REVOLUTION
By Grant Wood (1891-1942)
Copyright 1995/Licensed by VAGA,
New York

page 34 (top left)
The Burial of the Count of Orgaz,
detail, 1586

page 34 (top right)
View of Candia, 1582
Bibliothèque Nationale de France,
Paris, France

page 34 (bottom)
*Cleveland Museum, south facade, and
the Lagoon of Fine Arts Garden*
Photograph by Howard Agriesti
Cleveland Museum of Art, Cleveland,
Ohio

page 35 (top)
The Burial of the Count of Orgaz,
1586
By El Greco

Oil on canvas
189 x 141¾ in.
(480.1 x 360 cm.)
Church of Santo Tomé,
Toledo, Spain
Photograph from Photographie
Giraudon, Paris, France and Art
Resource, New York

page 35 (middle)
Enthroned Madonna and Child,
13th century
Byzantine
Tempera on panel
51⅝ x 30¼ in.
(131.1 x 76.8 cm.)
Gift of Mrs. Otto H. Kahn
National Gallery of Art,
Washington, D.C.

page 35 (bottom)
*Breuer wing of The Cleveland
Museum of Art*
Photograph
Marcel Breuer, Architect
Archives of The Cleveland
Museum of Art

page 36 (top)
*View of El Greco's palace in Toledo,
Spain*
Photograph from Roger-Viollet,
Paris, France

page 36 (middle)
View of Toledo, ca. 1600
By El Greco
Oil on canvas
47¾ x 42¾ in
(121.3 x 108.6 cm.)
H. O. Havemeyer Collection,
Bequest of Mrs. H. O.
Havemeyer, 1929
The Metropolitan Museum of Art,
New York, New York

page 37
*CHRIST ON THE CROSS WITH
LANDSCAPE*
By El Greco (Domenicos
Theotokopoulos, 1541-1614)
page 38 (top left)
Portrait, Frederic E. Church, 1870

By L. Sturm (1844-1926)
Oil on porcelain
5¾ x 4¼ in. (14.6 x 10.8 cm.)
Olana State Historic Site
New York State Office of Parks,
Recreation and Historic Preservation,
Waterford, New York

page 38 (top right)
New England Scenery, 1851.
By Frederic Edwin Church
Oil on canvas.
36 x 53 in. (91.4 x 134.6 cm.)
George Walter Vincent Smith
Collection
The Corcoran Gallery of Art,
Washington, D.C.

page 38 (bottom)
*Entrance to The Corcoran Gallery of
Art*
Photograph
The Corcoran Gallery of Art,
Washington, D.C.

page 39 (top)
*"Heart of the Andes," painting by
Frederic Edwin Church, on display at
the Metropolitan Sanitary Fair,* 1864
Photograph
Collection of The New-York
Historical Society, New York,
New York

page 39 (bottom left)
*Interior of The Corcoran
Gallery of Art*
Photograph
The Corcoran Gallery of Art,
Washington, D.C.

page 39 (bottom right)
W.W. Corcoran, 1883
By Mathew B. Brady
Photograph
The Corcoran Gallery of Art,
Washington, D.C.

page 40 (top)
Southwest Facade, Olana, ca. 1870
By Frederic Edwin Church
Ink and watercolor on paper
13 x 21¹⁵/₁₆ in. (33 x 55.6 cm.)

Olana State Historic Site
New York State Office of Parks,
Recreation and Historic Preservation,
Waterford, New York

page 40 (top inset)
Sketch of Exterior Cornice at Olana,
ca. 1871-72.
By Frederic Edwin Church
Pencil and watercolor on paper
12 x 19⅛ in. (30.5 x 48.6 cm.)
Olana State Historic Site
New York State Office of Parks,
Recreation and Historic Preservation,
Waterford, New York

page 40 (middle)
Niagara Falls, New York, ca. 1854
Photograph
Library of Congress,
Washington, D.C.

page 41
NIAGARA
By Frederic Edwin Church
(1826-1900)

page 42 (top left)
Claude Monet, ca. 1895
Photograph
Bibliothèque Nationale de France,
Paris, France

page 42 (top right)
Un atelier aux Batignolles, 1870
By Henri Fantin-Latour
Oil on canvas
80¼ x 107¾ in.
(203.8 x 273.7 cm.)
Musée d'Orsay, Paris, France
Photograph from Photographie
Giraudon, Paris, France and Art
Resource, New York

page 42 (bottom)
Facade of The Currier Gallery of Art
Photograph
The Currier Gallery of Art,
Manchester, New Hampshire

page 43 (top)
Impression, Sunrise, 1873
By Claude Monet

Oil on canvas
19 x 24³/₄ in. (48 x 63 cm.)
Musée Marmottan, Paris, France
Photograph from Photographie
Giraudon, Paris, France and Art
Resource, New York

page 43 (middle left)
The Bath, 1868
By Charles Gleyre (1800-1874)
Oil on canvas
35¹/₂ x 25 in. (90.2 x 63.5 cm.)
Gift of Walter P. Chrysler, Jr.
The Chrysler Museum, Norfolk,
Virginia,

pages 43-44 (middle)
Women in the Garden, 1867
By Claude Monet
Oil on canvas
100¹/₂ x 72³/₄ in.
(255.3 x 184.8 cm.)
Musée d'Orsay, Paris, France
Photograph from Art Resource, New
York

page 44 (top)
*View of Claude Monet's garden at
Giverny, France*
Photograph by Edwina Smith

page 44 (bottom)
*Claude Monet and Camille Monet in
the Studio Boat*, 1874
By Edouard Manet (1832-1883)
Oil on canvas
32 x 39¹/₄ in. (81.2 x 99.7 cm.)
Bayerische Staatsgemäldesammlun-
gen, Munich, Germany
Photograph from Art Resource,
New York

page 45
THE SEINE AT BOUGIVAL
By Claude Monet (1840-1926)

page 46 (top left)
Howard Pyle in his studio, 1910
Photograph
Helen Farr Sloan Library,
Howard Pyle Collection
Delaware Art Museum,
Wilmington, Delaware

page 46 (middle)
*Once It Chased Dr. Wilkinson into the
Very Town Itself*, 1909
By Howard Pyle
Illustration for "The Salem Wolf"
from December, 1909 issue of
Harper's Monthly Magazine
Oil on canvas
27 x 17¹/₂ in. (68.6 x 44.5 cm.)
Private collection
Brandywine River Museum, Chadds
Ford, Pennsylvania

page 46 (bottom)
*Delaware Art Museum, 1938 build-
ing with new wing on right*
Photograph by Jon McDowell
Delaware Art Museum,
Wilmington, Delaware

page 47 (top)
Wreck in the Offing!, 1878
By Howard Pyle
Illustration for March 9, 1878 issue
of Harper's Weekly Magazine
Gouache
14³/₄ x 21¹/₈ in.
(37.5 x 53.7 cm.)
Gayle and Alene Hoskins Fund
Delaware Art Museum, Wilmington,
Delaware

page 47 (bottom)
*Upper and lower atrium lobbies,
Delaware Art Museum*
Photograph
Delaware Art Museum, Wilmington,
Delaware

pages 47-48 (top)
*Howard Pyle and students at his
Chadds Ford, Pennsylvania, studio*,
1902
Photograph
Helen Farr Sloan Library, Howard
Pyle Collection
Delaware Art Museum, Wilmington,
Delaware

pages 47-48 (bottom)
Johnny's Fight with Cherry, 1928
By N.C. Wyeth (1882-1945)
Illustration for "Drums," by James

W. Boyd, Charles Scribner's Sons,
New York, 1928
Oil on canvas
40 x 32 in. (101.6 x 81.3 cm.)
Gift of Willis du Pont
Delaware Art Museum,
Wilmington, Delaware

page 48 (middle)
Lady Lilith, 1868
By Dante Gabriel Rossetti
(1828-1882)
Oil on canvas
38 x 33¹/₂ in. (96.5 x 85.1 cm.)
Samuel and Mary R. Bancroft
Memorial
Delaware Art Museum,
Wilmington, Delaware

page 48 (bottom)
Howard Pyle's Studio, 1911
By Ethel Pennewill Brown Leach
(1878-1960)
Oil on canvas
30¹/₂ x 20¹/₂ in.
(77.5 x 52.1 cm.)
Louisa DuPont Copeland
Memorial Fund
Delaware Art Museum, Wilmington,
Delaware

page 49
THE MERMAID
By Howard Pyle (1853-1911)

page 50 (top left)
The Artist and the Connoisseur, 1565
By Pieter Bruegel
Ink
9⁷/₈ x 8¹/₂ in. (25 x 21.6 cm.)
Graphische Sammlung Albertina,
Vienna, Austria
Photograph from Art Resource,
New York

page 50 (top right)
View of Antwerp, 1624
Engraved, hand-colored map
By C. Visscher, Amsterdam, The
Netherlands
Library of Congress,
Washington, D.C.

page 51 (top)
Hunters in the Snow, 1565
By Pieter Bruegel
Oil on oakwood
46 x 63³/₄ in. (117 x 162 cm.)
Kunsthistorisches Museum, Vienna,
Austria
Photograph by Erich Lessing from
Art Resource, New York

page 52 (top)
Big Fish Eat Little Fish, 1556
By Pieter Bruegel
Pen drawing in dark grey on paper
8¹/₂ x 11 in. (21.6 x 30.2 cm.)
Graphische Sammlung Albertina,
Vienna, Austria
Phototgraph from Photographie
Giraudon, Paris, France and Art
Resource, New York

page 52 (bottom)
The Wedding Banquet, detail, 1567
or 1568
By Pieter Bruegel
Oil on wood panel
44⁷/₈ x 64¹/₈ in.
(114 x 163 cm.)
Kunsthistorisches Museum, Vienna,
Austria
Photograph from Saskia Ltd. and Art
Resource, New York

page 53
THE WEDDING DANCE
By Pieter Bruegel (1530-1567)

page 54 (top left)
Narihira and the Pilgrim, detail
showing signature and seal
By Ogata Korin
Small fan

page 54 (top right)
Street Scene in the Yoshiwara
By H. Moronobu
From the series, "Yoshiwara no Tei"
Harris Brisbane Dick Fund, 1949
The Metropolitan Museum of Art,
New York, New York

page 54 (middle)
Narihira and the Pilgrim, Rimpa

school, Edo period, 17th-18th century
By Ogata Korin
Small fan
Ink, color and gold on gesso
14 x 8^{15}/$_{16}$ in. (35.6 x 22.7 cm.)
Freer Gallery of Art, Smithsonian Institution, Washington, D.C.

page 55 (top)
Plate, Edo period, ca. 1702-1703
By Ogata Kenzan (1663-1743)
Glazed clay
1 x 6^2/$_3$ x 6^2/$_3$ in.
(2.4 x 16.9 x 16.8 cm.)
Freer Gallery of Art, Smithsonian Institution, Washington, D.C.

page 55 (middle)
Tama-ya Hanamurasaki Dochu no Zu, 1796
By Chobunsai Eishi (1756-1829)
Woodblock print
8^1/$_2$ x 14^7/$_8$ in.
(21.6 x 37.8 cm.)
Clarence Buckingham Collection
The Art Institute of Chicago, Chicago, Illinois

pages 55-56 (bottom)
Charles Lang Freer in Japan, 1907
Photograph
Charles Lang Freer Papers
Freer Gallery of Art and Arthur M. Sackler Gallery Archives, Smithsonian Institution, Washington, D.C.

page 56 (right)
Portrait of Nakamura Kuranosuke
By Ogata Korin and Ogata Kenzan
The Museum Yamato Bunkakan, Nara, Japan

page 57
CRANES
By Ogata Korin (1658-1716)

page 58 (top left)
Portrait of Giovanni Bellini
By Vittore Carpaccio
(ca. 1460-1526)
Lead point, pen, bistre, heightened

with white
Institut de France, Musée Condé, Chateau de Chantilly, France
Photograph from Photothèque Giraudon, Vanves, France

page 58 (top right)
Madonna of the Meadows, ca.1505
By Giovanni Bellini
Transferred to canvas from panel
26^1/$_3$ x 33^4/$_5$ in. (69 x 86 cm.)
The National Gallery, London, England
Photograph from Art Resource, New York

page 58 (middle)
Chapter of the Order of the Crescent
By Giovanni Bellini
Vellum
7^3/$_8$ x 5^1/$_8$ in. (18.7 x 13 cm.)
Bibliothèque Nationale de France, Paris, France

page 58 (bottom)
Henry Clay Frick, ca.1915
Photograph
The Frick Collection, New York, New York

page 59 (top)
Dead Christ with the Virgin Mary and Saint John the Evangelist and Saints Mark and Nicholas, ca.1472
By Giovanni Bellini
Canvas
45^1/$_4$ x 124^4/$_5$ in. (115 x 317 cm.)
Palazzo Ducale (Doge's Palace), Venice, Italy
Photograph from Cameraphoto-Arte, Venice, Italy and Art Resource, New York

page 59 (middle left)
St. Francis in the Desert, detail.

page 59 (bottom)
Entrance to The Frick Collection
Photograph
The Frick Collection, New York, New York

pages 59-60 (middle)
Doge Leonardo Loredan, 1501-1502
By Giovanni Bellini
Oil on poplar panel
24^1/$_4$ x 17^3/$_4$ in. (61.5 x 45 cm.)
The National Gallery, London, England

page 60 (top right)
Madonna and Saints, 1505
By Giovanni Bellini
Transferred to canvas from panel
16^1/$_2$ x 7^3/$_4$ ft. (5 x 2.35 m.)
Church of San Zaccaria, Venice, Italy
Photograph by Erich Lessing from Art Resource, New York

page 60 (bottom)
Garden Courtyard of the The Frick Collection
Photograph
The Frick Collection, New York, New York

page 61
ST. FRANCIS IN THE DESERT
By Giovanni Bellini (1430-1516)

page 62 (top left)
Portrait of the Artist, ca.1787
By Thomas Gainsborough
Oil on canvas
29^1/$_2$ x 24 in. (75 x 61 cm.)
Royal Academy of Arts, Piccadilly, London, England
Photograph from The Bridgeman Art Library Ltd., London, England

page 62 (top right)
A view of London, with the Mansion House at right, 1751
By Thomas Bowles
Engraving
The Guildhall Library, London, England

page 62 (middle right)
The Blue Boy, detail
X-ray photograph

page 62 (bottom left)
The South Terrace of The Huntington Art Gallery

Photograph
The Huntington Art Collections, San Marino, California

page 63 (top)
The Artist with his Wife and Child, 1751-1752
By Thomas Gainsborough
Oil on canvas
35^1/$_2$ x 27 in. (90.2 x 68.6 cm.)
The Marchioness of Cholmondeley, Houghton, England
Photograph by Heinz Zinram from The Bridgeman Art Library Ltd., London, England

page 63 (middle right)
George Villiers, Second Duke of Buckingham (1628-87) and Lord Francis Villiers (1629-48)
By Sir Anthony van Dyck (1599-1641)
Courtesy Her Majesty Queen Elizabeth II
Royal Collection Enterprises, Ltd., Windsor Castle, England

pages 63-64 (top)
Study for a Music Party
By Thomas Gainsborough
Red chalk and stump
9^1/$_2$ x 12^3/$_4$ in.
(24.1 x 32.4 cm.)
The British Museum, London, England

page 64 (top)
Opening day of the Royal Academy exhibit in 1787
By P. Martini
Engraving
The British Museum, London, England

page 64 (bottom left)
The North Vista from The Huntington Library
The Huntington Library, San Marino, California
Photograph by Bob Schlosser

page 64 (bottom right)
Sarah Barrett Moulton: "Pinkie," 1794

By Thomas Lawrence (1769-1830)
Oil on canvas
57^1/$_2$ x 39^1/$_4$ in.
(146 x 99.6 cm.)
The Huntington Art Collections,
San Marino, California

page 65
THE BLUE BOY
By Thomas Gainsborough
(1727-1788)

page 66 (top left)
Self-Portrait, 1659
By Rembrandt Harmensz van Rijn
Oil on canvas
33^1/$_4$ x 26 in. (84.5 x 66 cm.)
Andrew W. Mellon Collection
National Gallery of Art,
Washington, D.C.
Photograph by Richard Carafelli

page 66 (top right)
The Anatomy of Dr. Nicolaes Tulp,
1632
By Rembrandt Harmensz van Rijn
Oil on canvas
66^{15}/$_{16}$ x 85^3/$_8$ in.
(170 x 217 cm.)
Mauritzhuis, The Hague, The
Netherlands
Photograph by Erich Lessing from
Art Resource, New York

page 66 (middle)
Diana at her bath, 1630-1631
By Rembrandt Harmensz van Rijn
Etching
7 x 6^1/$_4$ in. (17.8 x 15.9 cm.)
The British Museum, London,
England

page 67 (top)
Saskia in a Straw Hat, 1633
By Rembrandt Harmensz van Rijn
Silverpoint on vellum
7^1/$_4$ x 4^1/$_4$ in. (18.5 x 10.7 cm.)
Kupferstichkabinett Staatliche
Museen, Berlin, Germany
Photograph from Bildarchiv
Preussischer Kulturbesitz, Berlin,
Germany

pages 67-68 (middle)
Aristotle with a Bust of Homer, detail

page 68 (top)
The Night Watch, 1642
By Rembrandt Harmensz van Rijn
Oil on canvas
12 x 14^3/$_8$ ft. (3.63 x 4.37 m.)
Rijksmuseum, Amsterdam, The
Netherlands

page 68 (middle)
Head of Homer
Greece, Hellenistic period
Artist unknown
Marble, fine-grained
16^1/$_8$ x 8^1/$_4$ in. (41 x 21 cm.)
E. P. Warren Collection
Museum of Fine Arts, Boston,
Massachusetts

page 68 (bottom right)
Alexander the Great, 1655
By Rembrandt Harmensz van Rijn
Oil on canvas
45^3/$_8$ x 34^1/$_2$ in.
(115.5 x 87.5 cm.)
Art Gallery and Museum,
Glasgow, Scotland

page 69
*ARISTOTLE WITH A BUST OF
HOMER*
By Rembrandt Harmensz van Rijn
(1606-1669)

page 70 (top left)
Portrait of the artist, 1965
By Duane Michals
Photograph

page 70 (bottom right)
Time Transfixed, 1938
By René Magritte
Oil on canvas
57^7/$_8$ x 38^7/$_8$ in.
(147 x 98.7 cm.)
Joseph Winterbotham Collection
The Art Institute of Chicago,
Chicago, Illinois

page 71 (top left)
Magritte and his Mother, ca. 1898

Photograph
Galerie Isy Brachot, Brussels,
Belgium

page 71 (top right)
Love Song, 1914
By Giorgio de Chirico (1888-1978)
Oil on canvas
28^3/$_4$ x 23^3/$_8$ in. (73 x 59.4 cm.)
Nelson A. Rockefeller Bequest
The Museum of Modern Art, New
York, New York
Copyright 1995 Foundation Giorgio
de Chirico/Licensed by VAGA,
New York

page 71 (bottom)
*Architect's drawing of the front facade
of the Museum of Contemporary Art,
Chicago*
Josef Paul Kleihue, Architect
Collection of the Museum of
Contemporary Art, Chicago, Illinois

pages 71-72 (middle)
Free Hand, 1965
By René Magritte
Oil on canvas
32 x 25^5/$_8$ in. (81.3 x 65.2 cm.)
Collection of Mr. and Mrs. Paul
Mellon
National Gallery of Art,
Washington, D.C.

page 72 (top right)
La Clairvoyance, 1936
By René Magritte
Gouache
21^1/$_3$ x 25^3/$_4$ in.
(54.2 cm x 65.3 cm.)
Private Collection
Photograph from Photographie
Giraudon, Paris, France and Art
Resource, New York

page 72 (middle)
The False Mirror, 1928
By René Magritte
Oil on canvas
21^1/$_4$ x 31^7/$_8$ in. (54 x 81 cm.)
The Museum of Modern Art,
New York

page 73
THE WONDERS OF NATURE
By René Magritte (1898-1967)

page 74 (left)
Portrait of Jackson Pollock
The Archives of American Art,
Smithsonian Institution,
Washington, D.C.

page 74 (top right)
The She-Wolf, 1943
By Jackson Pollock
Oil, gouache, and plaster on canvas
41^7/$_8$ x 67 in. (106.4 x 170.2 cm.)
The Museum of Modern Art, New
York, New York

page 74 (bottom)
*View of The Museum of Contemporary
Art, Los Angeles*
Arata Isozaki, Architect
The Museum of Contemporary Art,
Los Angeles, California
Photograph by Tim Street-Porter

pages 75-76 (middle)
Portrait and a Dream, 1953
By Jackson Pollock
Oil on canvas
58^1/$_2$ x 134^3/$_4$ in.
(149 x 342 cm.)
Gift of Mr. and Mrs. Algur H.
Meadows and the Meadows
Foundation Incorporated
Dallas Museum of Art,
Dallas, Texas

page 75 (bottom)
*Interior view of The Museum of
Contemporary Art, Los Angeles prior
to opening in 1983*
The Museum of Contempoary Art,
Los Angeles, California
Photograph by Squidds & Nunns

page 76 (bottom right)
Jackson Pollock, 1950
By Hans Namuth
Photograph
Collection of the Center for Creative
Photography, The University of
Arizona, Tucson, Arizona

page 102 (top right)
Young Soldier, 1861
By Winslow Homer
Oil, gouache, black crayon on canvas
14⁵/₁₆ x 6¹¹/₁₆ in.
(36 x 17.5 cm.)
Gift of Charles Savage Homer, Jr.
Drawings and Prints Department
Cooper-Hewitt Museum, New York,
New York and Art Resource,
New York
Photograph by Ken Pelka

page 102 (bottom)
*The Pennsylvania Academy of
the Fine Arts*
Photograph
The Pennsylvania Academy of the
Fine Arts, Philadelphia, Pennsylvania

page 103 (top)
The Carnival, 1877
By Winslow Homer
Oil on canvas
20 x 30 in. (50.8 x 76.2 cm.)
Amelia B. Lazarus Fund, 1922
The Metropolitan Museum of Art,
New York, New York

page 103 (bottom)
*Interior of The Pennsylvania Academy
of the Fine Arts, Grand Stairway, fac-
ing "Death on the Pale Horse"*
Photograph by Rick Echelmeyer
The Pennsylvania Academy of the
Fine Arts, Philadelphia, Pennsylvania

pages 103-104
Right and Left, 1909
By Winslow Homer
Oil on canvas
28¹/₄ x 48³/₈ in.
(71.8 x 122.9 cm.)
Gift of the Avalon Foundation
National Gallery of Art,
Washington, D.C.

page 104 (top)
*Winslow Homer and his Brother
Charles Savage Homer Jr., Fishing on
the Rocks at Prout's Neck, Maine,*
1900
Photographer unknown

Gift of the Homer Family
Bowdoin College Museum of Art,
Brunswick, Maine

page 104 (bottom)
Homeward Bound, 1867
By Winslow Homer
Woodblock published in December
21, 1867 issue of Harper's
Weekly magazine
Library of Congress,
Washington, D.C.

page 105
FOX HUNT
By Winslow Homer (1836-1910)

page 106 (top left)
Portrait of Pablo Picasso, 1912
Photograph from Réunion des
Musées Nationaux and SPADEM,
Paris, France, and Art Resource,
New York

page 106 (top right)
Fragment of Iberian sculpture
From Osuna, Andalusia, Spain
Stone
National Archeological Museum,
Madrid, Spain

page 106 (bottom)
Philadelphia Museum of Art
Photograph
Philadelphia Museum of Art,
Philadelphia, Pennsylvania

page 107 (top)
Les Demoiselles d'Avignon, 1907
By Pablo Picasso
Oil on canvas
96 x 92 in. (243.8 x 233.7 cm.)
Acquired through the
Lillie P. Bliss Bequest
The Museum of Modern Art,
New York, New York

page 107 (middle)
Ritual mask
From Babangi tribe, French Congo,
Africa
Wood

Musée Barbier Muller,
Paris, France

page 108
Guernica, 1937
By Pablo Picasso
Oil on canvas
11¹/₂ x 25¹/₂ ft.
(3.35 x 7.62 m.)
Centro de Arte Reina Sofia,
Madrid, Spain
Photograph from Photographie
Giraudon and SPADEM, Paris,
France, and Art Resource, New York

page 108 (bottom)
*The Great Hall, Philadelphia
Museum of Art*
Photograph
Philadelphia Museum of Art,
Philadelphia, Pennsylvania

page 109
*SELF-PORTRAIT WITH
PALETTE*
By Pablo Picasso (1881-1973)

page 110 (top left)
Self-Portrait, ca. 1897
By Pierre-Auguste Renoir
Oil on canvas
16³/₁₆ x 13 in. (41.1 x 33 cm.)
Sterling and Francine Clark Art
Institute, Williamstown,
Massachusetts

page 110 (top right)
Le Peintre Impressionniste, 1877
By Cham (Amédée de Noé)
Caricature published in "Le
Charivari"
Bibliothèque Nationale de France,
Paris, France

page 110 (bottom)
View of The Phillips Collection
Photograph by
Lautman Photography
The Phillips Collection,
Washington, D.C.

page 111 (top left)
Cover of the catalogue for the First

Impressionist Exhibition
page 111 (top middle)
*Nadar's Studio, 35 boulevard des
Capucines, Paris,* 1874
Photograph
Bibliothèque Nationale de France,
Paris, France

page 111 (bottom)
*Marjorie and Duncan Phillips in the
Main Gallery of the Phillips Memorial
Art Gallery,* ca. 1922
Photograph by Clara E. Sipprel
The Phillips Collection,
Washington, D.C.

pages 111-112
Portrait of Paul Durand-Ruel, 1910
By Pierre-Auguste Renoir
Oil on canvas
25⁵/₁₆ x 21¹/₄ in. (65 x 54 cm.)
Photograph by Photo Routier
Document Archives Durand-Ruel,
Paris, France

page 112 (top)
Nude, Effects of Sunlight, 1875-1876
By Pierre-Auguste Renoir
Oil on canvas
31⁷/₈ x 25⁵/₈ in.
(81 x 65 cm .)
Musée d'Orsay, Paris, France
Photograph by Erich Lessing from
Art Resource, New York

page 112 (middle)
The Marriage at Cana, 1562-1563
By Paolo Veronese (1528-1588)
Oil on canvas
22 x 32¹/₂ ft.
(6.66 x 9.90 m.)
Louvre Museum, Paris, France
Photograph by Erich Lessing from
Art Resource, New York

page 113
*THE LUNCHEON OF THE
BOATING PARTY*
By Pierre-Auguste Renoir
(1841-1919)

page 114 (top left)
Diego Rivera and Frida Kahlo, 1932

Photograph
Library of Congress, Washington, D.C.

page 114 (top right)
Marine Fusilier, 1914
By Diego Rivera
Oil on canvas
$44^7/_8$ x $27^1/_2$ in.
(114 x 170 cm.)
Carillo Gil Collection, Mexico
Reproduction authorized by INBA

page 114 (middle)
Farm workers in agave field, Mexico
By Hugo Brehme (1882-1954)
Photograph
Library of Congress,
Washington, D.C.

page 115 (top left)
Tehuana Women, 1923-1928
By Diego Rivera
Fresco
Ministry of Education, Mexico City,
Mexico
Photograph by John Neubauer

page 115 (middle)
Detroit Industry, 1932-1933
By Diego Rivera
Fresco
Detroit Institute of Arts, Detail of
north wall
Gift of Edsel B. Ford
Detroit Institute of Arts,
Detroit, Michigan

page 115 (bottom right)
*View of the new San Francisco
Museum of Modern Art*
Mario Botta, Architect
San Francisco Museum of Modern
Art, San Francisco, California
Photograph by R. Barnes

pages 115-116 (top)
Detroit Industry, 1932-1933
By Diego Rivera
Fresco
Detroit Institute of Arts, North wall
Gift of Edsel B. Ford
Detroit Institute of Arts, Detroit,
Michigan

page 116 (bottom)
The Two Fridas, 1939
By Frida Kahlo
Oil on canvas
27 x 27 in. (68.6 x 68.6 cm.)
Museo de Arte Moderno, Mexico
Reproduction authorized by INBA

page 117
THE FLOWER CARRIER
By Diego Rivera (1886-1956)

page 118 (top)
*Marc Chagall with his wife Bella and
daughter Ida in his Paris studio*, ca.
1923
Photograph
Private Collection

page 118 (bottom)
*View of restored and expanded
Guggenheim Museum*, 1992
Frank Lloyd Wright, Architect;
Museum annex by Gwathmey Siegel
& Associates Architects
Solomon R. Guggenheim Museum,
New York, New York,
Photograph by David Heald

page 119 (top left)
Green Violinist, 1923-1924
By Marc Chagall
Oil on canvas
78 x $42^3/_4$ in. (198 x 108.6 cm.)
Gift, Solomon R. Guggenheim,
1937
Solomon R.Guggenheim Museum,
New York, New York
Photograph by David Heald

page 119 (bottom)
The Guggenheim Museum SoHo
Solomon R. Guggenheim Museum,
New York, New York
Photograph by Lee Ewing

pages 119-120
To Russia, with Asses and Others,
1911-1912
By Marc Chagall
Oil on canvas
$50^3/_8$ x $42^1/_8$ in.
(128 x 107 cm.)

Musée National d'Art Moderne,
Centre Georges Pompidou,
Paris, France
Photograph from Centre Georges
Pompidou and Art Resource,
New York

page 120 (top)
*Works of art confiscated by the Nazis,
in Berlin, during World War II*
Photograph
Library of Congress,
Washington, D.C.

page 120 (middle)
*Eiffel Tower from right bank of the
Seine*, 1901
By Greater New York Stereoscopic
Company
Photoprint on stereo card
Library of Congress,
Washington, D.C.

page 120 (bottom left)
Birthday, 1923
By Marc Chagall
Oil on cardboard
$31^3/_4$ x $39^1/_4$ in.
(80.6 x 99.7 cm.)
Acquired through the
Lillie P. Bliss Bequest
The Museum of Modern Art,
New York, New York

page 121
*PARIS THROUGH THE
WINDOW*
By Marc Chagall (1887-1985)
Photograph by David Heald

page 122 (top left)
Portrait of Piero della Francesca
Engraving
Library of Congress,
Washington, D.C.

page 122 (top right)
Polyptych of Saint Anthony, ca.
1460-1470
By Piero della Francesca
Oil and tempera on poplar panel
133 x $90^1/_2$ in. (338 x 230 cm.)
Galleria Nazionale dell'Umbria,

Perugia, Italy
Photograph from Scala Fotocolor,
Florence, Italy and
Art Resource, New York

page 122 (bottom)
*View of Sterling and Francine Clark
Art Institute*
Photograph
Sterling and Francine Clark Art
Institute, Williamstown,
Massachusetts

page 123 (top left)
Legend of the True Cross, 1452-1466
By Piero della Francesca
Fresco and mixed media
6 x 3 x 3 ft. (15 x 7.70 x 7.50 m.)
Church of San Francesco,
Arezzo, Italy

page 123 (bottom)
Measured heads, 1469-1470
By Piero della Francesca
From "De prospettiva Pingendi..."
Biblioteca Palatina, Parma, Italy

page 123-124 (top)
*View of Sala del caminetto degli
Angeli, Palazzo Ducale, Urbino, Italy*
Photograph from Scala Fotocolor,
Florence, Italy and Art Resource,
New York

pages 123-124 (inset)
Portrait of Federico da Montefeltro,
1472-1474
By Piero della Francesca
Oil on panel
$18^1/_2$ x 13 in. (47 x 33 cm.)
Uffizi Gallery, Florence, Italy
Photograph from Scala Fotocolor,
Florence, Italy and Art Resource,
New York

page 124
Polyptych of the Misericordia, detail,
1445-ca. 1460
By Piero della Francesca
Oil and tempera on panel
$8^1/_2$ x $6^7/_8$ ft. (3.30 x 2.73 m.)
Sansepolcro Museum, Sansepolcro,
Italy

Photograph from Scala Fotocolor, Florence, Italy and Art Resource, New York

page 125
VIRGIN AND CHILD ENTHRONED WITH FOUR ANGELS
By Piero della Francesca
(ca. 1406-1492)

page 126 (top left)
Self-portrait, 1928
By Reginald Marsh
Etching
4 x 5 in. (10.2 x 12.7 cm.)
Library of Congress,
Washington, D.C.

page 126 (top right)
Irving Place Burlesque, 1928
By Reginald Marsh
Lithograph
$9^3/_4$ x $11^1/_2$ in.
(24.7 x 29.2 cm.)
Print Collection
Miriam and Ira D. Wallach Division
of Arts, Prints and Photographs
Astor, Lenox and Tilden
Foundations
The New York Public Library,
New York, New York

page 126 (bottom)
The University of Arizona Museum of Art
Photograph
The University of Arizona,
Tuscon, Arizona

page 127 (top)
Coney Island Beach, 1934
By Reginald Marsh
Egg tempera on board
$35^5/_8$ x $39^5/_8$ in.
(90.5 100.6 cm.)
Gift of Mrs. Reginald Marsh
Yale University Art Gallery,
New Haven, Connecticut

pages 127-128
Depression: Breadline, 1932
Photograph

8 x 10 in. (20.3 x 25.4 cm.)
Franklin D. Roosevelt Library,
Hyde Park, New York

page 127 (bottom)
Interior of The University of Arizona Museum of Art
Photograph
The University of Arizona,
Tuscon, Arizona

page 128 (top)
Murals by Reginald Marsh in the U.S. Customs House, New York City, 1936-1937
Photograph
8 x 10 in. (20.3 x 25.4 cm.)
Still Pictures Branch, National
Archives, Washington, D.C.

page 128 (bottom)
Bread Line—No One Has Starved, 1932
By Reginald Marsh
Etching
$6^1/_2$ x 12 in. (16.6 x 30.5 cm.)
Print Collection
Miriam and Ira D. Wallach Division
of Art, Prints and Photographs
Astor, Lenox and Tilden
Foundations
The New York Public Library,
New York, New York

page 129
MONDAY NIGHT AT THE METROPOLITAN
By Reginald Marsh (1898-1954)

page 130 (top)
Portrait of George Caleb Bingham, ca. 1860
By Frank Thomas
Photograph
State Historical Society of Missouri,
Columbia, Missouri

page 130 (middle)
The Itinerant Artist, ca. 1850
By Charles Bird King (1785-1862)
Oil on canvas
$44^3/_4$ x 57 in. (113.6 x 144.8 cm.)
New York State Historical

Association, Cooperstown,
New York

page 130 (bottom)
Washington University Gallery of Art with sculpture by Alexander Calder in foreground
Fumihiko Maki, Architect
Photograph
Washington University Gallery of
Art, St. Louis, Missouri

page 131 (top)
The Jolly Flatboatmen, 1846
By George Caleb Bingham
Oil on canvas
$38^1/_8$ x $48^1/_2$ in.
(96.9 x 123.2 cm.)
Private Collection, on loan to the
National Gallery of Art,
Washington, D.C.
Photograph by Jose A. Naranjo

pages 131-132
Distribution of the American Art-Union Prizes, 1847
Lithograph
Kenneth M. Newman, The Old Print
Shop, Inc., New York, New York

page 132 (top)
Order No. 11, ca. 1865-70
By George Caleb Bingham
Oil on linen
56 x 78 in. (142.2 x 198.1 cm.)
State Historical Society of Missouri,
Columbia, Missouri

page 132 (bottom right)
Portrait of Daniel Boone, 1820
By James Otto Lewis
Engraving, after a painting by
Chester Harding
St. Louis Art Museum,
St. Louis, Missouri

page 133
DANIEL BOONE ESCORTING SETTLERS THROUGH THE CUMBERLAND GAP
By George Caleb Bingham
(1811-1879)

page 134 (top left)
Self-portrait, 1925-1930
By Edward Hopper
Oil on canvas
$25^1/_8$ x $9^7/_{16}$ in.
(63.8 x 51.4 cm.)
Josephine N. Hopper Bequest
Collection of Whitney Museum of
American Art, New York, New York

page 134 (top right)
Parisian Woman, 1906-1907 or
1909
Watercolor on composition board
$11^{13}/_{16}$ x $9^7/_{16}$ in.
(30 x 24 cm.)
Josephine N.Hopper Bequest
Collection of Whitney Museum of
American Art, New York, New York

page 134 (bottom)
View of Whitney Museum of American Art
Marcel Breuer (1964-1966),
Architect
Photograph by Sandak/G.K. Hall,
Inc.

page 135 (top right)
Nighthawks, 1942
By Edward Hopper
Oil on canvas
$33^1/_8$ x 60 in. (84.1 x 152.4 cm.)
Friends of American Art Collection
The Art Institute of Chicago,
Chicago, Illinois

pages 135-136
Portrait of Gertrude Vanderbilt Whitney, 1916
By Robert Henri (1865-1929)
Oil on canvas
50 x 72 in. (127 x 182.9 cm.)
Gift of Flora Whitney Miller
Collection of Whitney Museum of
American Art, New York, New York

page 136 (top right)
Morning Sun, 1952
Oil on canvas
$28^1/_8$ x $40^1/_8$ in.
(71.4 x101.9 cm.)
Museum Purchase: Howald Fund

Columbus Museum of Art,
Columbus, Ohio

page 136 (middle)
Street Scene, 1929
Photograph by White Studio
Gift of Harold Friedlander
Museum of the City of New York,
New York

page 137
EARLY SUNDAY MORNING
Edward Hopper (1882-1967)

page 138 (top left)
Portrait of Canaletto
By Visentini after a drawing by
Giovanni Battista Piazetta
Frontispiece from the second (1742)
edition of "Urbis Venetiarum
prosectus..."
Engraving
Courtesy Her Majesty Queen
Elizabth II
Royal Collection Enterprises, Ltd.,
Windsor Castle, England

page 138 (top right)
*Entrance to the Grand Canal:
Looking West,* ca.1730
By Canaletto
Oil on canvas
19$^1/_2$ x 29 in. (49.5 x 74 cm.)
Gift of Sarah Campbell Blaffer
The Robert Lee Blaffer Memorial
Collection
The Museum of Fine Arts,
Houston, Texas
Photograph by T. R. DuBrock

page 138 (middle)
*Title page (2nd state) of "Vedute da
Antonio Canal..."*
By Canaletto
Engraving
Courtesy Her Majesty Queen
Elizabeth II
Royal Collection Enterprises, Ltd.,
Windsor Castle, England

page 138 (bottom)
*Interior of the Yale Center for
British Art*
Photograph by Richard Caspole
Yale Center for British Art, New
Haven, Connecticut

page 139 (top)
*London: Westminster Abbey, with a
Procession of Knights of the Order of
the Bath,* detail, ca. 1749
By Canaletto
Oil on canvas
40 x 40 in. (101.6 x 101.6 cm.)
Courtesy The Dean and Chapter of
Westminster, London, England
Photograph from Scala Fotocolor,
Florence, Italy and Art Resource,
New York

page 139 (bottom)
*Paul Mellon at the Yale Center for
British Art*
Photograph by Diana Walker,
Time magazine

pages 139-140
*The Bucintoro Returning to the Molo
on Ascension Day,* ca. 1730
By Canaletto
Oil on canvas
30$^1/_4$ x 49$^3/_8$ in.
(76.8 x 125.5 cm.)
Courtesy Her Majesty Elizabeth II
Royal Collection Enterprises Ltd.,
Windsor Castle, England

page 140 (top)
*San Marco: the Crossing and North
Transept, with Musicians Singing,*
1766
By Canaletto
Pen and brown ink and gray wash
14 x 10$^5/_8$ in. (35.5 x 27 cm.)
Hamburger Kunsthalle, Hamburg,
Germany
Photograph by Elke Walford

page 140 (bottom)
*View of the Yale Center for
British Art*
Photograph by Richard Caspole
Yale Center for British Art, New
Haven, Connecticut

page 141
*WESTMINSTER BRIDGE,
LONDON, WITH THE LORD
MAYOR'S PROCESSION ON
THE THAMES*
By Canaletto (Giovanni Antonio
Canal, 1697-1768)

FURTHER READING

BELLINI
Meiss, Millard, *Giovanni Bellini's St. Francis in the Frick Collection*. Princeton, New Jersey: Frick/Princeton University Press, 1964.

BIERSTADT
Anderson, Nancy K. and Linda S. Ferber, *Albert Bierstadt, Art & Enterprise*. New York: Brooklyn Museum/Hudson Hills Press, 1990.

BINGHAM
Constant, Alberta Wilson, *Paintbox on the Frontier: The Life and Times of George Caleb Bingham*. New York: Crowell, 1974.

BRUEGEL
Cuttler, Charles, *Northern Painting*. New York: Holt Rinehart & Winston, 1968.
Hughes, Robert and Piero Bianconi, *The Complete Paintings of Bruegel*. New York: Abrams (Classics of the World's Great Art), 1967.
Klein, Arthur H. and Mina C. Klein, *Peter Bruegel the Elder*. New York: Macmillan, 1968.
Roberts, Keith, *Bruegel*. London: Phaidon, 1971.
Stechow, Wolfgang, *Pieter Bruegel the Elder*. New York: Abrams, 1990.
Sullivan, Margaret A., *Bruegel's Peasants*. Cambridge: Cambridge University Press 1994.

CANALETTO
Bindman, David and Lionello Puppi, *The Complete Paintings of Canaletto*. New York: Abrams, New York, 1968.
Links, J. G., *Canaletto: Every Painting*. New York: Rizzoli, 1981.

CARAVAGGIO
Hibbard, Howard, *Caravaggio*. New York: Harper & Row, 1983.

CHAGALL
Chagall by Chagall, edited by Charles Sorlier; translated by. John Shepley. New York: Abrams, 1979.
Compton, Susan, *Chagall*. New York: Abrams, 1985.

CHURCH
Stebbins, Jr., Theodore E., *Close Observation: Selected Oil Sketches by Frederic E. Church*. Washington, D. C.: Smithsonian Institution Press.

COPLEY
Brown, Milton and Sam Hunter, et al. New York: Abrams, 1979.
Flexner, James Thomas, *America's Old Masters*. New York: Dover, 1939/1967.
Frankenstein, Alfred, *The World of Copley*. Alexandria, Virginia: Time-Life Books, 1970.

DIEBENKORN
Nordland, Gerald, *Richard Diebenkorn*. New York: Rizzoli, 1987.

EL GRECO
Brown, Jonathan, et al., *El Greco of Toledo*. Boston: New York Graphic Society (Little, Brown), 1982.
Franco, Fernando Marias, *El Greco*. New York: Crescent, 1991.
Guidol, José, *El Greco*. New York: Viking, 1973.
Horga, Ioan, *El Greco*. Bucharest: London/Meridiane Publishing House, 1975.

DELLA FRANCESCA
Bertelli, Carlo, *Piero della Francesca*. New Haven and London: Yale University Press, 1992.
Gould, Cecil, *An Introduction to Italian Renaissance Painting*, London: Phaidon, 1957.
Lightbown, Ronald, *Piero della Francesca*. New York/London/Paris: Abbeville, 1992.

de Vecchi, Pierluigi, *The Complete Paintings of Piero della Francesca*. New York: Abrams, 1967.
Venturi, Lionello, *Piero della Francesca*. Cleveland: Editions d'Art Albert Skira, Lausanne/World Publishing Co., 1959.

GAUGUIN
Andersen, Wayne, *Gauguin's Paradise Lost*. New York: Viking, 1971.
Bodelsen, Merete, *Gauguin og Van Gogh i Kobenhavn i 1893*. Copenhagen: Ordrupgaard Kobenhavn, 1984.
Denvir, Bernard, *Gauguin: Letters from Brittany and the South Seas*. New York: Clarkson Potter, 1992.

HOMER
Cooper, Helen A., *Winslow Homer Watercolors*. New Haven, Connecticut: National Gallery of Art/Yale University Press, 1986.
Flexner, James Thomas and the editors of Time-Life Books, *The World of Winslow Homer*. New York: Time-Life Books, 1966.

MAGRITTE
Calvocoressi, Richard, *Magritte*. New York: Phaidon, Oxford/Dutton, 1979.
Sylvester, David, *Magritte*. New York: Menil Foundation/Abrams, 1992.

MARSH
Goodrich, Lloyd, *Reginald Marsh*. New York: Abrams, 1972.

MATISSE
Elderfield, John, *Henri Matisse: A Retrospective*. New York: Museum of Modern Art, 1992.
Russell, John and the editors of Time-Life Books, *The World of Matisse*. New York: Time-Life, 1969.

MONET
House, John, *Monet: Nature into Art*. New Haven and London: Yale University Press, 1986.
Mount, Charles Merrill, *Monet*. New York: Simon and Schuster, 1966.

O'KEEFFE
Cowart, Jack, Juan Hamilton, and Sarah Greenough, *Georgia O'Keeffe: Art and Letters*. Washington, .D.C.: National Gallery of Art, Washington, D.C., 1987.
Lisle, Laurie, *Portrait of an Artist: A Biography of Georgia O'Keeffe*. New York: Seaview Books, 1980.
O'Keeffe, Georgia, *Georgia O'Keeffe*. New York: Studio Press (Viking), 1976.
Robinson, Roxana, *Georgia O'Keeffe: A Life*. New York: Harper & Row, 1989.

PICASSO
Berger, John, *The Success and Failure of Picasso*. Penguin, Harmondsworth, 1965, reprint ed. Pantheon, New York, 1980.
O'Brian, Patrick, *Picasso: A Biography*. New York: Norton, 1994 (reprinted from a London edition of 1976).
Rubin, William, editor, *Pablo Picasso: A Retrospective*. New York: Museum of Modern Art, 1980.

POLLOCK
Landau, Ellen G., *Jackson Pollock*, New York: Abrams, 1989.
Naifeh, Steven and Gregory White Smith, *Jackson Pollock: An American Saga*. New York: HarperPerrenial, 1991.

PYLE
Ford, Boris, editor, *The Cambridge Guide to the Arts in Britain, vol. 7: The Later Victorian Age*. Cambridge, New York, etc.: Cambridge University Press, 1989.
The Brandywine Heritage, introduction by Richard McLanathan.

Chadds Ford, Pennsylvania: Brandywine River Museum, .
Ford, Boris, editor, *The Cambridge Guide to the Arts in Britain, vol. 7: The Later Victorian Age*. Cambridge, New York, etc.: Cambridge University Press, 1989.
Pitz, Henry C., *The Brandywine Tradition*. Boston: Houghton Mifflin, 1969.

REMBRANDT

Clark, Kenneth, *An Introduction to Rembrandt*. New York: Harper&Row, 1978.
Schwartz, Gary, *Rembrandt: His Life, His Paintings*. New York: Viking, 1985.

RENOIR

Arts Council of Great Britain, *Renoir*. London: 1985.

Fosca, François, *Renoir: The Man and His Work*. Englewood Cliffs, New Jersey: Prentice-Hall, 1962.

RIVERA

Helms, Cynthia Newman, editor, *Diego Rivera, A Retrospective*. Detroit: Founders Society of The Detroit Institute of Arts in association with W. W. Norton and Company of New York and London.
Wolfe, Bertram, *The Fabulous Life of Diego Rivera*. New York: Stein and Day, 1963.

RUSSELL

Chapin, Louis, *Charles M. Russell: Paintings of the Old American West*. New York: Artabras (Crown), 1978.
Garst, Shannon, *Cowboy-Artist: Charles M. Russell*. New York: Julian Messner, 1960.

Hassrick, Peter H., *Charles M. Russell*, New York: Abrams, 1989.
McCracken, Harold, *The Charles M. Russell Book*. Garden City, New York: Doubleday, 1957.

SEURAT

Courthion, Pierre, *Seurat*. New York: Abrams (Library of Great Painters), undated.

VAN GOGH

Bailey, Martin, editor, *Van Gogh: Letters from Provence*. New York: Clarkson Potter, 1990.
Hammacher, A. M. and Renilde Hammacher, *Van Gogh: A Documentary Biography*. New York: Macmillan, 1982.
Pickvance, Ronald, *Van Gogh in Saint-Rémy and Auvers*. New York: Metropolitan Museum of Art, 1986.

OTHER BOOKS

Arnason, H. H., *History of Modern Art*. New York: Abrams, 1986.
Martindale, Andrew, *Man and the Renaissance*. New York: McGraw-Hill, 1966.
Rewald, John, *The History of Impressionism*. New York: Museum of Modern Art, 1961.

REDEFINITION

PRESIDENT AND EDITOR	**EDWARD BRASH**
TEXT EDITOR	**MARY YEE**
FORMAT DESIGN	**JANICE OLSON**
PICTURE EDITORS	**SUSI LILL** **REBECCA HIRSH**
PICTURE RESEARCH	**ZACHARY DORSEY**
DESIGN	**CATHERINE RAWSON** **EDWINA SMITH**
FINANCE, ADMINISTRATION, AND PRODUCTION DIRECTOR	**GLENN SMEDS**
ADMINISTRATIVE ASSISTANT	**MARGARET HIGGINS**
INDEX	**MEL INGBER**
COLOR SEPARATION AND PRINTING	**TIEN WAH PRESS (PTE.) LTD,** **SINGAPORE**

The editors wish to acknowledge and thank Maria Vincenza Aloisi, Paris, France, for her invaluable assistance in communicating with the museums, picture agencies, and libraries of France.

For other contributions, the editors wish to thank Beatrice T . Dobie, Alexandria, Virginia, and Laura M. Ronning and Linda M. Barrett of the United States Historical Society, Richmond, Virginia.